American Material Culture
and Folklife
A Prologue and Dialogue

American Material Culture and Folklife

Simon J. Bronner, Series Editor

Assistant Professor of Folklore and American Studies
Pennsylvania State University, The Capitol Campus

Other Titles in This Series

American Material Culture and Folklife
A Prologue and Dialogue

Edited by
Simon J. Bronner

Assistant Professor of
Folklore and American Studies
Pennsylvania State University
Middletown, Pennsylvania

UMI RESEARCH PRESS

Ann Arbor, Michigan

Produced and distributed by
UMI Research Press
an imprint of
University Microfilms International
A Xerox Information Resources Company
Ann Arbor, Michigan 48106

Library of Congress Cataloging in Publication Data

American material culture and folklife.

 (American material culture and folklife)
 Bibliography: p.
 Includes index.
 1. Material culture—United States—Addresses, essays,
lectures. 2. United States—Antiquities—Addresses,
essays, lectures. 3. Folklore—Research—United States—
Addresses, essays, lectures. I. Bronner, Simon J.
II. Series.

E159.5.B76 1985 973 84-23755
ISBN 0-8357-1622-8 (alk. paper)

To Thomas Schlereth,
who deserves to have a material culture book dedicated to him.

Contents

Preface

The enduring, forthright artifact as a fixture of culture still begs to be understood. Despite the artifact's three-dimensionality, we have yet to fully grasp all its meanings and messages. Indeed, the object, although manifest, is typically enigmatic and multifaceted. To be sure, much headway has been made in studying the artifact. Students increasingly look beyond dusty documents and fleeting words to material things on the shelf and on the landscape for cultural revelations. That the artifact is being used as cultural evidence is not news. But when the artifact is treated as a cipher, a symbolic key to unlock problems of human thought and action, then we witness a number of significant concepts unfolding, especially when attention is given to the cultural and psychological roots of folk tradition. The task at hand is to match pressing questions to appropriate methods and theories. Undertaking this task by presenting perspectives on folk artifacts used by various researchers commands the attention of this book.

The use of the terms folk, popular, and elite serves a heuristic function in the study of cultural products. Although marked by limitations, using these labels helps clarify central research concerns. Surely folk, popular, and elite often overlap; and even more surely, divisions of the categories in the modern world suffer from scholars' arbitrariness and disciplinary arrogance. Yet the object made with skills and apprehended with attitudes acquired from informal learning, the object not mass-produced but rather locally made and used, the object shared by a community—in short, the object associated with folk tradition—is a distinctive type of evidence for the illumination of culture and history.

The folk object tends to vary more than elite and popular things across space, and it tends to persist longer over time. The folk artifact tends to be made by hand rather than machine. It is usually more personal to the maker and user, and more typical of the community in which they live. Concentrating on such objects, while being keenly aware of concomitant tradition, thus sheds light on particular forms of learning, manufacture, and community—and consequently makes our studies focused and manageable.

As this book is not exclusively on folk tradition, owing to the "nature of things," so the examples in this book are not restricted to the United States. Nonetheless, this book is meant as a contribution to American Studies. There is a temptation in American Studies as a strictly historical and literary discipline to be too inwardly directed, despite the nation's connection to global movements and societies. Folklife and material culture studies—with their strong association to ethnology and integration with world history, geography, sociology, psychology, and literature—look to social, creative processes that show cultural continuities and differences among people across time, and across space. The concern here is mainly with American things, but it is not limited to them, so that we might learn about America and its human inhabitants in terms of cultural and psychological relations.

But why another book of essays? Considering the diversity of approaches and questions in folklife and material culture studies, a set of essays in a single volume provides a guideboard to study. You can take in different points of view from one source. You can organize, compare and contrast ideas, and ultimately emerge with some conceptions of study that would not be apparent from a lengthy study of one problem taken from a single standpoint. To facilitate this opportunity, I edited for succinct essays, rather than extended treatises, and added brief comments with added questions and ideas. This volume also differs from other anthologies, inasmuch as the essays are not reprints, save one exception, but represent recently completed, original research. In addition, the special problems for the folk artifact are treated in prose and illustration more extensively than elsewhere, and from many perspectives within folklife studies. This does not belittle the value of other anthologies. Indeed, I hope the student will consult anthologies and treatises, listed in my bibliographic notes, in anthropology, archaeology, history, and American Studies. In sum, the volume here allows some important voices to step out from the choir of cultural studies to be heard.

This book, like other artifacts, has a guiding structure and content. In part I, I explain the historical background of material folk culture research, its premises, and the promises of cultural revelations which that research holds. Then I add background notes in introductions to the sections of the book. In the prologue section, three experienced scholars set up the backdrop against which the later dialogues emerge. Henry Glassie, whose influence permeates many of the discussions and citations, builds humanistic generalizations to be drawn from the interplay of architect and architecture, artificer and artifact. John Vlach advocates the communal basis of folklife study, and prefigures the dialogue between, for instance, Warren Roberts and Michael Owen Jones. Sergeij Tokarev gives examples of material culture studied from a sociohistorical perspective, and anticipates discussions such as the one taking place among Bernie Herman, Dell Upton, and Tom Carter.

The next two sections feature dialogues in the form of commentaries on analytical approaches to folklife and material culture, and on the relationships between folklife and museums and historical agencies. In some instances, commentaries clarify information, raise questions, or suggest future direction, as in those following Patricia Hall and Ormond Loomis's essays. In several instances debates surface, as with Warren Roberts' essay. To be sure, debates among analysts too rarely find their way into print, but the differences of opinion you will encounter are an important part of this volume, for they point to the healthy assessment and development of fundamental methods and philosophies in folklife and material culture studies.

A distinctive feature of the dialogues is the attention given to newer modes of analysis—especially performance, phenomenological, neo-Marxist, and behavioristic perspectives. Despite the disagreements among some of the contributors, one point is clear: an awareness of the world of physical things can open significant doors to knowledge about why we do what we do, why we are who we are, and why our world looks the way it does.

I am often asked by students of disciplines outside of folklife to tell them how folklorists "do" material culture, as if all folklorists were like-minded. My answer, however, gives the many methods folklorists employ, the recurrent questions they ask, and the assumptions their studies imply. Although I cannot exhaust all the possible methods, questions, and assumptions in this volume, at least I point to several perspectives currently used in examining social and material life. The contributors employ different analytical tools and they examine a variety of genres: craft, art, architecture, food, clothing, and furniture come forward.

This book brings out issues of study, and issues of living. My hope is that through the discussions begun here, you will be provoked to reflect on the broad philosophical implications of things, and thus bring some revelations to bear on your comprehension of the artifactual, psychological, and social worlds around you.

Artifact study is very much in the public eye. It is a branch of learning not dominated by academe. Museums, historical societies, research institutes, public arts agencies, design trades, and regional centers are actively involved in interpreting folk artifacts and artificers. Accordingly, the contributors' backgrounds (listed at the end of the volume) are diverse. John Vlach, Michael Owen Jones, Henry Glassie, Warren Roberts, Thomas Adler, and Roger Welsch are academics who nonetheless have had their feet in the museum world. Darwin Kelsey, C. Kurt Dewhurst, Marsha MacDowell, and Elaine Eff are more closely affiliated with museums, but they bespeak the growing research and education component of museum work. Others use government programs as their base of operations: Ormond Loomis in Florida, Robert Teske in Washington, D.C. Inta Carpenter and Sergeij Tokarev work for research institutes. Several contributors work in historical agencies, arts and humanities councils, or regional cultural

centers: W.K. McNeil, Elizabeth Mosby Adler, Patricia Hall, Alice Hemenway, and John Braunlein. Thomas Adler, Gerald Parsons, and I bring experience in archives to the volume, as well as that of the halls of academe and the museum.

The book has its share of "young Turks" as well as some "old guards." The contributors represent more than a folklife discipline, for they also call upon backgrounds in history, anthropology, sociology, geography, literature, linguistics, psychology, museology, art and architecture, and philosophy. By coming together here, they underscore the variety and continuity, the extent and vitality, within American material culture and folklife studies.

Being a social artifact, this book was given life with the help of many individuals and institutions. My thanks, especially, to the contributors and to other knowing friends who offered instructive advice—Thomas Schlereth, Kenneth L. Ames, Deborah Bowman, Elizabeth Cromley, Ronald L. Baker, Louis C. Jones, Stephen Foster, William Ferris, Dan Ward, Eugene Metcalf, Sue Samuelson, Wilhelm Nicolaisen, Diana Fane, Polly Grimshaw, Neville Thompson, Beverly Brannan, and Pamela deWall. They helped me through the labor pains.

For topics which later became essays in the dialogue section, I drew from a symposium on issues and directions in material culture study held in 1979 at the New York State Historical Association, in Cooperstown. The prologue section arose out of long evenings of talk and drama through the 1980s with fellow folklorist stagehands—John Vlach, Henry Glassie, Peter Voorheis, John Moe, and Stephen Poyser. I must take responsibility, however, for the ultimate production.

To colleagues at Penn State—John Patterson, Michael Barton, Charles Townley, Stan Miller, James Hudson, and William Mahar—I owe gratitude for sharing their knowledge and lending their support. To students at Penn State— gifted aides such as Sara Ryan Costik, Theresa Vilcheck, Karen Atwood, Tom Dekle, Melinda Thomas, and Wallace Yowaiski—I owe appreciation for being part of the effort. I drew generous assistance from staff at the Folklore Institute at Indiana University, the Office of Advanced Studies at the Henry Francis du Pont Winterthur Museum, and the Center for Research and Graduate Studies at the Pennsylvania State University–Capitol Campus.

For their special attention to this project, I want to single out for thanks Penn State's Darrell Peterson, photographer in Instructional Services, and Kathy Ritter, secretary in the Behavioral Sciences suite where I work. Whether turning film into images, or paper into essays, they always seemed to work magic for my benefit. Thanks, too, go to the staff at UMI Research Press for being my academic jewelers, adding sparkle to scholarship.

I offer an extra note of appreciation to Bruce R. Buckley, former dean and professor of American folk culture at the Cooperstown Graduate Programs of the State University of New York, for his part in laying the groundwork for

many would-be scholars to pursue the study of material culture and folklife. He, together with the other foresighted doyens elsewhere to whom we today owe an intellectual debt, helped us to realize the objects of our interest. Although we in the coming generations may depart from their counsel, we are grateful for the dramatic spirit of scholarship they established, and inspiring *mise-en-scène* of learning, which we now try to enhance.

Simon J. Bronner
September 1984

(Darrell Peterson)

Part I: The Study of Material Culture and Folklife

One only knows a thing when one knows why it is, its reason.
—Aristotle (ca. 335 B.C.)

All material things, therefore, are in themselves insensible, and to be perceived only by our ideas.
—George Berkeley (1713)

As folklore deals with ideas, so it would be the mission of the folklore museum to collect, arrange, and classify the objects associated with them.
—Stewart Culin (1890)

We get by analysis into the insides of things only by reaching new outsides.
—George Herbert Mead (1932)

And then there are things, *the clutter left by the past, which are keys to it when properly understood.*
—Louis C. Jones (1956)

Experience is captured in a thing; an inner sense of harmony might appear as a thing in a world of tangible things.
—Yi-Fu Tuan (1980)

The Idea of the Folk Artifact

Simon J. Bronner

A craft, a house, a food, that comes from one's hands or heart, one's shared experience with other people in a community, one's learned ideas and symbols, visibly connects persons and groups to society and to the material reality around them. That interconnection is material culture. Material culture is made up of tangible things crafted, shaped, altered, and used across time and across space. It is inherently personal and social, mental and physical. It is art, architecture, food, clothing, and furnishing. But more so, it is the weave of these objects in the everyday lives of individuals and communities. It is the migration and settlement, custom and practice, production and consumption that is American history and culture. It is the gestures and processes that extend ideas and feelings into three-dimensional form.

Material culture studies revolve around human-made objects in social settings. The self-conscious study of material culture among folklorists and ethnologists in America dates back to the late nineteenth century. Taking note of the material progress of the "modern, industrialized" nation, Victorian scholars looked to the material culture of traditional societies—such as those of Indians, immigrants, and isolated regions—to locate the roots of their civilization (fig. 1-1). In the spirit of the Victorian rage for science, the study of folk artifacts provided "objective" evidence; artifacts were the cultural specimens for a natural history of civilization. Through the 1880s and 1890s, in meetings and publications of anthropology, folklore, and natural science, attention was given to "objective culture," composed of artifacts scientifically illustrating folklore, customs, and manners of traditional groups.

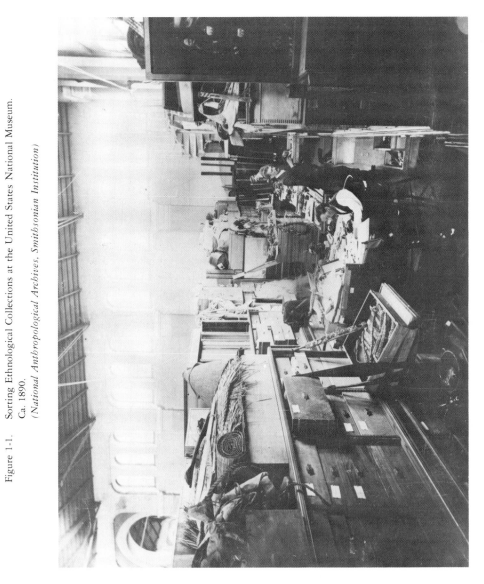

Figure 1-1. Sorting Ethnological Collections at the United States National Museum.
Ca. 1890.
(*National Anthropological Archives, Smithsonian Institution*)

The Exposition of 1893

American ethnology and folklore scholars received their chance to show off their studies and accomplishments at the World's Columbian Exposition, held in Chicago in 1893. The great material splendor of the "White City," as the Exposition was called, symbolized for its organizers the industrial and social advancement of a dominant American civilization. In keeping with the imagery of a new civilization, organizers included folklore and primitive technology—in their view, preindustrial and traditional markers of manners and customs belonging to a historical ancestry or an ethnographic present (fig. 1-2). Walking from the anthropology exhibits to the midway, visitors gaped at villages of exotic "primitive cultures" holding rituals. This realistic drama, with its genuine props and heartfelt actions of "natural" tradition, drew attention because of the Victorian's self-conscious invention of sentimental, dramatic ritual and pageantry. Some cultural groups on display were closer to home; Michigan loggers erected a hunting camp and passed the time as they would have in the woods. They offered a glimpse of what appeared to be a romantically independent and strenuous, traditional lifestyle.

The Exposition boasted learned congresses which proclaimed America's right to a place in the international (which primarily meant European) scholarly community. Fletcher Bassett, head of the Chicago Folklore Society, organized the third International Folklore Congress (the first two were in Paris and London) at the Exposition. Bassett wrote *The Folk-Lore Manual* (1892) to be a guide to the folklorist's purposes and concerns. The booklet outlined the materials of folklore often neglected by other disciplines—items like customs, songs, tales, and other oral traditions. He added a note on the special value of nonverbal evidence: "Finally, collection may well take the direction of tangible objects—visible proofs of the traditional customs, superstitions, and ceremonies."[1]

The study of objects in folklore had an influential following. Otis Mason (President of the American Folklore Society in 1891) and Thomas Wilson of the Smithsonian Institution wrote on the origin of modern invention and industry discernible in Native-American folk technology. Washington Matthews (President of the American Folklore Society in 1895), an Army surgeon, displayed his "museum"—field-collected ritual objects and crafts—which showed the "thoughts and sentiments" of native southwestern groups. Henry Mercer, an industrialist and also on staff at the University of Pennsylvania Museum, wrote on European-American tools, crafts, and housing representing the preindustrial era and leaving a folk cultural imprint especially on regions like Pennsylvania. Perhaps the strongest voice in the material culture movement belonged to Stewart Culin at the University of Pennsylvania (fig. 1-3). In exhibits and writings he set out to show the "language of things," and their distinctive story of culture and tradition. He collected among Chinese, Indian,

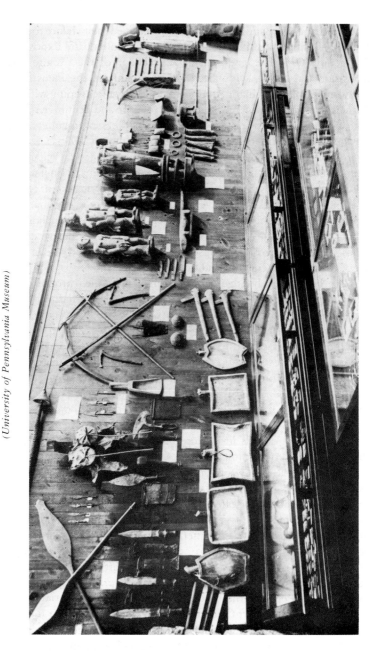

Figure 1-2. Ethnology and Folklore Exhibits, World's Columbian Exposition. Chicago, 1893.
(University of Pennsylvania Museum)

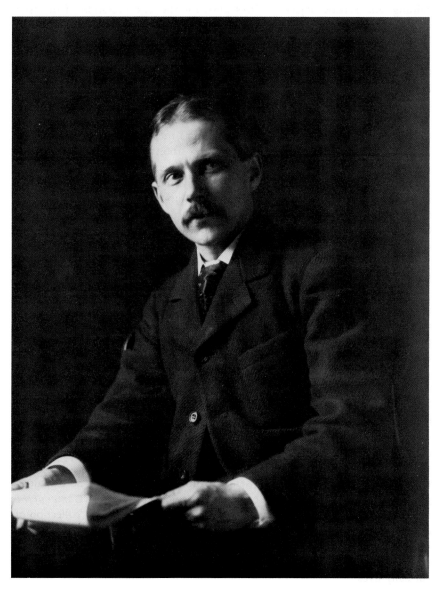

Figure 1-3. Stewart Culin.
Ca. 1905.
(National Anthropological Archives, Smithsonian Institution)

African, and European groups in America, and had a special interest in religious, gaming, and artistic objects. Culin's push for the interpretation of material culture earned him the title of Curator (and in 1897, President) of the American Folklore Society. Culin used "material culture" in contrast to the "antiquities" of archaeologists. The "material culture" used by ethnological folklorists took in functional objects and their backgrounds in living, observable societies (fig. 1-4). Material culture, Culin felt, was especially important to record from transitional cultures pressured to "Americanize" and lose their distinctive folk customs.

With other folklorists, Culin had traveled to the 1892 Exposition in Madrid to display American folklife and material culture, mostly from Indian, Asian, and European groups in America. At the 1893 Exposition in Chicago, Culin exhibited and wrote on traditional gaming and religious objects for a "modern" audience more aware of leisure and concerned with whether morality was declining or improving. Culin's display, showing the evolution of games from religious objects in folk cultures, was intended to draw connection to the moderns, for Culin believed that "primitive" and "modern" cultures shared many fundamental social and creative processes.

The Exposition put American materialism on display. A consuming public flocked to great collections of objects—folk, popular, and elite. Culin's "material culture" drew attention because it told of how other "ruder" publics, many right in their midst, used things and drew meaning from them. A frequent phrase used to describe the approach of the material-culture folklorists was that they provided "object lessons" for the age. Book and pamphlet titles appeared such as *Objects Used in Religious Ceremonies and Charms and Implements for Divination* (1892),*China in America: A Study in the Social Life of the Chinese in the Eastern Cities of the United States* (1887), and *Korean Games* (1895) by Stewart Culin, *The Decorated Stove Plates of the Pennsylvania Germans* (1899) by Henry Mercer, and *The Origin of Invention: A Study of Industry among Primitive Peoples* (1895) and *Indian Basketry: Studies in a Textile Art Without Machinery* (1904) by Otis Mason. The objects and lore the material culture folklorists collected, Culin insisted, told more than about roots of modern technology, religion, art, and amusement; the objects described and explained preexisting and coexisting social organizations and ideologies. His *Games of the North American Indians* (1907), Culin claimed, was the largest "collection of data existing on any particular subject referring to the objective culture of the Indian." Drawn from fieldwork and connected to belief and community, such ritualistic and ornamental objects were striking cognates of the "phenomena of out daily lives."[2]

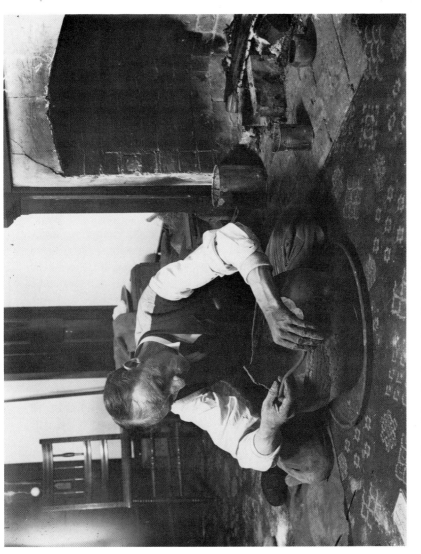

Figure 1-4. Frank Hamilton Cushing of the Bureau of American Ethnology Demonstrating How to Make a Coiled Pottery Vessel. Ca. 1890.

(National Anthropological Archives, Smithsonian Institution)

Modern Material Culture Studies

A comparable rage for material culture study in American folklore did not arise again until the 1960s. Exemplary titles included *New Found Folk Art of the Young Republic* (1960) by Louis C. and Agnes Halsey Jones, *Pattern in the Material Folk Culture of the Eastern United States* (1968) by Henry Glassie, and *Forms on the Frontier: Folklife and Folk Arts in the United States* (1969) edited by Austin and Alta Fife and Henry Glassie. Again underlying many of the works were questions of alternative social organizations and ideologies in the face of visibly rapid social and technological change. Some works held a preservationist rationale of identifying and saving the physical remnants of a nostalgic preindustrial past, while others called for a search for meaning (rather than the routine of modern life) in labor and leisure suggested by traditional practices and communities. Folk objects and their makers appeared to hold a handwrought, compassionate social "reality" in contrast to the commercial "plasticness" of growing modern middle-class life and high technology. An interest in understanding the flow of everyday life (in contrast to the "monumental" history of great men and institutions) and its shaping influence on a diversified American culture demanded new documents of people, such as those provided by folk objects (fig. 1-5). This interest was related to the supposition that through artifacts one could understand cultures on "their own terms," in the hopes of avoiding elitist prejudices of previous studies based on literary evidence.

In the 1970s, with works such as *The Hand Made Object and Its Maker* (1975) by Michael Owen Jones, *Folk Housing in Middle Virginia* (1975) by Henry Glassie, *American Folklife* (1976) edited by Don Yoder, and *The Afro-American Tradition in Decorative Arts* (1978) by John Vlach, material folk culture study stepped forward more boldly onto the ground of method and theory. The study caught more scholarly and public attention. Some of the attention came as a result of a bicentennial pride in America's rugged traditional houses and crafts. But there was also a critical bent in many studies that confronted American middle-class preconceptions of materialism and modernism by studying American subcultures in ethnic, racial, and regional communities. Such communities were apparently removed from the image offered by national, consensus histories of a dominant bourgeois, homogenized nation. Its work most often combined historical and ethnographic concerns, but in contrast to the scientific rhetoric of 1893, this study drew much of its vocabulary from the humanities. Still, a degree of the past assumption of objectivity drawn from social sciences remained as researchers looked to objects for lasting, "truthful," and quantifiable messages. And still there was the psychological goal of "getting into the heads" of makers and users as researchers sought to connect things to ideas held collectively by a society and in the mind of a particular maker and user.

A figure illustrating the rediscovery of material culture research is Louis C. Jones (fig. 1-6). Jones had left his revered place as professor of literature and folklore in 1947 to become director of the New York State Historical Association and its museums. He oversaw a house museum with a collection of fine, popular, and folk art, and a village museum depicting the folklife of an upstate New York farm and community during the nineteenth century. Looking to interpret the collections led him to write about studying the artifact in the light of human experience. The everyday artifact, he told his suspicious colleagues in academe, revealed basic patterns of American culture which did not find expression in the historian's documents.

I asked Jones how he came to his standpoint. He told me a story. One day in the fall of 1947, he walked through the Farmers' Museum of the New York State Historical Association with George Campbell, an ex-farmer who had worked on the farm that later became the museum. Stopping at a collection of farm implements, Jones asked, "George, what do you call that?" Jones felt an uneasiness brought on by his unfamiliarity with interpreting the material world of New York state farm life. He called himself a folklorist, and like most American folklorists in 1947, his interests lay in oral tradition, particularly songs and tales. George was amused that the professor could not identify an implement basic to the cultivation of a farmer's field. "Why, that's an A-drag," George replied.

The object reminded Jones of witchcraft lore he had collected about the placement of an A-drag at a Rensselaer County crossroads to insure that witches would not come. Recollecting the incident, Jones felt a profound revelation at the moment he made the connection between the object and culture: "Suddenly I realized that there was a world of three-dimensional objects, of artifacts that were just as much part of the academic concern, which had been mine, as the words were. It was a great help because then I began to see that the songs and stories and customs and objects, and ultimately the art were all part of the same level of society. They were the things that the academic historians had been ignoring, that the academic aestheticians had been ignoring, so this was a great eye opener to me." Fixing on the object let him telescope culture, and bring the past closer to the present.

Today, the man on the street flocking to popular books on folk artifacts and the academic checking journals for new perspectives on material culture search alike for "object lessons" on meaning derived through the traditional structures that decorate, house, clothe, and feed us. We often turn to tradition for signs to interpret, ideas to use. The spirit of investigation today, in contrast to the rhetoric of 1893, supports cultural pluralism and calls for an egalitarian ethic in material culture study.

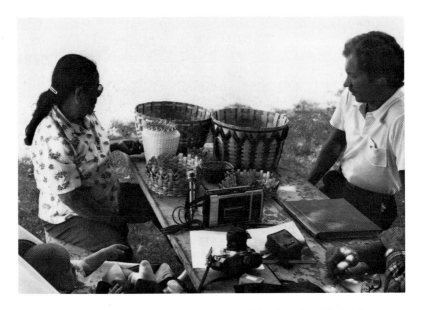

Figure 1-5. Kurt Dewhurst Interviews Native-American, Black Ash
 Basketmaker Edith Bondie at her Home.
 Hubbard Lake, Michigan.
 (Folk Arts Division, Michigan State University Museum)

Figure 1-6. Agnes Halsey Jones and Louis C. Jones with Carving by
 Pennsylvania Artist John Scholl (1827-1916) in New
 York State Historical Association's Folk Art Collection.
 Cooperstown, New York, 1975.
 (Courtesy Louis C. Jones)

Premises of Material Culture Study

Several premises underlie the use of objects for grasping the ideas in American cultural life: (1) *objects signify culture;* (2) *objects provide information which supplements, and may be distinct from, written and oral evidence; and* (3) *physical information on objects can be synthesized with knowledge on spiritual and intellectual realms of human life.*

Premise One: "The Ideas This Fair Spectacle Must Suggest"

An often-repeated challenge is J. Hector St. John De Crèvecoeur's classic question posed in 1782, "What then is the American, this new man?" Yet few note that Crèvecoeur's answers emphasized, above all, the "material difference" between Europe and America.[3] In delineating the houses, roads, orchards, meadows, and bridges arising out of a "wild, woody, and uncultivated" land he recognized that American technology was derived from Europe, yet was "displayed in a new manner." This observation led him to speculate on the "ideas this fair spectacle must suggest."[4]

Crèvecoeur saw patterns among seemingly unrelated objects on the landscape, and he associated the appearance of such objects with beliefs, customs, and values. He drew information about the identities of individuals by taking note of their material surroundings. In an early assessment of America's regional differences in culture, Crèvecoeur wrote of how the forms of agriculture and construction influenced the European settlers. "Europeans submit insensibly to these great powers, and become, in the course of a few generations, not only Americans in general, but either Pennsylvanians, Virginians, or provincials under some other name. Whoever traverses the continent must easily observe those strong differences, which will grow more evident in time."[5]

Crèvecoeur assumed a basic analytical premise—objects signify and influence mental concepts inherent in culture. Fundamental to his assumption is the belief that individuals who make and use objects will leave their cultural imprint on artifacts. By viewing patterns and forms of objects the observer can therefore organize the imprints into understandable codes of meanings.

Standing before the Harvard Tercentenary Conference of Arts and Sciences (1936), noted anthropologist Bronislaw Malinowski elaborated on the object's relationship to culture. "Culture," he said, "is nothing but the organized behavior of man. Man differs from the animals in that he has to rely on an artificially fashioned environment: on implements, weapons, dwellings, and man-made means of transport."[6] Malinowski anticipated resistance to this claim for the priority of material culture in social inquiry. He referred to the irritation and scorn his colleagues displayed when faced with his interest in construction details and technical skills in his famous ethnography of the Trobiand Islands.[7] To

convince his audience of the high value of objects as cultural evidence, he showed that to produce and to manage the material world, human beings require knowledge and techniques shared among members of a social group. By understanding the material world, then, the ethnographer can understand the spiritual and social world of the group, and thus gain insight into the "large-scale molding matrix," the "gigantic conditioning apparatus," which he called culture.[8]

Today we generally balk at the idea that we are passively subject to the power of culture. We think of ourselves as having more free choice to mold and change identities in various situations. Still, Malinowski aptly points out the immediacy of material culture in human lives. Often that immediacy lulls us into ignoring material culture. The removed and commonly exotic document or word attracts our gaze, even as the typical symbols of cultural objects lie within our grasp.

Every person makes and uses objects of some sort. In the activities of making and using things, humans surround themselves with objects according to personal and social standards, needs, identities, and instincts. They use technology available in the society, and adapt products and processes according to individual and social demands and mores. Consequently, by observing people engaged in organizing surroundings, displaying aesthetic features, and developing attitudes and beliefs—based on the encircling physical world— analysts can draw inferences on the motivations for, and the meanings of, human behaviors.

The cultural worlds people live in are both socially and personally defined. People learn about their environments through social contacts, but they discover and comprehend the surroundings by themselves again and again. Objects are references people use to tangibly outline the worlds they know, the ones they try to cope with, and those they aspire to or imagine. Creative objects—including art, craft, architecture, clothing, and food—become markers for the physical and intellectual surroundings with which people identify. Such objects reify intangible, abstract human and spiritual relations in those surroundings. The significance humans attach to their objects can be traced to the artifact's ability to be touched and seen, and its three-dimensional, manipulable quality. The artifact endures and symbolizes. When people manipulate forms they create symbolic expressions. When students of artifacts study the various expressions generated by cultural knowledge, they reveal a telling segment of human conduct and communication. The artifact is part of a system drawing together maker, user, and apprehender; the system ties mind to behavior, goods to social and political organization, and the individual to self and society. "Culture" acts as a nominal reference to the system and the ideas that generate and preserve it.

Premise Two: "Touch My Property, Touch My Life"

When talking about "material culture," writers usually refer to everyday objects, whether folk or popular. Describing the culture part of material culture is a task designed to uncover the typical, acquired, and cultivated behavior and thought shared by common individuals within a society. Objects are necessary as evidence, because as historian George Kubler points out, "The moment just past is extinguished forever save for the things made by it."[9] Yet histories are most concerned with the words written, and less often spoken or sung, rather than with the material and behavioral components of culture.

Although many writers have recognized that objects can serve as supplementary evidence to the written and oral record simply by virtue of its material representation of form and design, few analysts have commented on the distinctions among the different types of evidence—oral, written, and artifactual. John Kouwenhoven is one who boldly challenged the overreliance on verbal data by scholars. He argued that celebrated authors and gallery-insulated artists do not represent the bulk of society; common people who tell of their values and ideas in everyday objects do.

Kouwenhoven declared words to be deceptive and misleading evidence because of the inherent limitations of language. To Kouwenhoven, verbal symbols "are at best a sort of generalized, averaged-out substitute for a complex reality comprising an infinite number of individual particularities."[10] Details of texture, color, and form conveyed to our senses, such as those Louis C. Jones perceived in his encounter with the A-drag, are often obscured by verbal symbols. Thus Jones did not truly comprehend the intellectual significance of the A-drag until he experienced the artifact.[11]

What is needed, Kouwenhoven contended, is a sensory awareness of objects created in a "direct, untutored response to the materials, needs, attitudes, and preoccupations of society."[12] In that way, the details, or in Kouwenhoven's words the "experienced particulars," of American culture can be illuminated. Kouwenhoven based his case for the use of objects as cultural evidence on the need for a total sensory experience to perceive the details of culture. Looking analytically at objects involves seeing, smelling, touching, tasting, and hearing— far more reliable sources of data construction than words by themselves can provide.

The most significant characteristic of the artifact is the concrete, manipulable nature of the artifact. People cognitively associate objects with particular time periods and experiences, social groups and situations, and with certain landscapes and locales. Material culture is therefore history; it is sociology, psychology, geography, and anthropology; it can be philosophy, literature, and drama. Evidence that can be held and seen, such as objects, establish tangibly the existence of cultural styles. Objects have the advantage of

being directly compared, according to formal features, and according to processes of conception, perception, manufacture, use, and distribution.

In our histories, the common overreliance on the static and unusual written word to make inferences about the whole of American culture represents a subjective bias, for scholars frequently presuppose, misleadingly, that all people, typically, effectively, and truthfully express their values and beliefs in the primary imposed medium of scholars—the officially written word. In everyday experience, however, people directly express and reveal themselves in their daily encounters with the physical world. After waking, we groom, dress, eat, and perhaps find transportation to work. Each of these actions involves personal choices about identities we will display that day and the interactions with people we will face. Each action therefore reveals something of our thoughts and purposes.

Indeed, we can speak of the human body as part of material culture, for we are objects unto ourselves. We worry about how we "carry ourselves," what "image we give," and significantly, how "we look" and "what shape" we are in. Our bodies have become objects to design and manipulate. Our objects are linked to our bodies, since we tend to project the shape of the human body onto objects. Planes have noses, cars have faces, guitars have necks. The predominance of rectangles in technological design can be traced to people conforming shapes to the body. Our beds, houses, and coffins are shaped that way, but so too are painting frames, place mats, and sports fields.

We need objects as "visible proofs," as Fletcher Bassett said, because of our reliance on vision and touch to verify reality. "I see what you mean," "eyewitness," "eye-opener," "insight," and "the mind's eye" are phrases which underscore the notion that visual awareness is necessary to convert opinion to fact. We use our senses to "think things through," and we use objects to verify our thoughts. People will make their point with an *illustration*; they want to *show* you what they mean.

"Seeing is believing," but remember too that "feeling is the truth."[13] When shoppers ask to "see" a product, they really ask to handle it; they want to touch it before they make their decision. You don't want to be "out of touch with reality." What makes the telephone call worthwhile when you can't see the person on the other end? Because you can "reach out and touch someone," the telephone company tells us. The "hands-on" exhibit in museums enriches the educational experience of visitors, for they use touching to investigate and comprehend the way they would everyday. Remember that Apollo 10's close sighting of the moon failed to satisfy the American public. What captured their imagination was Neil Armstrong's walk on the moon. Armstrong picked up the moon's surface in his hands. Yes, it was real and less mysterious. The rocks he brought back held a special fascination for the public because they could touch them, literally apprehend them firsthand.

We best understand oral and written data when they can be objectified, that is, given some three-dimensional reference. Americans speak of *grasping* or *holding* ideas, *tackling* or *handling* a problem, and *covering all sides* of an issue. Theories are built on a solid foundation of firm evidence. Pillars of thought are carved or shaped out of bodies of information. Even verbal data are often defined as types of artifacts, or as "mentifacts." Oral and written literature are given artifactual characteristics such as texture, structure, and form. It is no wonder that validating an artifact like the "shroud of Turin" caught the imagination of the Christian world. It was thought that through the touchable object, religious legends could be verified. We like our evidence concrete and clinching.

Spoken words, written documents, and performed movements are necessary to give the object life and meaning. The object becomes distinctive evidence, though, when verifying other types of evidence, or surviving in instances where other types do not exist. For the record of American everday life, the latter is usually the case. One American Studies scholar was moved to write, "a close recording and interpretation of material culture can provide insights into the life of the common man—who left no written record and whose lives will be revealed only by studying what remains of their homes, their cities, their places of work—the things they left behind."[14]

Artifacts can also challenge what we say, for artifacts represent what we actually do. That is why researchers will consider the artifact separately at times from other evidence. By directly studying the material components of culture, "the real thing" so to speak, the researcher can reintegrate the distant removes of literary and oral evidence. Material culture researchers not only realize the maxim, "Seeing is believing, but feeling's the truth," then, but they also grasp the human principle expressed in the folk saying, "touch my property, touch my life."

Premise Three: "The Tangible as well as the Spiritual and Intellectual"

Given that objects signify culture, and given that objects are distinctive evidence, then it follows that knowledge from objects can be synthesized with the whole of human experience, including spiritual, intellectual, and social life. When such knowledge is not connected to human experience, we come up with a shallow, one-dimensional picture of cultural endeavor. This is the complaint leveled against antiquarians and some museologists. In 1940, for example, anthropologist Gladys Reichard, editor of the *Journal of American Folklore*, criticized collectors who set objects apart "as if they were isolated from all other aspects of life."[15] She urged that objects be "coordinated with the social, religious, economic, and psychological background of their owners," and the study of culture include the *tangible* as well as the spiritual and intellectual.

As Reichard suggested, there was (and for that matter still is) a tendency to treat the object apart from the contexts in which it normally operates. The tangible existence of objects tempts researchers to remove the artifact from its natural setting in order to examine the details of its existence. In this perspective, the object is treated as complete; it is viewed as static, ordered, and concluded. Yet human behavior, especially in material culture, is characterized by processes and movements—activities marked by organized behavior. Thus the premise that studying objects is connected to social, intellectual, and spiritual existence implies that we need to approach the artifact as a process related to influencing systems, which include social, political, psychological, and economic. We need to understand the artifact in light of its natural habitat and its makers and users. Placing the item in a box and taking it home, as analysts are often wont to do, might illuminate the formal details of the object, but may negate the ultimate goal of comprehending human behavior and thought.

"Material culture" hence describes much more than objects; it strikes deep into the relation of human existence and expression. It is a study of people and their wrought reality. When we talk of "natural setting," we mean the environment, and also the human and intellectual setting. Often, this includes a concern with the person's subjective view of his surroundings. How does one's perception shape the things one makes and the opinions one holds? Researchers can look for cultural universals, but are careful to note the patterns and preferences of a particular person or society.

Summing up material culture research in several countries, S.A. Tokarev declared that the goal of that study is to investigate the relationship of things to people, people to things, and most importantly, people to one another.[16] You can sense this humanistic concern in American studies. Folklorist Don Yoder, for instance, oriented his influential definition of folklife research "toward 'life,' the life of the society under study and of the individual within that society."[18] Historian Thomas Schlereth described material culture study as "the study through artifacts of the belief systems—the values, ideas, attitudes, and assumptions—of a particular community or society, ususally across time."[17] Behavioral scientists Mihalyi Csikszentmihalyi and Eugene Rochberg-Halton add, "To understand what people are and what they might become, one must understand what goes on between people and things."[19]

Although using "people" generally, writers in material culture have emphasized people as they divide into groups. When people meet face to face, the thinking goes, people share interests and backgrounds that affect their behavior. Common groups are ethnic, racial, regional, religious, and occupational. People use objects to express strategically their group identities. They can dress and eat a certain way at an Italian festival in Philadelphia and follow the tradition of their workmates when they dress and eat the next day. Both styles call for one's perception of the situations and people one will face.

The researcher examines the persistence and vitality of group identity and boundary by collecting and interpreting folk products peculiar to the group.

You can readily find studies of America's ethnic and racial products, but the material culture arising from one's job, age, and sex has been given less than its due.[20] Concerned with this inattention, for example, Lizabeth A. Cohen interpreted the home furnishings of urban workers from 1885 to 1915 to draw conclusions on the attitudes arising from the life of labor resulting from the Industrial Revolution. Bruce Nickerson mentioned blue-collar crafts in his answer to the question "Is There a Folk in the Factory?"[21] Based on techniques informally passed down to them, factory workers construct tools and figures from scrap materials. Coal miners have anthracite carving, lumberjacks boast carved chains, and prisoners, an institutional group, make their own folk implements and beverages.[22]

Different age groups prefer different styles of artifacts. The things children make, unlike adult things, are often hidden, ephemeral, and temporary, thus making documentation difficult (fig. 1-7). Often what is called children's material culture are actually things made by adults for children. Unlike "public" skills and performances common in middle age, the creative objects of the elderly tend to be esoteric, or are made in seclusion. As the generations become more defined, so too do their products.

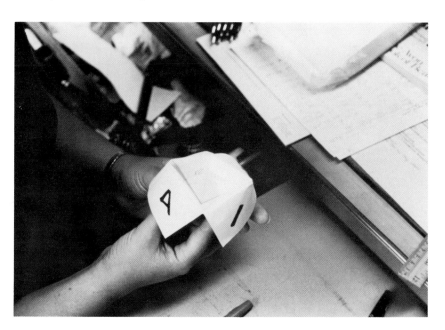

Figure 1-7. Folded Paper, Fortune-Telling Gaming Object, Common among Pre-Teens. *(Simon Bronner)*

The rise of women's studies has inspired considerations of the different creative spheres dominated by men and women. We are finding that women's genres exist in the public mind: for example, quilting, weaving, and cooking. A lesson to be drawn is how American culture categorizes masculine and feminine roles. Wood and metal are masculine; think of the carver and the blacksmith. Textiles and foodstuffs are feminine. Boiling and baking belong to women. Roasting and broiling are masculine; think of the barbecue chef. Such mental categories are hidden in patterns of displaying, advertising, and designing goods, and imply generative grammars.

We freely display objects to give us a sense of place, and of a group's past and pride in certain situations, but objects also can tell the private story of a person. When some individuals are inspired to create out of an inner vision or a personal experience, we ask why. When Mississippi blues singer James Thomas made strange death skulls out of clay, William Ferris wrote of Thomas's personal attitude toward death shaped by his Afro-American experience (fig. 1-8). When Kentucky chairmaker Chester Cornett made imposing chairs of confinement, Michael Owen Jones found aspects of Chester's personality to explain the design (fig. 1-9).[23]

At the other end of the continuum are investigations of larger chunks of the world's society. Is there a "Western" outlook as opposed to an "Eastern" one? What are the traits that are fundamentally human, no matter where people are found? These questions arise in discussions of *worldview*: "Cognitive, existential aspects of the way the world is structured."[24] Westerners think like their products—forward-moving and linear. The abstract notion of progress is like that; government legislation is like that; time is structured like that. Dwellings, sentences, and art are typically rectilinear and Westerners arrange words and things in straight lines. "Stay in line," "Go straight," and "Speak straightforwardly," we are told. The numerical concept of threes pervades American language and material culture. Americans customarily eat three meals a day; divide sizes into small, medium, and large; observe red, yellow, and green traffic signals, and so on.[25] This pattern finds expression in the prevalent design of balancing a central element with two other equal elements. A central door is flanked equally by windows; the speaker is flanked by two flags. We learn a sense of order, balance, and proportion in design that we apply to society.

Can we go beyond America to cross-cultural tendencies having to do with material life? The importance of the sense of touch to help people reason and solve problems crosses many cultures. Show a puzzle to someone, and they want to handle it, touch it, and "work it out." To check whether an image is "real," or to know and control it, people are inclined to reach out, feel it, and put it in their hands. Talk to someone about a distressing subject or in an uncomfortable situation and they commonly "play with something." Having an object to grasp gives a sense of security; it gives you *something to hold on to.*

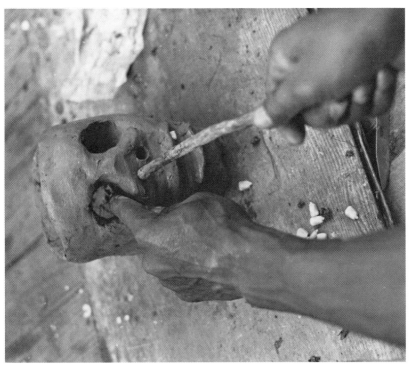

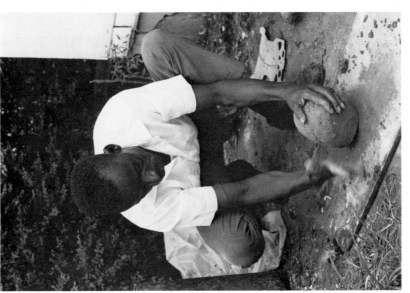

Figure 1-8. James Thomas.
Leland, Mississippi.
(William Ferris, Archives and Special Collections, University of Mississippi)

Figure 1-8. James Thomas.
Leland, Mississippi.
(William Ferris, Archives and Special Collections, University of Mississippi)

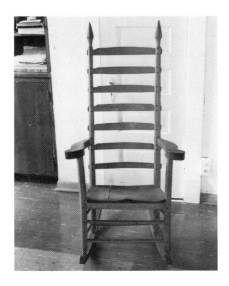

Figure 1-9.

Slat-Back Rocker Made by Chester Cornett of Kentucky while Living in Cincinnati, Ohio. 1974.
(Simon Bronner)

People use objects as symbols. Each person recognizes objects as metaphors for human experience and value. I look at the Verrazano Narrows Bridge in New York City and recall my adolescence. Someone else might see it as a symbol for the expansion of the city or for faith in technological progress and design. Objects become important to communication because they contain symbols which we can convey when we give them to someone, or in making and using them. "Words cannot express the way I feel," one may say, giving you an object to convey emotion and experience.

In design, construction, and context, the "star barn" (as it is known locally) near Middletown, Pennsylvania, illustrates several themes and symbols of American material culture and folklife (fig. 1-10, cover). Its overhanging forebay, banked entrance on the nongable end, three levels and three bays represent German-American folk tradition prevalent in southcentral Pennsylvania. Built around 1868, the barn was also subject to national, popular movements. It has "Carpenter Gothic" decorations such as high-arched louvers, a large cupola, and an octagonal spire. Following the heightened symmetry of post-eighteenth century, Anglo-American classicism, the doors, windows, and louvers are geometrically placed and laterally paired. Two matching silos once flanked the banked entrance. Showing nationalistic spirit, the central louver is a five-pointed star. The star is framed and emphasized by a front-facing gable, which declared an increasing sense of frontality in the presentation of American design. For its time, the barn's 40-foot spire symbolized an upwardly aspiring community and nation. The barn's colonial bannerette weathervane capped an eclectic, American approach to the built environment—a combination of local and national, ethnic

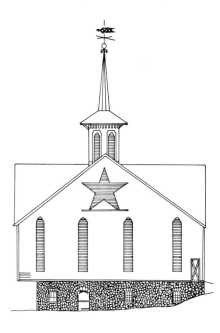

Figure 1-10.

Side View of Nineteenth-Century Pennsylvania-German Bank Barn, Combining Folk and Popular Designs.
Middletown, Pennsylvania, 1982.
(Sara Ryan Costik)

and "American," old and new, folk and popular. The barn announced the social status and values of its builder John Motter, who was described upon his death in 1901 as "a most worthy and highly respected citizen, a man who through an active business career accumulated a handsome competence through the exercise of preserverance, thrift, economy and integrity. His family . . . represents several homes within the county." Reaching 106 feet across, 66 feet deep, and 80 feet high, and lying next to a major highway, the imposing (and still working) barn remains on the landscape as a prominent symbol for the region and community of tradition and change.

People do not need a tangible product to invoke the power of artifacts. Gestures become part of material culture. Think of the controversy created when students chose not to pledge allegiance (by *touching* the hand over their heart) to the *flag*. In religion, clasping hands in prayer, making a sign of the cross, and kneeling assume symbolic shapes and material references. Children display a priority system by imitating objects in the popular children's game, "Rocks, Paper, and Scissors." Actions may speak louder than words, and actions often refer to material culture.

Artifacts tell of the everyday past and the cultural present. Significantly, they lead us to consider, too, the principles and processes that transcend time, that make us the social animals we are. Material culture study cannot stand exclusively, however, on physical evidence. Having redressed much of the evidential imbalance of years past, many writers are anxious to reintegrate the

material facts with customary, gestural, oral, and written evidence. We turn increasingly to the shadowy areas at the outer borders of the tangible and intangible such as ritual, play, labor, festivity, and belief. Still, the academic quest for philosophical knowledge obtained from artifactual study has only begun in earnest in the last generation. Its importance is revealed again by Louis C. Jones. Only three years after his eye-opening experience in the Farmer's Museum, he could point to research on the buildings, occupations, and surroundings in his New York State crossroads village and declare that material objects and pursuits there are the "focused reflection of the struggles we have passed through, for these we must understand or we are unarmed for the struggles which lie ahead."[26]

The Folk Artifact in Perspective

All objects are not created equal. Whether made by hand, by tradition, by whim, kit, or assembly line, the object is evidence of different cultural experiences. The categories folk, popular, and elite commonly are used to describe and separate for analysis such cultural experiences, their settings and products.

The categories are never as neat or separable as we would hope. Folk, popular, and elite are abstractions—narrow labels imposed on the concrete object. The object cannot be folk or popular in and of itself. What we call the folk object is an abbreviation for an object representing, at least in part, informal learning processes. Similarly, "material culture" presents problems, for it properly refers to material manifestations of culture, since culture is not concrete but rather an abstraction. Even then, "material" as an adjective to complement social and verbal culture can appear too neutral and passive a term to describe the active, reactive, and creative behavior of making and using things. Dividing culture into material, social, and verbal, as in dividing culture into folk, popular, and elite, is most often a scholarly convenience. The categories appeal to our predilection for stratified organization and heuristic purpose. They help order the jumble of artifacts we encounter daily into classes that are comprehensible and manageable in our culture.

"The mind of every man," Henry Glassie reminds us, "is apt to include ideas which can be classed as elite, popular, and folk: at least there is not one in America who does not carry both folk and popular culture. And, as the mind is a compound of ideas from various sources, the objects we can touch may be purely of one category or they may represent syntheses—often, very complicated syntheses."[27] When writers and curators plant the flag of "folkness" on an object, then, they generally stake their claim on the object's connection to characteristics and ideas commonly associated with folk groups, styles, and practices.

"Folk" usually describes products of informal learning—word of mouth, imitation, and custom. The label "popular" is typically given to products of current

fashion—especially those given sanction by the formal culture of print and other popular media. "Elite" ideas come from the highly formalized world of genteel tastes and pursuits. Overlap, and overgeneralization, are unavoidable. Attempts to draw causal arrows are fallacious, for usually folk, popular, and elite are part of one another in the object.

Even the sketches of folk, popular, and elite given thus far might give the wrong impression that such categories are objectively determined. Commonly, the analyst intuitively decides. I recall folklorist Richard M. Dorson proudly boasting a treasure trove of folk items he and his students found in the virgin urban land, for the folklorist anyway, of Gary, Indiana. "But are they really folk?" an incredulous commentor asked of their finds. Tongue in cheek, Dorson replied, "Well, we're folklorists, so the things we found must be folk." The audience laughed, partly because his remark hit on persistent ambiguities in the labeling by many disciplines which train students to collect. The choices a collector and curator make about what fits their collection profoundly affect the perceptions of others when they view and organize in their own minds the objects on display.

Call an object folk and you invoke mixed assumptions about process, content, purpose, and perception. I will discuss these separately.

Process

"Where did you learn that from?" the interviewer forthrightly asks. His eyes open wide as the informant replies, "from my daddy." He makes a note that the practice is traditional—folk. Had the informant answered "from a magazine and television," the interviewer would have thought "hmm, popular culture."

People often mistakenly assume that knowledge passed through generations is necessarily folk whereas information given by peers or current media is popular. The flow of time is less telling than the technique and repetition of knowledge. The folk process, as it is usually conceived, should be informal (fig. 1-11). "Informal" does not mean haphazard, unsophisticated, or unselfconscious; it refers to a transmission and context of learning. Your friend tells you a joke and you later tell it to another friend, altering the story in the process. On break at the factory, you watch a fellow worker carve a chain out of a stick of wood. You go over and he shows you how to do it. You try your hand at it. You go home for Thanksgiving and you participate in customs that have been part of your family's celebration since you can remember. In these instances, you learned informally by word of mouth, demonstration and imitation, and custom.

Human activities today rarely derive from one type of learning. Folk carvers and musicians have their specialty magazines, clubs, and classes. Given detailed instructions for a technique (formal), we ask someone to show us how it's done (informal). Schemes of cultural ladders just don't hold up.

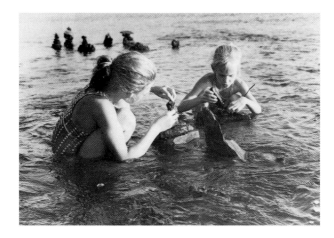

Figure 1-11. An Example of Folk Process. Children (Neva and Sadie
deWall) Making Rock Structures in the Susquehanna River.
Harrisburg, Pennsylvania, 1983.
(Simon Bronner)

Sometimes, the process of manufacture is a touchstone for the analyst. The popular object is mass-produced, standard, and distributed nationally. The folk object is locally made, indeed often handmade, variable, and distributed locally (fig. 1-12). The folk artist, then, controls his product from start to finish, rather than work on an assembly line. The trouble with this scheme is that implied in such distinctions are associations of rural artisanry with folk, in contrast with industry supposedly connected to popular. But artisanry can be highly formalized, while we find industrial workers learning attitudes and techniques informally.[28] In fact, many of the "fine arts" craftsmen of the nineteenth century venerated for their exquisite furniture and decorative arts made their products in the manner of the folk artist I described.[29]

Other considerations must be made. Although analysts primarily refer to process for determining the folkness of an object, they typically rely on other guidelines: the textual content of the object, the purpose and community for which it was made, and the perception of the artifact by the artist and his audience, and the biases of the analyst.

Content

When no maker stands behind the artifact to tell us how he made the thing and how he learned the skills to make it, we turn to the style of the artifact. We compare it to other known, repeated designs we consider traditional. As we look

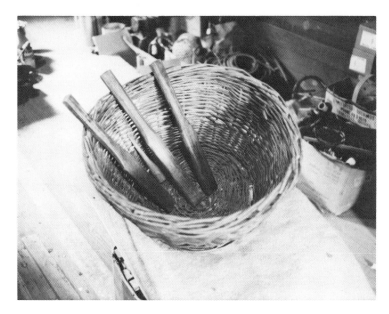

Figure 1-12. Willow Basket and Basketmaking Tools Used by Edward Hausmann.
Vandenburg County, Indiana, 1978.
(Simon Bronner)

at scribbling and call it childlike without knowing whether its maker is a child or
not, so too do we often talk about a folk object as something done in a folk style.

Nathaniel Hawthorne used this part of human nature in his American
parables. His "Chippings with a Chisel" opens with a moving narrative
describing the variety of stones in a local cemetery. Their form and content gave
him pause as he walked through.

> The elder stones, dated a century back or more, have borders elaborately
> carved with flowers, and are adorned with a multiplicity of death's heads,
> crossbones, scythes, hourglasses, and other lugubrious emblems of
> mortality, with here and there a winged cherub to direct the mourner's spirit
> upward. These productions of Gothic taste must have been quite beyond the
> colonial skill of the day, and were probably carved in London and brought
> across the ocean to commemorate the defunct worthies of this lonely isle.
> The more recent monuments are mere slabs of slate, in the ordinary style,
> without any superfluous flourishes to set off the bald inscriptions. But
> others—and those far the most impressive, both to my taste and feeling—
> were roughly hewn from the gray rocks of the island, evidently the unskilled
> hands of surviving friends and relatives.[30]

Hawthorne divided the stones in his sight into three categories comparable to what is today called elite, popular, and folk. Hawthorne made links between the object's design and composition and its origin. Elaborateness spoke to him of finer skills and elite guilds of Europe. "Ordinary," current, and common belongs, he felt, to the unswerving repetition of popular taste. The handworked roughness of the last category was the most personal, perhaps the most variable and eccentric.

Today galleries bring in visitors with the claim of *folk* paintings. They, like Hawthorne, find that rough-hewn quality to their liking, but despite their digging, they infrequently know where or when the paintings were done or who did them. Style dictates to them the label of folkness (fig. 1-13). That can be deceiving. Many folk styles exist, that is, localized folk ways of doing and depicting things (fig. 1-14). Many elite artists admired by the artworld paint primitively. And research of folk artists reveals considerable training and expertise, although, rarely, using the criterion of process, in the elite-labeled genre of "painting."

Many folklorists cringe at the frequent use of folk to mean crude or old. Henry Glassie argued for folk style as a conservative attitude toward design, one that stresses the tried and true in the community. Other folklorists are quick to point out instances where variation and innovation are essential to folk aesthetics. A major research agenda for museums and fieldworkers is thus revealing the continuities and variants of folk style. Occasionally, the word "vernacular" appears, especially when describing regional artifacts like houses, whose learning processes are often hidden in the past or vague because of the variety of specialists and tasks involved (fig. 1-15). The content of such houses resemble "folk" styles and attitudes, but with its concentration on form and place, commonly sidesteps cognitive and creative processes to cut a wide cultural swath.

If the object's form is read like a text, then motifs can be recognized that can be compared to known traditions. If you see a carved chain lying on a museum's dusty shelf and you lack knowledge on its maker, you still might conclude that it is a folk design because you are aware of comparable examples (fig. 1-16). Or else you might assume that because it fits a genre, like whittling or quilting, thought of as folk in typical classifications, then your object is probably folk too. A certain leap of faith is made in such comparative claims for an object's folkness. Intuitively though, people accept those objects as folk which are typical and repetitive. They still relegate, however spuriously, originality and uniqueness to a loftier status.

The text of an object might also suggest symbols one would call traditional, even if they are found on an apparently elite object. Symbols and the ideas they represent transcend genres. During America's Bicentennial, museums highlighted symbols of American patriotism etched in clay, wood, painting, and any number of materials and textures.[31] Crossbones and the winged cherub on

Figure 1-13. Historic Tavern Sign. An Example of an Object
 Arbitrarily Labeled "Anonymous Folk Art" and
 Read for its Content.
 (The Eleanor and Mable Van Alstyne Folk Art
 Collection. Smithsonian Institution)

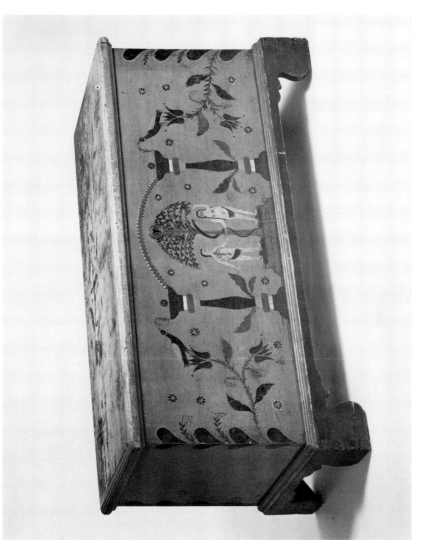

Figure 1-14. Pennsylvania-German Chest with Folk Motifs.
Ca. 1800.
(Courtesy, The Henry Francis DuPont Winterthur Museum)

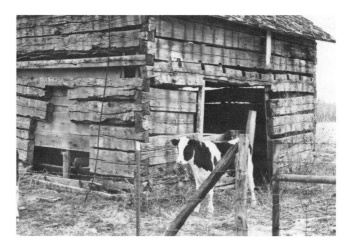

Figure 1-15. Traditional Log Construction. Nineteenth-Century
Dwelling, Twentieth-Century Farm Outbuilding.
Vigo County, Indiana, 1979.
(Simon Bronner)

Hawthorne's illustrious stones signify different attitudes toward death. Their representations repeat and vary; they are learned and shared within a social group. Such an instance raises the distinction between folk *in* an object, as in symbols and designs, and folk *of* an object, where its process and purpose are considered traditional.

Purpose

Even if an object fulfills the tests of process and content, it still may not make it as folk if its maker is not considered a genuine practitioner or if the intent of the object was not for an appropriate situation or social group. The stickball bat made from broom handles by urban children for their personal use becomes a folk object. When a manufacturer got the idea to mass produce and market an "official" slim bat used for stickball, it became popular. The woman making quilts for her grandchildren the way her grandmother made one for her grabs the attention of the folklorist. When a woman makes quilts for art shows and clubs, or learns to make quilts from a kit or class, the object attracts the student of popular culture. When the woman becomes a "textile artist" with creations proudly protected in a refined gallery, the art historian and critic are usually nearby.

More often than not, though, students from the disciplines find themselves side by side considering the complex workings of tradition in American culture.

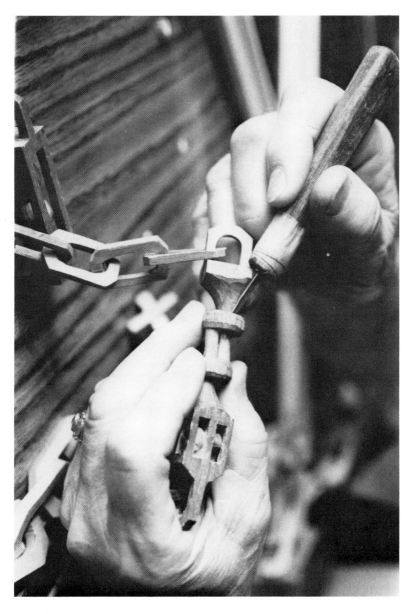

Figure 1-16. A Longstanding Folk Art Tradition. Earnest Bennet Carving
a Wooden Chain with a Slip Joint and Caged Balls.
Indianapolis, 1980.
(Simon Bronner)

Unfortunately they don't always see one another. Although we feel safer operating in the center of our fields, the objects we encounter in American culture force us to the hazy borders (fig. 1-17).

A subjective judgment often made in evaluations of objects is the sincerity and genuineness of the maker. Did the made object come from the experience or background of the maker? For whom is the object made? Ideally, and some may argue rarely, the object is intended for members of one's social group, be it family, or small ethnic, religious, regional, or occupational networks within the larger community (fig. 1-18).

The situations for which objects are made also enter the picture. The television cook who demonstrates how to make "traditional" Chinese mooncakes lacks an appropriate context for the object, one might argue. Yet those made for the Moon Festival in Chinatown qualify. We must be careful to note that appropriate contexts change. One of the important tasks in our understanding of American culture is to describe the shifts in what the society considers an appropriate situation and surrounding for certain types of objects.

We cannot dismiss new uses to which old objects are put. What about plows holding up mailboxes, wagonwheels lining the driveway, and old bathtubs for garden Madonna shrines? Conversely, new objects fill traditional functions. Think about tractor tire planters, the Bic pen spitball shooter, and the Clorox

Figure 1-17. A Modern Object "On the Borders."
Elmira, Oregon, 1982.
(Kristin Congdon)

Figure 1-18. Communal Interaction. Traditional Sausage Making by the Blemker Family the Day after Christmas. Dubois County, Indiana, 1979. *(Simon Bronner)*

bottle tree. Sometimes the object is secondary to the activity, even though objects are affected: rearranging and redoing interiors of houses, decorating the Christmas tree, and home garden landscaping. Such examples of recycling and functional conversions are part of the continuing manipulation of artifacts and symbols that people display. The objects are not folk, while their purposes and contexts might be.[32]

Perception

As beauty is in the eye of the beholder, so too is an object's folkness. We realize that the communities of which objects are a part may not consider their things to be folk or traditional. Indeed, they could think of them as "popular around here." The reverse can also be true. This situation points out that there exists a difference between the insider's and outsider's view of how objects are organized. The perceptions of folkness by analysts have a large bearing on what the public considers folk, but often people have their own ideas about Grandpa's folk things—"that old, crude, and whimsical stuff he made." A hundred years ago, folklorists talked of folk objects as materials used in rituals and ceremonies. Today, that has expanded to include almost anything made or altered according to folk processes and purposes.

This subjectivity in organizing our objects troubles many, even if it strives to represent reality. To be sure, many are not ready to accept the offhand statement

made by Roger Welsch that "If the museums exhibitor or researcher can sense the sympathetic vibrations that Bachelard feels are at the core of art, then it is the stuff called folk art."[33] Henry Glassie counters ably by saying that when diverse things found in a folk art gallery are based on curatorial whim, "those things cannot be interpreted properly without knowing which are art and to which the adjective 'folk' is appropriate."[34] Judgments made solely on the evidence of an isolated artifact lead to confusion, for without context, without some information on purpose, process, and content the artifact becomes not a statement on culture, but a mirror of the labeler's attitudes and tastes, perhaps even his expediency.

As you read the essays in this volume, realize that the analyst's perceptions decidedly affect the designations he or she makes. Yet the writer bases those designations usually on some combination of content, process, purpose, and perception. What I have shown are some of the guiding principles for the abstractions that have organized the studies of American culture. Given that objects hold many meanings depending on where they are and who views them, is the concept of folk really applicable? Not as a noun describing a class or caste of people or a "low brow" style, but it can be useful as an adjective to draw attention to processes and activities, views and ideas, the object represents. Folk objects can be both part of folklore—generally thought of in literary or textual terms—or folklife—generally thought of in ethnological or cultural terms. In this book, the latter is stressed, but should not be overstated or considered exclusive.

The folk object is not one created by "the folk" just as the popular object is not made by the populace. The object holds its folkness and its other attributes beneath its surface. Once "into" the object, we are forced to learn of the people and places it knew, its makers and users, its homes and travels, and its identities and relations. Outside of the object we struggle with our biases about its proper handling and interpretation, its correct niche in the cultural scheme.

All objects need to be known for the lessons they teach and the meanings they hold. Our concern for the folk object is not meant to belittle other types, but rather to closely heed a significant part of the diverse world of our own making. Thought to be discriminated from mass culture, the personal folk object gives tangible clues to immediate human experience and local lineage. Hawthorne reflecting on his folk stonecarvings tells, for example, "when affection and sorrow grave the letters with their own painful labor, then we may be sure that they copy from the record on their hearts."[35]

To understand objects and the relations they represent better, we need to keep the artifact in perspective. Know its sources and the ideas that lie encoded within the object's creation, design, and use. Know the diverse approaches to, and reasons for, unlocking the artifact's secrets. Recognize the applications to which "object lessons" can be put. Realize the social and intellectual forces which impel analysts to hold the views they do. The message for today's humanistic

researchers of material culture is to be concerned with prescription as well as description, with analysis as well as observation, and with advancement of concepts as well as calls of neglect. That message is implicit in the contributions to this volume. The writers here ask you to evaluate the way they view the objects of American culture. They see and grasp in the material world the promise of new knowledge, new insights into people and the ways they think and act.

Notes for Chapter 1

1. Fletcher Bassett, *The Folk-Lore Manual* (Chicago: Chicago Folk-Lore Society, 1892), p. 12.

2. Stewart Culin, "The Origin of Ornament," *Free Museum of Science and Art Bulletin* 2 (1900): pp. 235–42. The quote on "objective culture" is taken from a letter to William Henry Holmes, chief of the Bureau of American Ethnology, 30 November 1906.

3. J. Hector St. John de Crèvecoeur, *Letters from an American Farmer* (reprint ed., 1782; London: J.M. Dent, 1971), p. 21.

4. Ibid., p. 39.

5. Ibid., p. 48.

6. Bronislaw Malinowski, "Culture as a Determinant of Behavior," in *Factors Determining Human Behavior* (Cambridge: Harvard University Press, 1936), p. 133.

7. Bronislaw Malinowski, *Coral Gardens and Their Magic* (reprint ed., 1935; New York: Dover Publications, 1978), p. 240.

8. Malinowski, "Culture as a Determinant," p. 133.

9. George Kubler, *The Shape of Time: Remarks on the History of Things* (New Haven: Yale University Press, 1962), p. 79.

10. John A. Kouwenhoven, "American Studies: Words or Things?," in *American Studies in Transition*, ed. Marshall W. Fishwick (Boston: Houghton Mifflin, 1964), pp. 15–35. The quote is on p. 20.

11. For discussion of relationships between "experiencing the artifact" and language, see Thomas A. Adler, "Personal Experience and the Artifact: Musical Instruments, Tools, and the Experience of Control" in this volume; Brook Hindle, "How Much is a Piece of the True Cross Worth?," in *Material Culture and the Study of American Life*, ed. Ian M.G. Quimby (New York: W.W. Norton, 1978), pp. 5–20; Peter Farb, *Word Play* (New York: Alfred A. Knopf, 1974), pp. 191–230; James Deetz, "Material Culture and Archaeology—What's the Difference?," in *Historical Archaeology and the Importance of Material Things*, ed. Leland Ferguson (The Society for Historical Archaeology, 1977), pp. 9–12.

12. Kouwenhoven, "Words or Things?," p. 29.

13. The cases for vision and touch in American culture are made, respectively, by Alan Dundes, "Seeing is Believing," in *Interpreting Folklore* (Bloomington: Indiana University Press, 1980), pp. 86–92; and Simon J. Bronner, "The Haptic Experience of Culture," *Anthropos* 77 (1982): pp. 351–62.

14. Harold Skramstad, "American Things: A Neglected Material Culture," *American Studies International* 10 (1972): p. 13.

15. Gladys A. Reichard, "Craftsmanship and Folklore," *Journal of American Folklore* 53 (1940): p. 195.

16. S.A. Tokarew, "Von einigen Aufgaben der ethnographischen Erforschung der materiellen Kultur," *Ethnologia Europaea* 6 (1972): 163–78, translated in this volume.

17. Don Yoder, "Folklife Studies in American Scholarship," in *American Folklife*, ed. Don Yoder (Austin: University of Texas Press, 1976), p. 4.

18. Thomas J. Schlereth, "Material Culture Studies in America, 1876–1976," in *Material Culture Studies in America*, ed. Thomas J. Schlereth (Nashville: American Association for State and Local History, 1982), p. 3. His statement is based on Jules David Prown, "Mind in Matter: An Introduction to Material Culture Theory and Method," *Winterthur Portfolio* 17 (1982): p. 1.

19. Mihalyi Csikszentmihalyi and Eugene Rochberg-Halton, *The Meaning of Things: Domestic Symbols and the Self* (Chicago: University of Chicago Press, 1981), p. 1.

20. Recent examples of racial and ethnic material culture studies are John Michael Vlach, *The Afro-American Tradition in the Decorative Arts* (Cleveland: Cleveland Museum of Art, 1978); William Ferris, ed., *Afro-American Folk Art and Crafts* (Boston: G.K. Hall, 1983); Yvonne Lockwood, "The Sauna: An Expression of Finnish-American Identity," *Western Folklore* 36 (1977): pp. 71–84; Neil Grobman, *Wycinanki and Pysanky: Forms of Religious and Ethnic Folk Art from the Delaware Valley* (Pittsburgh: Pennsylvania Ethnic Heritage Studies Center, 1981); Robert Thomas Teske, "Living Room Furnishings, Ethnic Identity, and Acculturation among Greek Philadelphians," *New York Folklore* 5 (1979): pp. 21–32.

21. Lizabeth A. Cohen, "Embellishing a Life of Labor: An Interpretation of the Material Culture of American Working-Class Homes, 1885–1915," *Journal of American Culture* 3 (1980): pp. 752–75; Bruce Nickerson, "Is There Folk in the Factory?," *Journal of American Folklore* 87 (1974): pp. 133–39. See also, Doris D. Fanelli and Simon J. Bronner, "Workers and Trades," in *American Folk Art: A Guide to Sources*, ed. Simon J. Bronner (New York: Garland, 1984).

22. Angus Gillespie, "Traditional Anthracite Coal Carving in Northeastern Pennsylvania" (Paper read at the American Folklore Society meeting, Detroit, 1977); Marsha MacDowell and C. Kurt Dewhurst, "Expanding Frontiers: The Michigan Folk Art Project," in *Perspectives on American Folk Art*, ed. Ian M.G. Quimby and Scott Swank (New York: W.W. Norton, 1980), pp. 54–78 (lumbering); Bruce Jackson, "Folk Ingenuity Behind Bars," *New York Folklore Quarterly* 22 (1966): pp. 243–50.

23. William Ferris, "Vision in Afro-American Folk Art: The Sculpture of James Thomas," *Journal of American Folklore* 88 (1975): pp. 115–31; Michael Owen Jones, *The Hand Made Object and Its Maker* (Berkeley: University of California Press, 1975).

24. Alan Dundes, "Folk Ideas as Units of World View," in *Toward New Perspectives in Folklore*, ed. Américo Paredes and Richard Bauman (Austin: University of Texas Press, 1972), pp. 93–103; Barre Toelken, "Folklore, Worldview, and Communication," in *Folklore: Performance and Communication*, ed. Dan Ben-Amos and Kenneth Goldstein (The Hague: Mouton, 1975), pp. 265–86.

25. Alan Dundes, "The Number Three in American Culture," in *Interpreting Folklore* (Bloomington: Indiana University Press, 1980), pp. 134–59; Henry Glassie, "Folk Art," in *Folklore and Folklife: An Introduction*, ed. Richard M. Dorson (Chicago: University of Chicago Press, 1972), pp. 253–80.

26. Louis C. Jones, "Folk Culture and the Historical Society," *Minnesota History* 31 (1950): p. 16.

27. Henry Glassie, "Artifacts: Folk, Popular, Imaginary and Real," in *Icons of Popular Culture*, ed. Marshall Fishwick and Ray B. Browne (Bowling Green: Bowling Green University Popular Press, 1970), p. 105.

28. See Michael Owen Jones, "A Feeling for Form, as Illustrated by People at Work," *Folklore on Two Continents*, ed. Nikolai Burlakoff and Carl Lindahl (Bloomington: Trickster Press, 1980), pp. 260–69; Robert S. McCarl, Jr., "The Production Welder: Product, Process and the Industrial Craftsman," *New York Folklore Quarterly* 30 (1974): pp. 243–53.

29. Charles F. Hummel, "The Dominys of East Hampton, Long Island, and Their Furniture," in *Country Cabinetwork and Simple City Furniture*, ed. John D. Morse (Charlottesville: The University Press of Virginia, 1970), pp. 35–108; Robert F. Trent, *Hearts and Crowns* (New Haven Colony Historical Society, 1977).

30. Nathaniel Hawthorne, *Twice-Told Tales and Other Short Stories* (reprint ed., 1837; New York: Washington Square Press, 1960), p. 321.

31. Louis C. Jones, *Outward Signs of Inner Beliefs: Symbols of American Patriotism* (Cooperstown, N.Y.: New York State Historical Association, 1975); E. McClung Fleming, "Symbols of the United States: From Indian Queen to Uncle Sam," in *Frontiers of American Culture*, ed. Ray B. Browne, Richard H. Crowder, Virgil L. Stafford (Lafayette: Purdue University Studies, 1968), pp. 1–24.

32. See Wilhelm Nicolaisen, "Distorted Function in Material Aspects of Culture," *Folklore Forum* 12 (1979): pp. 223–36; John Michael Vlach, "Quaker Tradition and the Paintings of Edward Hicks: A Strategy for the Study of Folk Art," *Journal of American Folklore* 94 (1981): pp. 145–65; Michael Owen Jones, "L.A. Add-ons and Re-dos: Renovation in Folk Art and Architectural Design," in *Perspectives on American Folk Art*, ed. Ian M.G. Quimby and Scott Swank (New York: W.W. Norton, 1980) pp. 325–63.

33. Roger Welsch, "Beating a Live Horse: Yet Another Note on Definitions and Defining," in *Perspectives on American Folk Art*, ed. Ian M.G. Quimby and Scott Swank (New York: W.W. Norton, 1980), pp. 218–33.

34. Glassie, "Artifacts: Folk, Popular," p. 112.

35. Hawthorne, *Twice-Told Tales*, p. 321.

(Joel Sater, Courtesy of Humanities Division, Penn State-Capitol Campus)

Part II: Prologue to Analysis and Presentation

"Conduct," the American philosopher George Herbert Mead told his students, "is the sum of the reactions of living beings to their environments, especially to the objects which their relation to the environment has 'cut out of it.'" In fact, he described humans as implemental animals who rely on the world of physical things—the world of perceptual reality, the world of our contacts and manipulations—for symbols and meanings. Objects, he asserted, are the proximate goal of our sights and sounds, and they are the instrumental stuff in which we embody our ends and purposes, form our social networks and experiential as well as psychological modes. Behavior is what he sought to elucidate, and through that search he grasped Mind, Society, Self, and the physical and psychological world that is there for us.

Mead was not a folklorist and he predated the American Studies movement, but he managed to articulate some of the conceptual underpinnings of material culture and folklife studies. At a 1977 conference on the importance of material things, for example, William L. Rathje told the audience of an idea that characterized their studies: "material culture is not merely a reflection of human behavior; material culture is a part of human behavior." Yet, as Michael Owen Jones pointedly states, "one should avoid confusing the records of behavior with what they are records of or mistaking objects for the processes they manifest." Of course, researchers vary on what they say is their purpose of study; but at its most basic level, they generally study the cultural life of people—the experiential and psychological modes they use to structure their social, spiritual, and physical environment. As an organizing principle, we may have the charge of comprehending human conduct and the products and processes which that conduct effects and involves.

To be sure, the methods for material culture and folklife study vary, and the principal emphases—whether the individual, group, region, process, or product—differ. Perhaps most fundamental to the diversity of analytical and presentational orientations is a disagreement over the concept of culture and history. Do culture and history have an independent existence possessed by groups and societies? Or are they a vague analytical abstraction with no

determinative force? In other words, does culture arise from the interaction of people, manifested only in individual minds?

In addition to concepts of behavior and culture, what of structure? That term, so dear to linguists, is especially appropriate to material culture and folklife, for when we talk of objects and activities we refer to tangible structures, and intangible frameworks of thought and behavior. And in the complex interactions and processes in which humans participate—the course of life—we find structures too. But we need to realize structure as a dynamic concept, one that accounts for the complexity, indeed the frequent capriciousness of humans operating in variables of time and space.

The authors of the essays in this section seek structures, or frameworks, for their studies. By doing so, they also infer assumptions about the structure of the artifacts and behavior associated with the people they study. Tokarev implies that people adopt culture passively, and they are generally conservative toward culture change. The active work of creators learning, designing and building signify culture for Glassie. Whether the work becomes poems or buildings, it is a sign of people constructing culture. Vlach seeks communities as basic social structures. People, he claims, gravitate toward the sharing and communing order of group life and tradition. Collectively, the authors give prevalent research agendas in the field. Major genres of interest are covered. Glassie opens with a philosophical inquiry into architecture, a subject which commands the lion's share of material culture research. Vlach follows by probing the burgeoning field of folk art. Tokarev examines foodways, shelter, and clothing.

Implicit in many studies of folklife is either the assumption of the individual, or perhaps the group as the core research concern. As someone who has done major biographical and community studies, and who now directs a folklife studies program within American Studies, John Vlach brings forward the issue of the object's relation to society. A scholar of folk art, architecture, race and region—folklore and material culture—Vlach plies his distinctive methodological structure on the study of tradition and community. He speaks especially to the concept of "folk group" vis-à-vis the community or region of which it is a part as a cardinal point (which to others in this volume is a point of contention).

Henry Glassie has helped to shape the resurgence of material culture and folklife studies into what it is today. His writings and teaching at major training centers of Indiana University and the University of Pennsylvania have made deep imprints on material culture study. His essay here reflects on the lessons of his research and, by using architecture as an example, the understanding that the study of artifacts offers. Measuring a house, outlining its structure, noting its movement, talking to people—Glassie notes how these "scientific" endeavors also produce symbolic, impressionistic knowledge about landscape and memory, indeed about the character and integrity of makers, their pursuits and concerns.

Analysis and presentation of American life cannot exclude foreign contributions, for to understand ourselves we need to look beyond, as well as within, our borders. S.A. Tokarev's essay serves to raise comparisons to be made from a Marxist sociohistorical perspective. In the search for theoretical and methodological continuities for material culture research, Tokarev touches on American culture in the larger historical and cultural context of the world's peoples. And he points to a polestar of material culture study—in their design and use traditional objects mediate social relations and signify mental and behavioral operations in everyday life. Tokarev, a world-acclaimed ethnographer, adds balance to the volume by reminding us of alternative visions of history and its artifacts, visions especially common in Europe and not without its applications in America.

Prologues are customarily preliminary courses of action and speech which background things to come. Glassie, Vlach, and Tokarev present broad frameworks which presage the dialogues that ensue in this volume. By anticipating central themes and introducing provocative issues that often emerge when researchers discuss material culture and folklife, the authors bespeak some of the intellectual guideposts which influence the direction of our approaches.

Further Reading

In his writings and lectures Mead expounded the concept that the significance of things is in their relation to individuals—the life of the object is in its use. Mead's opening quote comes from his essays, "A Behavioristic Account of the Significant Symbol," *Journal of Philosophy* 19 (1922): pp. 157–63, and "The Nature of Aesthetic Experience," *International Journal of Ethics* 36 (1926): pp. 382–93. Of considerable value to students of material culture is his essay, "The Physical Thing," published in *The Philosophy of The Present* (1932; reprint ed., Chicago: University of Chicago Press, 1980).

The proceedings of the conference on "The Importance of Material Things" is available as *Historical Archaeology and the Importance of Material Things*, ed. Leland Ferguson (Special Publication Series, No. 2, The Society for Historical Archaeology, 1977). Rathje's quote is on p. 37 of his "In Praise of Archaeology: Le Projet du Garbage" in the proceedings. Henry Glassie's "Archaeology and Folklore: Common Anxieties, Common Hopes" and James Deetz's "Material Culture and Archaeology—What's the Difference?" in the same volume also critically reflect on the study of material culture and folklife.

Michael Owen Jones's statement comes from "L.A. Add-ons and Re-dos: Renovation in Folk Art and Architectural Design," in *Perspectives on American Folk Art*, ed. Ian M.G. Quimby and Scott T. Swank (New York: W.W. Norton, 1980), p. 355. Don Yoder most recently chronicled the folklife studies movement

in his *American Folklife* (Austin: University of Texas Press, 1976). Material folk culture studies are surveyed in Simon J. Bronner, "'Visible Proofs': Material Culture Study in American Folkloristics," *American Quarterly* 35 (1983): pp. 316–38.

Let me also refer the reader to background works touching on philosophy and history, such as George Kubler's *The Shape of Time: Remarks on the History of Things* (New Haven: Yale University Press, 1962), John Kouwenhoven's *Beer Can by the Highway: Essays on What's American About America* (Garden City: Doubleday, 1961), Alan Gowans' *Images of American Living: Four Centuries of Architecture and Furniture as Cultural Expression* (1964; reprint ed., New York: Harper and Row, 1976), Yi-Fu Tuan's *Segmented Worlds and Self: Group Life and Individual Consciousness* (Minneapolis: University of Minnesota Press, 1982), and Robert Plant Armstrong's *The Affecting Presence: An Essay in Humanistic Anthropology* (Urbana: University of Illinois Press, 1971).

For method and theory, one can also consult significant articles such as Iorwerth C. Peate's "The Study of Folk Life: and its Part in the Defence of Civilization," *Gwerin* 2 (1959): pp. 97–109; Sigurd Erixon's "Folk-life Research in Our Time," *Gwerin* 3 (1962): pp. 275–91; Richard S. Latham's "The Artifact as Cultural Cipher," in *Who Designs America?*, ed. Laurence B. Holland (Garden City: Doubleday, 1966); Henry Glassie's "Meaningful Things and Appropriate Myths: The Artifact's Place In American Studies," in *Prospects 3*, ed. Jack Salzman (New York: Burt Franklin, 1978) and his "Folkloristic Study of the American Artifact: Objects and Objectives," in *Handbook of American Folklore*, ed. Richard M. Dorson (Bloomington: Indiana University Press, 1983), pp. 376–83; Günther Wiegelmann's "'Materielle' und 'geistige' Volkskultur," *Ethnologia Europaea* 4 (1970): pp. 187–93; Nils Stora, "Trends in Nordic Ethnological Material Research," *Studia Fennica* 27 (1983): pp. 23–45; Yi-Fu Tuan, "The Significance of the Artifact," *The Geographical Review* 70 (1980): pp. 462–72; Jules David Prown, "Mind in Matter: An Introduction to Material Culture Theory and Method," *Winterthur Portfolio* 17 (1982): pp. 1–20; and my own "Toward a Philosophy of Folk Objects: A Praxic Perspective," in *Personal Places*, ed. Daniel Franklin Ward (Bowling Green: Bowling Green State University Popular Press, 1984).

In recent years, the American material culture and folklife bookshelf has been enhanced by several general collections of analytical essays: Thomas J. Schlereth, ed., *Material Culture Studies in America* (Nashville: American Association for State and Local History, 1982) and his *Artifacts and the American Past* (Nashville: American Association for State and Local History, 1980); Ian M.G. Quimby, ed., *Material Culture and the Study of American Life* (New York: W.W. Norton, 1978); Richard A. Gould and Michael B. Schiffer, eds., *Modern Material Culture: The Archaeology of Us* (New York: Academic

Press, 1981); Simon J. Bronner and Stephen P. Poyser, eds., *Approaches to the Study of Material Aspects of American Folk Culture (Folklore Forum* 12 (1979), Special Issue); Edith Mayo, ed., *Focus on Material Culture (Journal of American Culture* 3 (1980), Special Issue); Miles Richardson, ed., *The Human Mirror: Material and Spatial Images of Man* (Baton Rouge: LSU Press, 1974).

The writings on the concept of culture in "material culture" are legion. Some basic statements of varying viewpoints are found in David Bidney, *Theoretical Anthropology* (New York: Columbia University Press, 1953); Eric R. Wolf, *Anthropology* (New York: W.W. Norton, 1974); Elvin Hatch, *Theories of Man and Culture* (New York: Columbia University Press, 1973); Marvin Harris, *Cultural Materialism: The Struggle for a Science of Culture* (New York: Random House, 1979); Alan Dundes, ed., *Every Man His Way: Readings in Cultural Anthropology* (Englewood Cliffs, N.J.: Prentice-Hall, 1968); see also the definition of "culture" in Åke Hultkrantz, *General Ethnological Concepts* (Copenhagen: Rosenkilde and Bagger, 1960), and my discussion of the issue in "Concepts in the Study of Material Aspects of American Folk Culture," *Folklore Forum* 12 (1979): pp. 133–72.

The "Concepts" article expands the "structures of analysis" notion presented in my introduction to the prologue section. By referring to conceptual models of frameworks of analytical behavior, we are reminded that, as Michael Owen Jones briefly mentions in his "L.A. Add-ons" article, the techniques used to discern culture building and ritualizing also apply to analysts' hypothesizing and reporting. There is the temptation to overemphasize the historical organizing of our studies, but in the essays that follow, the conceptual is emphasized. Thus I hope that ideas and issues take center stage, without necessarily sacrificing the historical perspective. Such organizational matters are discussed in a special issue of *Midwestern Journal of Language and Folklore* on "The History of Folkloristics: An Exchange of Views" (1977). In that issue especially note Kay L. Cothran's "Meta-Folkloristics and the History of the Discipline" and Dan Ben-Amos's "The History of Folklore and the History of Science." Also instructive are Clifford Geertz's, "Ideology as a Cultural System," in *The Interpretation of Cultures* (New York: Basic Books, 1973), especially pp. 230–33; Michael Owen Jones, "The Study of Folk Art Study: Reflections on Images," in *Folklore Today,* ed. Linda Dégh, Henry Glassie, Felix J. Oinas (Bloomington: Indiana University, 1976), pp. 291–303; Thomas A. Burns, "Folkloristics: A Conception of Theory," *Western Folklore* 36 (1977): pp. 109–34; Glassie's "Archaeology and Folklore," referred to earlier; M. Merleau-Ponty, *The Structure of Behavior* (London: Metheun, 1965); Thomas S. Kuhn, *The Structure of Scientific Revolutions* (second edition; Chicago: University of Chicago Press, 1970); Jean Piaget, *A Structural Study of the Sciences of Man* (New York: Harper Torchbooks, 1970).

A brief history of material folk culture studies is given in my "The Hidden Past of Material Culture Studies in American Folkloristics," *New York Folklore* 8

(1982): pp. 1–10. For further bibliographic aids on material folk culture, consult Thomas Schlereth, ed., *American Material Culture: A Guide to Current Research* (Lawrence: University Press of Kansas, 1985); Simon J. Bronner, ed., *American Folk Art: A Guide to Sources* (New York: Garland, 1984); Howard Wight Marshall, *American Folk Architecture: A Selected Bibliography* (Washington, D.C.: American Folklife Center, Library of Congress, 1981); Susan Sink, *Traditional Crafts and Craftsmanship in America: A Selected Bibliography* (Washington, D.C.: American Folklife Center, Library of Congress, 1983); Don Yoder's chapters on "Folk Costume" and "Folk Cookery" in *Folklore and Folklife,* ed. Richard M. Dorson (Bloomington: Indiana University Press, 1972); Charles Camp's bibliographic survey, "Foodways in Everyday Life," *American Quarterly* 34 (1982): pp. 278–89; and Jan Harold Brunvand's notes to "Material Folk Traditions," in his *The Study of American Folklore: An Introduction* (New York: W.W. Norton, 1978).

Simon J. Bronner

Artifact and Culture, Architecture and Society

Henry Glassie

Culture

Buildings, like poems and rituals, realize culture. Architects rationalize their actions differently. One will say he designs and builds as he does because that is the way of his people and to do otherwise would be wrong. Another will argue that his professional practice correctly manifests scientific and universal laws of architecture. Both create entirely from within the smallness of their own experience.

All architects are born into architectural environments that condition their sense of beauty and social comfort. Before they have been burdened with knowledge about architecture, their minds inquire into the wholeness of their situation. They dismember the information that runs in their senses, and they associate accumulated scraps of experience without regard to the segregation of facts by logical class. Thick white paint layered on rough pine boards comes to connote home and call to mind the smells of old men, the sounds of bacon frying, the feel of linoleum on the kitchen floor. Memory grows wild, and the builder's mind expands, undirected by future projects, unchecked by useful categories. When the builder's attention is narrowed by training, whether in the dusty shop of a master carpenter or the sleek classroom of a university, past experience is not obliterated, and his education—the applied structure of admonition and precept—effortlessly incarnates in pedagogical technique (if not in content) his culture's basic values. Despite the rigors of training, the builder remains a confused, full person, and when it comes his time to act, his creation seems proper because it orders and incorporates the accumulated experience the builder shares with his fellows who do not build. The architect's product feels right because it integrates the architect's professional and nonprofessional, conscious

and unconscious being. The overtly architectural contrivance covertly embodies the norms of beauty, social order, and political propriety with which the architect as a person has learned to feel at ease.

As a cultural fact, architecture is like any realization of potential, like any projection of learned ideas. The things of the world—this sentence, that palace—preexisted themselves in the mind as plans derived from memory, and so they can be reversed in analysis. Things become plans, plans become sets of decisions, decisions arise out of intention. All things embody their creators and become for the period of their existence active images of their creators' wishes. In this, buildings are like other cultural things and there are no differences among kinds of building. Vernacular, nonvernacular, neovernacular—all are cultural ways to create, orderings of experience, like poems, like rituals.

Materialization

As cultural, architecture is conceptual, a matter of shaping memory into plans, plans into things that can be sensed by other people. So architecture is a variety of communication. The mode of its thinking connects architecture to all culture. The mode of its realization distinguishes architecture radically from other communications. To be architecture, an idea must be realized in materials. Materialization raises complexities in architectural communication not met in verbal communication. Materials limit concepts. Just as every building records intentions, so does it record situations, the resources in the scene beyond the mind that curtail intentions, making all buildings compromises between will and circumstance.

The decision to create a building is the decision to destroy some part of the material universe. Things are destroyed—trees are felled, stone is broken, old homes are razed—to make things better. The attempt to improve by destruction is technological. Every technological act entails changes in two major relations: one of the human to the nonhuman world, the other within the world of people.

Technology requires the sacrifice of extant materials that ultimately do not owe their presence to human beings and so technology—the means of transforming the natural into the cultural—exists as an index to a culture's valuation of nature. Nature could be valued as an active or as a passive resource. Among the people I have studied first-hand, the latter is the case (and it must be remembered what a curious leap of the imagination that is, for people are, after all, part of the natural world from which they are capable of conceptually separating themselves). Vernacular technologies involve local materials—green oak, damp clay—and the direct touch of the hand. Nonvernacular technologies, supported by intricate systems of transportation and lavish industrial techniques, need not utilize the locality or display the marks of the handtool. But the attitude toward the nonhuman world is, in essence, the same. Nature is erased. The

towering oak is dropped and dressed into lumber before it is joined into a frame. Clay is dug and stirred and shaped and dried into bricks before it is laid into walls. Wood and masonry techniques both involve a middle step—the hewn timber, the burned brick—in which nature is left behind and the human world is entered. Subsequent steps lead to the existence of new man-made entities. Then natural colors are hidden and form is unified beneath a coat of paint, usually bright white, which cracks the new creation away from nature and sets it forth as a purely human product, a clear emblem of superiority, of mastery over circumstance. The Western technology called modern is less a violation of the vernacular than it is an exaggeration of one impulse within the vernacular: its wish to free will from conditions, its intention to set the human being righteously in the role of exploiter.

There is a difference. When the environment mastered man, and man fought back with plow and axe, the act of struggling against nature with all one's power was courageous. When man sits coddled in a temperature-controlled office, forty stories above a city, the relentless continuation of that ancient struggle seems heartless. The fact of continuation remains. It is traditional—cultural, vernacular, natural—for the Western designer to think upon nature as a means to materialize the plans contrived in the freedom of the head. This attitude is exhibited most clearly in an aesthetic of artificiality, a traditional taste for repetitive identical units—bricks, for instance—and smooth, machined surfaces, such as planned boards, shaved chins, the slick fenders of automobiles. But, despite tradition, experience has been disrupted. Nature conquered nonchalantly at a distance is not like nature conquered face on. The hewn timber and steel beam both display the aesthetic of artificiality, but the tree I topple and plane to smoothness is my victory. I have known its transformation in my hands and fingers, while the steel beam mined and milled by another and buried somewhere in the concrete beneath me is so removed from my experience as to hold no message for my mind. The house carved out of the forest contains the narrative of the battle. It teaches its occupants continually about their position in the universe and surrounds them with a sense of their capabilities. From it they learn the validity of their culture. As artificiality spins to extremes, the walls around people come to contain no reminder of natural origins or human endeavor; they allow no penetration of sunlight or breeze or shifts of heat. The poetic dimension of technology dissolves. People lose the capacity to connect themselves, antagonistically perhaps, to the world they inhabit, and so surrender the right to know that they know. They are comfortable, their bodies are well cared for, but there is nothing around them for the mind to work upon in its quest for wisdom. Every change becomes a surprise, a source of disorientation, desperation, petty fears. As experience diminishes, the culture formulated out of experience grows weak. People become unsure of their own abilities and lose the inward capacity to resist that which lies beyond. Protected, they are vulnerable.

Technology is not merely the means to accomplish designs. Since technology is disruptive intervention in the universe, it could not be carried out unless profound moral questions had been provided with simple answers. From those answers the right to claim and alter the world proceeds. Since altered materials must be assembled by people, technology further demands that political questions gain simple answers so that labor can be organized. Technology is doubly cultural; it unfolds from theories about man's position in the universe and from theories about the relations of power among men. In the ideal vernacular, divisions in architectural work—design, construction, and use—are brought into unity in a single individual. The man who wants to shelter his cows plans a barn, cuts down some trees, chops them into lumber, splits shingles and pins, and builds the barn he uses. The barn is wholly his fault. Normally, these roles—design, construction, and use—are not filled by the same person. They are taken over by specialists, but the differentiation implicit in specialization is overarched by an experience of participation and an egalitarian ethic. A man wants a house. He talks with a builder. Together they design the house out of their shared experience of what a house should be. There is no need for formal plans. Students of vernacular architecture search for plans, wish for plans, but should not be surprised that they find none. The existence of plans is an indicator of cultural weakening. The amount of detail in a plan is an exact measure of the degree of cultural disharmony; the more minimal the plan, the more completely the architectural idea abides in the separate minds of architect and client. Once their pact is made, the client prepares the materials and the architect directs the erection of the house, performing the most difficult technological tasks himself, while the client serves as one of the laborers. The job is done, the laborer becomes occupant, using the house as he will, sitting tonight in a building he helped design and raise. It stands around him as a proof of his ability to accomplish his desires.

Actions among people building a home naturally take shape in accordance with the political norms of their culture. Vernacular politics are egalitarian. This does not mean that all the actors in a political event are the same or even equal. It means their diversity interlocks, their special talents and needs combine for mutual benefit. Mutuality usually comes of direct, joint participation. The user helps design. The designer builds. The result of participation is understanding. The laborer understands the design. The designer understands the needs of the user. The result of understanding is an egalitarian ethic that confines individualistic urges. Understanding the craft of the laborer, the user does not request fantastic shapes or risky operations, though he might nurture bizarre wishes for an exotic or lofty domicile. Understanding the needs of the user, the designer does not argue for a novel option, though it could bring him more profit. Design, construction, and use merge in an efficiently designed, solidly constructed, wholly useful—largely conventional—product.

Since the egalitarian ethic accepts specialization and varying degrees of talent, change can occur subtly. Specialization can increase without stress to the social fabric, the designer can cease to build, the mason can hire a carpenter, the carpenter can become a joiner and hire a man to nail boards together; but if specialization increases past the point of mutual understanding, the political order is poised for disruption. When the designer plans a house for someone he does not know, but in which he, the designer, would wish to live, the participatory base of the vernacular is lost, though its egalitarian ethic remains. But here we have reached the breaking point, the dividing line between vernacular and nonvernacular action, for the egalitarian spirit finds survival hard outside of participatory scenes. New political orders, generous perhaps, even democratic in tone, begin to rise and with them come the evils that breed in ignorance. When the designer plans for someone he does not know a dwelling that he, the designer, would be unwilling to inhabit, or when the laborer is asked to create an element for a whole that he does not understand, or when the user is asked to select from among a series of objects no one of which suits his needs, then the egalitarian ethic has vanished with the participatory experience. The political structure has become one of dominance and submission. The architectural product is no longer vernacular. It was produced by a society within which the relations among people are not egalitarian; they are exploitative.

Modern Western technology is a hyperbolic extension of certain features of the Western vernacular. It carries the old idea of artificiality and the old idea of craft specialization to extremes. The person familiar with the Western vernacular does not, therefore, find the new technology altogether alien. A person from outside the West might embrace modern technology as wholly good or reject it as wholly bad, but the traditional Western builder feels at once comfortable and confused. The smooth, sheetrocked and papered walls, the linoleum floors and metal roof of the modern country home are welcomed as perfections of the old wish for artificiality. Clean, repetitive concrete blocks have been gracefully incorporated into vernacular traditions on both sides of the Atlantic to replace clean, repetitive bricks and boards. Yet, the very man who praises his metal roof for its convenience, damns it for its demands. The thatched or shingled roof of the bad old days required hard and frequent handwork, but it could be laid on without cash, and it came of his own proud effort. The compartmentalization of labor is comprehensible as efficient on the basis of traditional divisions within the crafts of the past, and new kinds of labor are welcomed as productive of the cash necessary to the purchase of the metal roofs and electrical gadgets that spell the consumer's success. Yet, the very man who speaks with approval of his metal roof and power saw, laments the passing of convivial, collective modes of working. Constantly I am told that the great gain in comfort has been offset by the great loss of the security of mutual endeavor, that the great gain in cash has been offset by the great loss of the joys once found amid necessary toil.

The key to vernacular technology is engagement, direct involvement in the manipulation of materials (even when the goal is artificiality) and active participation in the process of design, construction, and use (even if the social organization of architectural creation includes high levels of specialization). The product of engagement is knowledge. As technologies evolve to indirect techniques for the manipulation of materials and to isolation of segments of the creative process, the major loss is the experience of engagment that produces the awareness of connectedness that enables people to evaluate their situation in the world and thus to be ambivalent about historical change.

Sheltering

As a concept drawn from shared experience, architecture is like all culture. As a concept rendered into the world technologically, architecture is like any artifact. All artifacts are double in nature. All are simultaneously ends and means. Ends in themselves, artifacts are aesthetic, realizations of ideas that excite the senses. Means to other ends, artifacts are tools, aids to human purpose. What distinguishes architectural objects from other artifacts is their complex capacity to provide two perspectives on the artifact's duality. Like any artifact, architecture can be sensed from without, but only architecture can be entered and sensed from within.

From the external perspective, as objects for the eye of a distanced beholder, vernacular buildings appear first as works of art, as arrangements of volume and void and color, as sculpture. Architectural art, in the traditions I have studied, is invested but minimally in decorative detail. Ornaments are modest in scale, simple in shape, weak in reference, and they are shoved to the edges where they deflect attention from themselves and emphasize the overall form of the building. Confined to the margins, reduced from power in size and by location, details shift frequently over time in vague agreement with changes of style in distant centers, indicating clearly that the creator was aware of urbane fashion, and while not rejecting it, he chose to hold it firmly in check, making fashion subordinate to the basic formal idea. That idea of basic form changes so rarely that changes must be read as evidence of cultural reorganization and that stability must be read as expressive of deep cultural desire.

The plain, uncluttered form of the vernacular building is the artful external presentation of its internal idea. The aesthetic of the vernacular building is not ornate but logical. It approximates prose more than poetry. As fine prose becomes transparent to let its ideas shine through (in contrast to poetry in which the words draw attention to themselves), the facade of a vernacular building offers little excitement or resistance and always enables the viewer to predict with some assurance the plan within.

The eye is pulled by the building's appearance into its plan, into its use. The student of vernacular architecture is drawn past the sculptural exterior into the working interior. Though some scholars reduce architecture to flat pictures of facades, the vernacular emphasizes that the most important dimensions of buildings lie inside. The experience of the interior makes some artifacts into architecture and brings the student into confrontation with architecture's main reasons for being: the provision of internal spaces to shelter people and help them order social occasions.

Just as modern technologies have exaggerated the tendencies to the artificial within the Western vernacular, while ignoring the equally important egalitarian social aspects of traditional craft, nonvernacular theories of architectural purpose stress the sheltering functions of buildings, their capacity to create artificial environments, while undervaluing their social goals. "Progress" is effected by breaking the old tradition down, focusing on some of its virtues (those by which advancement can be most easily measured) then forging ahead with the pretense that only those matter, while letting other of the old virtues drift from attention. Those others are the most difficult to assess because they lead clearly away from the material world into social values and so to complex, finally unresolvable problems.

Buildings must offer both protection from the elements and stages for social play, but the evidence in the vernacular traditions that I know—and I remind you that none of them developed in extreme climates—is that environmental modification is of less importance than social organization in shaping homes. The old houses in an Irish community I studied form around one large central space called a kitchen (fig. 2-1). It expands through the full depth of the house, lifts to the ridge of the roof, and is entered directly from outside. One end of the kitchen is warmed and lit by a small fire. Other rooms are low, dark, lacking a source of heat (fig. 2-2). When I asked in the summer, I was told that it never gets cold in Ireland. When I asked in the winter, while winds pounded at the house, I was told the cold would not last, but it did, and for much of the year the house was simply too cold for comfort. But that is because the primary goal of the house is not environmental, it is social. The house is designed to remain open to the neighbors, to be exposed to all outsiders, so that its inhabitants can answer a sacred commandment to hospitality. The soul's duty is more important than the body's comfort, and the house is designed primarily to bring people into intimate interaction and only secondarily to protect them from the mutable weather. In eighteenth-century America, houses in the coldest and warmest parts of the Atlantic seaboard underwent dramatic changes that left them less efficient environmentally. Their designers had not gone crazy. They had chosen to make them more efficient in the social sphere and that decision necessitated a decrease of efficiency in another of the domains in the field of design. The central hearth

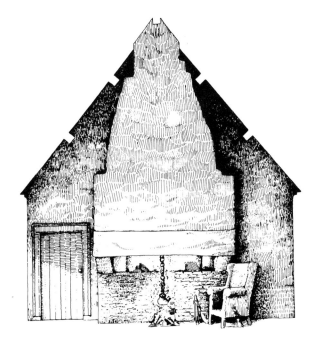

Figure 2-1. Hearth Wall of Peter Flanagan's Home.
County Fermanagh, Northern Ireland.
(Henry Glassie)

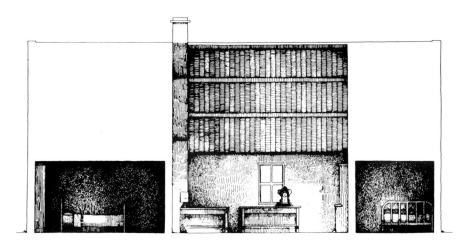

Figure 2-2. Section of the Old House of Ballymenone.
County Fermanagh, Northern Ireland.
(Henry Glassie)

around which low rooms tightly clustered in icy New England gave way to a central, unheated hallway that admitted cold blasts in the winter but permitted a more polite internal organization of behavior. The houses of the hot humid Deep South were originally a single room in depth so that breezes could flow from window to window through all the rooms. Then a second rank of rooms was ordered behind the first, stifling the welcome winds, but providing a series of spaces into which social activities could be divided for cleanliness and privacy. It is as though in the whole complexity of the building, nature were conquered in technology, in the manipulation of trees into roofs and the smooth surfaces of walls, the people within the home learned to live with the mild bodily discomfort produced by climatic variation to make their dwelling a clearer symbol of their aspirations for social order.

When the student focuses on decorative detail, as the architectural historian often does, vernacular architecture displays steady changes in response to shifts in upper class taste, but most of the building remains out of focus and out of account while the desperate wish of the conservative scholar to demonstrate that the common people align quiescently behind distant leaders steals integrity and power from the people's own culture. If the student's external view takes in the whole building, then its deviation from fashion and adherence to the local tradition come to dominate its concept. The builder is granted his human freedom of choice, and the overall form of the buildings exterior leads the mind into its internal arrangements. If those arrangements are read as designed primarily to defend people from the climate, then the vernacular builder is revealed as not too clever and as shifting whimsically from more or less effective responses to his conditions. But if internal arrangements are understood in social terms, the vernacular architect is discovered to be a subtle and sensitive engineer. His design makes sense, changes in his plans follow an orderly course; the most important dimensions of vernacular culture are grasped and they become challenges to our own ideas of architectural order. Buildings contain people. They can shelter people, but they must organize human relations. Most deeply, vernacular homes are social facts; their primary order is ethical.

Of all the changes I have found in my study of vernacular architecture, the most important is social. The old house is open. No barrier blocks an entrance. Outsiders pierce effortlessly through one door to the very center of the home. Its interior is composed of a few large, multifunctional spaces. Entertainment and cooking happen together and people sleep together. The plan of the house grows from human activities and the nonsymmetrical facade grows from the plan so that people approaching the house know where the people of the interior are. Outsiders can easily imagine their way through the walls into the lives of the inhabitants. Such a house is based on trust. That is the world I was given in Ireland. The essence of trust, I was told, is confidence. The people inside are confident that the people approaching will bring within them the basic rules of

proper social exchange. The job of the house is to let them in. The job of the people is to act correctly and they can be trusted to do so.

Things change: the new house is closed (fig. 2-3). A barrier appears. A porch, vestibule, lobby, or hallway blocks entrance to the home. Visitors are halted in a social lock before they gain admission to the home's social center. The interior fragments into small compartments. There is one room for cooking, another for entertainment. Servants or women are removed from the house's sociable arena; labor separates from leisure. Chambers multiply, separating sleepers, categorizing the family into subclasses. Then a geometrically symmetrical mask is drawn across the house's facade, so, though the visitor can still predict the plan, he does not know where the people are within the home. He approaches without certainty, is stopped in a vestibule, and then is led into a domestic place stripped of the clutter of daily work.

Such a house assumes the potential for social disorder. It is shaped on distrust and defends against confusion through the rational arrangement of small, monofunctional cells within which behavior is contained with clarity. I have studied this change from the open and nonsymmetrical to the closed and symmetrical in the United States and in Ireland. Others have described comparable changes in England, Denmark, and Turkey. This architectural change happens at different times in different places to mark a crucial stage in cultural evolution. Houses change in intelligent response to a shift in social order, from one that unfolds out of a thick, face to face, neighborly experience to

Figure 2-3. Symmetrical, "Closed" House.
Rockbridge County, Virginia.
(Henry Glassie)

one that is imposed to compensate for the lack of that experience. The new house proposes a rational order out of a loss of confidence in the inherent order of social interaction.

The change from old to new houses follows upon an economic change during which an egalitarian, cooperative mode of work, founded upon sacred commandment, was traded for a hierarchical, competitive mode of work, founded upon secular law and rules of decorous behavior. The newly competitive worker reads a frightening lesson out of his own ambitions and constructs around him a house that defends his family against intrusion from others who might carry the selfishness he feels in himself to extremes—a house that proposes in its rational order an honorable truce between people separately pursuing their personal happiness. The housing change occurs in response to a change in the socioeconomic world and in advance of a change in the political world where legal reform, armed revolution, and new constitutions belatedly codify the social and economic shifts previously announced in architectural plans.

The message to the architect is that houses are cultural, that they are profoundly matters of social order. Since social order cannot be disjoined from economic aspiration and ideas of the sacred, then houses cannot be understood outside of their economic, political, and religious contexts, outside of their reality as cultural creations.

Study

Vernacular architecture records subtly but insistently the history of a people. The shift from communal to individualistic enterprise, from self-sufficiency to dependence; the gain in control over nature, accompanied by a loss of personal involvement in creation; the gain of convenience, accompanied by the loss of pleasure in work; the gain of bodily comfort, accompanied by a loss of confidence in the social order—all can be understood by an investigation of houses in large numbers. Vernacular architecture is a great resource for the scholar who wishes to write a more scientific and democratic history and thus provide his readers with a means for understanding their present estate. At the same time, the study of vernacular architecture holds practical implications for the future.

The careful, patient, and passive study of diverse traditions of architectural practice reveals that all architectural theories are cultural. All entail actions beyond design and construction. Every architectural tradition is also a tradition of attitudes toward nature (and therefore a teleology) and a tradition of social arrangement (and therefore a political ideology). Having learned that, we can return to our own architectural tradition to comprehend more completely its complexity, its cultural base, its ultimate arbitrariness. When we chance to think of technology as nonpolitical or define houses as shelter or speak of the human need for privacy, we will know that we are not talking of universal principles or of truth. Rather these are the conventions appropriate to an unusual culture that

accepts class distinctions as the natural result of inherent differences among people. It is a culture that dismisses concern for nature in itself as primitive animism, sentimental romanticism, or unrealistic environmentalism, and that approves of self-centered activities, even among adults. Strange notions feel natural and get proposed as human universals because we, like all people, are cultural beings.

Understanding that modern Western architecture is but one of the world's many traditions of design and having learned the arbitrariness of our own ways, we can question our own motives. From close study of vernacular architecture, we know that when we say, "It is human nature to be competitive, to fight for survival, to seek personal happiness," we are really saying, "It is the nature of bourgeois intellectuals in the capitalistic West to believe that it is human nature to be competitive, to fight for survival, to seek personal happiness." That self-awareness which can come only from careful inquiry into other traditions forces us to analyze our own culture, scraping its presuppositions into view, dismantling its structure of proposition, preparing it for real change and genuine improvement. Serious study is a positive revolutionary force.

The study of other architectural traditions simultaneously causes us to criticize our conventions and to learn respect for the conventions of others. Other architectural traditions will cease to be strange and quaint and finally unimportant; they will rise in our minds as coherent and reasonable. We will become unwilling to disturb them and will decide to protect them against members of our society who do not understand them and so are willing, even anxious to sweep them away. This attitude of protection will extend to dead as well as living cultures.

Expansion and intensification of historic preservation is one goal of the student of vernacular architecture. In the United States people from different social backgrounds and of diverse political persuasion are gathering with increasing excitement to protect the built environment against witless destruction. The task of the scholar and practitioner of architecture is to join and help lead, teaching their comrades in this good cause about the cultures that created the buildings and landscapes that they are fighting to preserve, and directing their attention to architectural works that are worthy of preservation but which because of class and racial bias have not yet gained the full approval of the preservation movement.

The enthusiasm for past architectural traditions is not matched by enthusiasm for live architectural traditions. But it is not hard to imagine a redirection of the preservationist's energies toward the creation of a hedge of sentiment and legal code around the vital traditions like those that now protect historical spaces. Wherever a vernacular tradition flourishes, where design, building, and use remain unified by an egalitarian ethic, where people continue to shape their own destinies architecturally—there the preservationist and scholar

should work to defend people against planners intent on preventing people from doing what they want to do. What they want to do may grate on the educated sensibility, may run counter to legal codes designed to protect the elite or may disturb some notions of proper decorum, but if it is their choice, it is their right. Our responsibility should be to protect their right to create as their culture suggests they should create.

When facing vernacular architecture, the architect's role is confined to protection. Architects must learn to preserve the surviving creations of dead cultures, securing them against decay, so that they can carry their messages into the future, helping people in days to come make better buildings. Architects must learn to refrain from fraudulent restoration and they must learn to expand their appreciation past the masterworks of the architectural history courses, helping to save for the future the architectural diversity of the past, stable, sturdy, usable, and unconfused by unnecessary alterations or fantastic efforts to achieve some pure early version of a building. A building's reality consists of the changes it has undergone as much as its original state. Its fabric is the rich record of those changes and to strip them away is to destroy historical data and assault the building's historical being. More important, and much more difficult given architectural education, is the architect's responsibility to help preserve continuing vernacular traditions, aiding people in their effort to maintain their freedom of action. Upon discovering a community that designs and builds for itself, according to its own ideals, the architect's role is not to join with capitalists and planners in the effort to undermine the community so that its several members can be shoved into isolation and sold unuseful, unnecessary commodities. The architect's role is to learn from those people so as to improve his own practice, making it more sensitive to human needs. Once he has learned from them, he will be conversant with two distinct architectural traditions and so he can serve as a cultural middle man. He can teach the people of the community about members of his own society who want to use them basely, as laborers and consumers of shoddy products, and he can work within his own society to protect vernacular traditions against attack.

Understanding the validity of the vernacular creates new jobs for the architect, jobs that must be mastered if the future is to be better than the past. These jobs do not involve designing, leveling the ground, and raising wondrous new piles; they involve the difficult task of learning to appreciate unappreciated architectural traditions, then working to save them, working to stabilize old structures against decline, working to protect architects without university training so that they can continue to practice. The study of the vernacular will make the architect a preservationist and a social activist. Plenty of occasions, though, will remain for the architect to design and build. These occasions follow disruption and dislocation. Neighborhoods will be transformed as their people choose to adopt new patterns for life. Our role cannot be to prevent them from

choosing change any more than it can be forcing them to change. Our role is to allow choice. People will choose personal comfort over environmental engagement, individualistic over collective social arrangements. We can and should do no more than help them select with awareness, then help them adapt to the consequences of their own decisions. Rural and urban neighborhoods will be transformed, buildings will decay past possible renewal, people will move, populations will increase. New buildings will be required, and architects will plan them. The architect attuned to the vernacular will strive to let the people for whom he is designing participate in the process of construction. That will not often be possible and may not be desired by the people. But in most cases it will be possible, despite fake arguments to the contrary, to have the user help design, to let people in on decisions concerning room size and arrangement. When that is not possible, there is still no excuse to design without attention to the varieties of human need. Some people need privacy, others need social intensity. One design cannot serve them both. Consider a simple American instance. In the rural southern United States the idea of the home characteristically includes an external social space, a wide porch or shady yard, where encounter is casual and informal and continual. When people from such settings move to northern cities they provide different environments with simple tests of their quality. If these southern people, most conspicuously black people, are packed into high rise apartment buildings, designed on analogy with buildings that please upper class urbanites so that they include private cubicles but no places for casual gathering, the people correctly rebel against the building, forcing it to decay rapidly, making it an unpleasant, alienated scene. But when the same people move into late Victorian houses in formerly bourgeois white neighborhoods, where houses are supplied with deep front porches and the shady streets before them providing places to gather, they lavish affection on their re-created houses and create the easy feel of a rural community within a thoroughly urban setting. Before he designs, the architect must study so that his design will answer the needs and incorporate the vernacular values of the people who must use the building he creates.

The architect's research replaces the shared experience that made the vernacular architect's product meet its user's needs. The architect who has studied the vernacular will not create a building that imitates the appearance of some old building. Study of the vernacular shows that materials change easily, that superficial details shift often, that what matters most is the basic plan, the ordering of rooms in which domestic life occurs. So the new building can employ the latest technology and it can present an up-to-date front, but it will still do its work well if it is arranged internally to allow people to continue on their way without disruption. No person would be able to articulate every detail of what the proper arrangement for his or her home would be. The right order of a home is created out of study. Serious study is not a matter of accumulating questionnaires

or photographs but of accumulating experience through participation. From experiences shared with the people for whom he is designing, from nights passed and drinks drunk with them, the architect becomes in his imagination the vernacular architect who created perfectly for his clients.

Study of the vernacular produces the knowledge that all architecture is cultural, that all cultures differ in structuring their hierarchy of values, so all buildings must be designed with specific cultures in mind. What is right for us is not necessarily right for them. That simple proposition complicates architectural practice. It can never again be the same. All architectural practice must be preceded by intense field study among the people for whom the architect plans to build, from whom he has stolen the right to design.

Notes for Chapter 2

Below, in lieu of footnotes, I list a few works which I feel are especially useful in the study and interpretation of artifacts and vernacular buildings in particular. I list a few of my own writings, as they include earlier formulations and expanded treatments of some of the ideas in this essay as well as reference to many other works.

Armstrong, Robert Plant. *The Affecting Presence: An Essay in Humanistic Anthroplogy.* Urbana: The University of Illinois Press, 1971.
_____. *Wellspring: On the Myth and Source of Culture.* Berkeley: University of California Press, 1975.
_____. *The Powers of Presence: Consciousness, Myth, and Affecting Presence.* Philadelphia: University of Pennsylvania Press, 1981.
Brunskill, R.W. *An Illustrated Handbook of Vernacular Architecture.* New York: Universe Books, 1970.
Deetz, James. *In Small Things Forgotten: The Archeology of Early American Life.* Garden City: Anchor Books, 1977.
Evans, E. Estyn. *Mourne Country: Landscape and Life in South Down.* Dundalk: Dundalgan Press, 1967.
Fitch, James Marston. *American Building: The Environmental Forces That Shape It.* Boston: Houghton Mifflin, 1972.
_____. "The Future of Architecture," *Journal of Aesthetic Education* 4 (1970): pp. 85–103.
Fitch, James Marston, and Daniel P. Branch. "Primitive Architecture." *Scientific American* 203 (1960), pp. 133–44.
Glassie, Henry. *Pattern in the Material Folk Culture of the Eastern United States.* Philadelphia: University of Pennsylvania Press, 1968.
_____. "Folk Art," in *Folklore and Folklife: An Introduction,* ed. Richard M. Dorson. Chicago: University of Chicago Press (1972), pp. 253–80.
_____. "The Variation of Concepts in Tradition: Barn Building in Otsego County, New York," in *Man and Cultural Heritage,* ed. H.J. Walker and W.G. Haag. Baton Rouge: Louisiana State University School of Geoscience (1974), pp. 177–234.
_____. *Folk Housing in Middle Virginia: A Structural Analysis of Historic Artifacts.* Knoxville: University of Tennessee Press, 1976; rpt. 1983.
_____. "Meaningful Things and Appropriate Myths: The Artifact's Place in American Studies," *Prospects* 3 (1977): pp. 1–49.

_____. *Passing the Time in Ballymenone: Culture and History of an Ulster Community*. Philadelphia: University of Pennsylvania Press, 1982.

Hoskins, W.G. "The Rebuilding of Rural England, 1570–1640." *Provincial England: Selected Essays in Social and Economic History*. London: Macmillan (1965), pp. 131–48.

Kniffen, Fred. "Folk Housing: Key to Diffusion," *Annals of the Association of American Geographers* 55 (1965): pp. 549–77.

Kubler, George. *The Shape of Time: Remarks on the History of Things*. New Haven: Yale University Press, 1967.

Morris, William. *Hopes and Fears for Art*. London: Ellis and White, 1882.

_____. *Signs of Change*. London: Reeves and Turner, 1888.

Norberg-Schulz, Christian. *Intentions of Architecture*. Cambridge: M.I.T. Press, 1968.

Pye, David. *The Nature of Design*. New York: Reinhold, 1967.

Rapoport, Amos. *House Form and Culture*. Englewood Cliffs, N.J.: Prentice-Hall, 1969.

Upton, Dell. "Ordinary Buildings: A Bibliographical Essay on American Vernacular Architecture," *American Studies International* 19 (1981): pp. 57–75.

The Concept of Community and Folklife Study

John Michael Vlach

The Importance of Community

It is a truism, or at least it ought to be, that folklife study involves close consideration of the concept of community. Originally conceived as an adjunct subfield of ethnology, folklife research needs its communal constraints to distinguish its objectives from the broader, more inclusive mandate of anthropology. Instead of studying all of culture, folklife scholars concentrate on the particular ideas and behaviors that demonstrate localized social patterns which are connected to family, neighborhood, town, or region. While these patterns do not always account for the full inventory of human action within a culture, they are, nevertheless, considered significant and may reflect core concerns. Something cannot be logically or legitimately labeled as folk unless it is in some way tied to a social unit, to a group. Should an artifact lack group affiliation it cannot offer productive insight to the folklife scholar except perhaps as an inverted mirror of tradition.

The essential characteristics of folk things stem from their communal nature. Because they are shared expressions they are not unique but typical and even commonplace; they are not usually monumental but ordinary and familiar; they are not singular but precedented, formulaic, and duplicated; they are not the product of a lone instant but are repeated continuously. All of these features arise from the centrality of communal identity in folk culture. So indispensable is community to the definition of folklore that even a contemporary attempt by folklorist Dan Ben-Amos to stress process rather than social unit still makes prominent reference to folklore's communal aspect when he defines folklore as "artistic communication in small *groups*."[1] Later in this volume Sergei A. Tokarev notes that the folklife scholar "is not interested in things per se, but in

their relationships to *people*, for ethnography is the science of *people*, not things."[2] Given such an orientation, the communal aspects of folklife are an inescapable responsibility of any research effort.

The folklife scholar who eschews concern for the communal does so at the risk of abandoning his discipline for some brand of highly descriptive behavioral sociology in place of the interpretive historical and cultural study that folklife was designed to be. Lamentable as such a scenario might seem, it appears, however, to be one of the trends lurking on the horizons of folklife research. Recent concern for material culture in American folklife study has been colored with novelty; hence current students of material culture are much given to experimentation as they chart the generally unexplored realm of the traditional artifact. The current material culture "explosion" in folklife has occurred at a point when folklife in general has attempted to retool itself with social science methods and terms, when folklorists have attempted to overcome an "inferiority complex" they had previously manifested when comparing themselves to anthropologists.[3] This has meant that American folklife scholarship, even at its genesis, was faced with a number of options derived mainly from the social sciences. Henry Glassie spoke about this tendency recently, admitting that he had once pushed folklife toward science by writing "some of folklore's most careful, quantified, and boring studies." He continued on to say, "For a while I wished to purge folklore in imitation of the best anthropology."[4] Fortunately Glassie stopped short of selling out folklore and returned to its most fundamental constructs, history and humanism—time and community—and with that focus has produced essential studies in folklore and folklife.[5]

The purpose of this brief essay is to remind practicing and potential folklife researchers of the value of folklife's disciplinary assumptions. In particular I will stress the importance of community as a folklife construct. This discussion may be an excursion through the obvious but it might also provide a clearer vision for the future of material culture studies in folklife and American Studies. Rather than proposing that we search for sophistication in the theoretical treasure troves of others, I recommend that we invest our energies in rethinking ways to act upon our given assumptions with more rigor.

The Definition of "Folk Art"

The dangers risked by ignoring the concept of community are seen quite clearly in the current state of folk art study. The subject of folk art has for half a century been prone to extensive confusion. A review of its scholarship, or better its commentary, reveals that until quite recently folklorists generally have not given much attention to this subject. Custodianship of this segment of material culture has thus by default been given over to collectors and museum curators who have had their own way with folk culture.[6] Collection of folk art has understandably

preceded thinking about it and in place of evaluation we find description. Moreover, it is gratuitous or conjectural description. At first antiquity was the prime criterion for the inclusion of an artifact under the rubric of folk art. Old paintings, old statues, and the like were accepted as examples of American folk expression. Then when the caches of nineteenth-century "stuff" hidden away in barns and attics "dried up," collectors turned to twentieth-century items and found that they too could be included if the prime criteria were shifted from age to deviation from fine art norms. Folk art then became identified as fine art with charming errors. In either case the strategy of identification downplayed the human issues involved in the design, creation, and use of artworks and focused more centrally on the works themselves. Two erroneous assumptions made were: (1) that old art is folk art because the past was a simpler, "folkier" period than the present; and (2) that folk artists just imitate fine art as best they can in their distinctively limited manner (fig. 3-1). These problematic assumptions reflect a simplistic sense of history and a naive and derogatory interpretation of folk art.[7]

Without laying the blame on specific individuals we might profitably examine instead the faulty thinking about folk art that manifests bad history and flawed social science. A solution to these problems in folk art study is to be found in applying a communal "litmus test." It is absolutely essential to ask first if an artwork is a communal expression. If it is, then certain further assumptions about the work are justifiable and appropriate. Judgments might then be made about content, technique, appreciation, and significance. Because folk art is by definition a collective social expression, when a piece of art is identified as folk the researcher has not one piece of information but many. Often dependable data on the biography of a piece are lacking or the information that is available is spotty. In such cases one can turn to the general principles that we usually expect to encounter in traditional expressions: that they will be historically precedented, that they will conform to a limited set of known patterns, that they will appear in several versions, and so forth. If a work of art is not communal then different assumptions have to be made and different expectations will then inform our further investigation.

But what seems to have happened repeatedly in American folk art study is that works that are not folk are nevertheless assumed to be so and consequently folk culture is presented in a distorted manner. For example, American folk art has been said to manifest a high sense of individualism and extreme variation, characteristics definitive of Western fine art.[8] Supposing that a body of artworks did demonstrate extensive variation and personalization, this would indicate that either there were several distinct traditions included in that body or that the tradition itself was highly fragmented because of some major social changes. These two circumstances are exactly the case for American cultural history; we have a heritage of plural peoples and many folk artists have departed from their

Figure 3-1. Edward Hicks, *Peaceable Kingdom.*
Ca. 1830-35.
(New York State Historical Association, Cooperstown, New York)

original traditions because of the opportunities for social mobility. Folk art commentators, however, have ignored these realities and lumped the whole of the American past into a jumbled undifferentiated mass and simplified their estimation of artists' concerns mainly because, in their view, those works seem to be simple expressions. They have mixed up the works of folk artists, popular artists, commercial artists, amateurs, students, and hacks and called them all by the same name. In fact, they have so reversed the definition of folk as to make it meaningless as an analytical category. If their view of folk art then seems confused, it is a circumstance they have brought upon themselves. The matter of art is indeed complex but the complications involved in art scholarship seem to arise from a continual compounding of an initial error in definition. The communal focus of folk art has unfortunately been ignored, giving rise to faulty evaluative criteria.

If the term folk art is used rigorously as an exclusive rather than inclusive category, some of the problems of the last half century may fade away. Only some of the art of the past, just as now, was motivated by communal concern. Only a portion of the work that survives from history comes from folk societies. By the middle of the eighteenth century in America a distinct class system was in place.[9] One consequence is that American art is differentiable in a manner similar to its people. Some portion of American art was created according to elitist dictates but much more art was a middle-class attempt to attain the order of the elite from a less adequate economic base. In the case of these latter works some folk principles of design and content were occasionally employed but these works ultimately have to be judged as derived from high-style motives. Folk art resides in yet another domain; one which is in contact with the other two social levels, but not derived from or dependent upon them. The vast numbers of portraits from nineteenth-century New England then are not really folk paintings but the art produced for a newly emergent bourgeoisie anxious to acquire symbols of success. Members of the middle class commissioned local painters to make their likenesses while their social betters contracted with the best studio- and academy-trained talents of the day. The flat, awkward, two-dimensional images that they got for their money are not quite fine art but their owners wanted them to be. They were images by which they might set themselves apart as enterprising, distinguished, and prosperous farmers and businessmen. This was not an art that contributed to social cohesion or expressed a mutually held communal identity. Rather it was an art of social division devoted to the cult of private personality, just exactly what folk art is not.

If our insights into American folklife have not been aided by the numerous studies of so-called folk painting, it is no wonder. As works they lack an authentic claim to folk culture and so reflect little information about folklife.[10] A more accurate and honest model of history might have made this insight available much sooner. It is not simply circular logic to suggest that we might learn

something about folklife by focusing on works of folk art because that obvious connection has been precisely the approach least followed.

If one were interested in New England as a folk region and wished to pursue its regional qualities through artifacts, it would be best to look at New England gravestones, domestic textiles, and furniture rather than paintings or samplers. Setting aside minor cavils that such forms are craft and not art, we can easily see that there is an aspect of design in these kinds of artifacts and therefore some measure of aesthetic judgment is involved. The study of gravemarkers, quilts and coverlets, and tables, chests and chairs brings us in touch with specific artisans having distinctive personalities, but it also puts us in touch with their wider public who use crafted objects not to set themselves apart as much as they used them to express a shared worldview, a communally held perspective on life. This is particularly apparent in gravestones where we find that tablet after tablet bears the same icon of death, either skull, cherub, or weeping willow, according to the prevailing theology of the day. Repetition of a standardized form from person to person is a powerful index of shared taste, of a democratic vision, of communal interests. Similarly quilts, being the commonplace bed covering and having familiar geometrically patterned tops, also provided social links in both behavior and decorative art. In like manner home furnishings often reflected the way in which skills that could have resulted in elaborate work were often constrained by customer preference to result in a plainer, more pragmatic artifact. Taken singly, gravemarkers, quilts, and chairs are mute, minuscule elements of collectanea; taken as classes of objects they can be made to speak eloquently and forcefully, for as generic statements they speak for many. Representing multitudes they can prevent faulty hypotheses based on minimal or skewed examples as often occurs when attractive but aberrant and idiosyncratic "masterpieces" are the sole focus of attention. Put bluntly, highlighting the concept of community prevents folklife researchers from studying the wrong stuff.

When the artifacts studied are demographically representative of a region or a group of people, the researcher has access to the full range of aesthetic ploys that were explored. With objects that demonstrate great historical stability like gravestones or quilts, the criteria of creativity they manifest are revealed as consistent and meaningful even if these criteria are different from the standards of high-style artworks. Folk things have their own kind of complexity and their own kind of beauty both of which are based on the internal priorities of folk society. Traditional art, therefore, is not better or worse than fine or popular art, it is just a different kind of art.[11] If one is then to get a command over those differences it is important to study a form or a social context in which elitist or normative popular values do not have a governing influence. A tightening of one's perspective to focus on the communal orientation of a folk group promotes a better understanding of these important differences. Studying folk art from the

communal point of view allows the researcher to appreciate local levels of sophistication and thus provides the weapon needed to debunk the mythology which enshrouds the "innocent, poor but happy, rustic folk artist" who never was.

If folk artists do not speak for the middle or elite classes, that should raise no great problem, for it is not the central goal of folklife research to explain the behavior of those social levels, even if some will claim that we are all the folk.[12] Often it is asserted that folklife research should take into account all the people of a given culture, let us say all Americans. We must recognize, however, that only inasmuch as Americans manifest some affiliation with a smaller group, with a community, do folklife researchers have any special expertise to comment upon them. What the communal construct implicitly suggests then is that the path to intellectual rigor and precision will be opened only with an insistence on methodological and theoretical particularism. We need not study all of society but should focus only on its folk portion. We should not study all of its artifacts, but only those with traditional aspects of design, content, or use. We are not accountable for all historical events, but only those that have some bearing on folk society and then we should fasten our interests specifically on the local rather than national significance of those events.

Field Research

Because communal identity is both a collective and an ideational concept, it is difficult to observe precisely in a field situation. A member of a group has a sense of his or her personal identity and then in addition probably has tacit knowledge of bonds of mutual interdependence with others. These bonds are often felt more than they are named and hence are only vaguely describable to outsiders. Thus researchers confront a situation in which they have to make basically the best and most reasonable guess they can about what seems to be the nature of communal identity. Inevitably there is even a likelihood of error and arrogance. One way to avoid these problems is to focus attention more on the member rather than the members of a folk society and thus make the individual rather than the group the subject of study.

One of the noteworthy recent trends in folklife study thus has been an increase in the number of life histories written about craftsworkers and folk artists.[13] In these works findings seem more verifiable and trustworthy. In place of a concern for community or society or culture we find attention directed mainly at makers and their artifacts. This focus, it is argued, brings the fundamental components required for an understanding of humanity within grasp. From an accurate appraisal of the actions of individuals it is assumed that we can build a valid model of human creativity. A sense of the communal is discovered at the end of such a study instead of informing the study from the

outset. But this sense of community is set on a global anthropological level, at a level where we recognize that all humans make and use things. While it is valuable to recognize such a unity, it is important in folklife study to move beyond facile insights to say how it is that specific peoples apply specific strategies to make specific things. That folklife casts a smaller net than anthropology is simply a fact. If that is a worry of folklife scholars, they need only realize that their smaller net is still capable of a rich and varied catch. James Deetz, a professor of anthropology, wistfully concedes that current folklife study has already ensnared the "soul of anthropology" while anthropologists were lost in the cerebral clouds of theory. The pursuit of life history as a strategy to find "hard" data replacing the "soft" sense of community is misdirected if that data is only to be spread thinly over the whole world. Argument about human verities based solely on the career of a single blacksmith, potter, or chairmaker is not going to be convincing.

Life history taking is a valuable technique in the folklife researcher's toolkit and it is not my contention that we ought not to study the individual performers of tradition. My own work on folk artists and craftspeople should be ample testimony to my preference for the biographical mode of scholarship.[14] But it is important to keep the communal construct in mind when writing biographical accounts of folk performers. One might, indeed often does, find craftspersons or artists who are extremely fascinating individuals. They might possess extensive skill and talent and brim with confidence and wisdom. These individuals deserve attention and respect as significant human beings. Yet folkloristic ethnographies cannot stop there with the universe inside the mind of a maker of objects; folklife studies are by the definition of the discipline also concerned with the maker's social universe. The two realms, being mutually interdependent, should be studied as a natural unit; one should not be considered at the expense of the other. Indeed, the interlock between personal history and social history implies that personal questions raised during the ethnographic process may yield insights for communal questions and vice versa.

Consider the comment of blacksmith Philip Simmons who, when asked about communal influences on his work, replied: "I owe all my career to the people of Charleston [South Carolina]. Without them giving me a chance, I couldn't have anything. I can't make a gate if they don't want 'em."[15] For Simmons, the affiliation with his local community is crucial (fig. 3-2). His sense of dependence on his clientele in no way diminished his talent or genius. His creativity remains vibrant and impressive, but it is channeled into forms that satisfy a conservative public demand; it is targeted at communal interests. To overlook that dimension of his work is to dismiss his fundamental connection to others which gives his ornamental ironwork its first order of traditionality (fig. 3-3). Just as he has to master iron and flame, so too are communal standards a kind of raw material or condition with which he must work and over which he

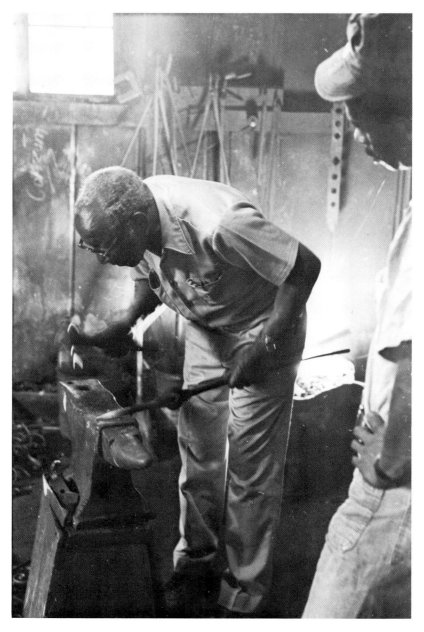

Figure 3-2. Philip Simmons Showing Willie Williams a Forging Technique.
Charleston, South Carolina, 1978.
(John Vlach)

Figure 3-3. Simmons's "Harp Gate."
Charleston, South Carolina, 1978.
(John Vlach)

must develop a command. A study focused on his creative processes could conceivably leave aside information on communal precedents and center on aspects of design, execution, and personal satisfaction. But such a study would be synchronic, formalistic, and psychological to a degree that folklife scholarship should not be.

The question might be raised about artists who seem not to have the same kind of productive, intimate group relationship that Philip Simmons has. Should such individuals be shoved into a communal network when none is acknowledged? If it is indeed the case that an artist works in isolation both in terms of the source of his ideas and the destination of his finished product, nothing is to be gained by constructing a hypothetical communal process to explain his career. Isolation itself should be interpreted as a symptom of the stresses which are destructive of communal power. When folk culture is under siege, for whatever reason, its expression will not conform to the standard expectations of either its members or its students. These stresses may be either social or personal in origin and should be included in a responsible ethnography. But cultural ills should not be seen as emblematic of folk culture; they are the accidents of history, not a given condition of the traditional mindset. Even if not lovely to behold, negative circumstances still should be reported. The folklife ethnographer should not retreat into the fascinating intricacies of an informant's personal vision as a way to avoid the sad account of a sick and dying tradition. Should we be intent on rendering a positive account we will select healthy traditions to study.

In these times not all traditions are as vital as they once were, particularly in the area of material culture. Generally it is those technologies with a strong domestic base—like foodways, woodcarving, or the textile arts—that continue to thrive. The main suggestion here is that just as in folk art study we do better if we restrict the range of admissible data, so too in ethnography we would do better if we restricted our choice of subject matter to thriving communities. This would be instead of chasing after the last vestiges of archaic culture or substituting idiosyncratic expressions of personal whimsy for tradition. Folkloristic ethnography should review life histories to develop insight on communal concerns. Individual lives are the minimal units out of which the collective reality of social existence is formed. The people we study work constantly to structure themselves into social units and the end results of that effort, inasmuch as that is their goal, should also be a goal of our scholarly endeavor.

The communal focus of folklife study directs researchers to appropriate data bases and directs them to useful strategies for the interpretation of that data. While there is a definite sense of limitation when communal concerns are invoked, attention to community does not restrict exploration of theoretical and methodological possibilities. A people's sense of groupness can be approached via structuralist, behaviorist, semiotic, humanist, or ethnographic tactics, to

name but a few. Even though there is a terminological link between the notion of community and folk society which might imply the appropriateness of Redfieldian anthropological theory, folklife researchers are not necessarily limited to that paradigm.[16] The variety of analytical schemes in this volume alone is adequate proof that there is no mode of intellectual cleverness that cannot be utilized. This diversity can be taken as a sign of health and well being for the discipline. Folklorist Roger Abrahams has noted that theoretical eclecticism indicated the vigor of folklore study as it reached a new stage of maturity during the 1960s.[17] In folklife study the number of approaches we encounter similarly demonstrates vigor and suggests that folklife researchers can stay in step with the latest analytical trends without fear of castigation from their colleagues. Nonetheless, this open and fast-paced experimentation leads to refined insight instead of fragmentation only if there is agreement on the ultimate objectives of the discipline. Community would have to be one of those key objectives along with technology, creativity, and history. Community locates the place where technology is enacted, determines the audience that will evaluate the level of creativity attained, and modifies the significance of history's sanctions. What reality does folklife have if not the reality of the community? The answer to this question will require all the analytical perspectives that folklife research can muster.

I hope this brief discussion will motivate some reflection on the state of folklife study. It may also provide a standpoint from which to discern tendencies and implications of the dialogues later in this volume. Folklife study cannot help but benefit from reevaluation of its analytical goals and procedures. Novel scholarly movements are, as we note in the case of folklife research, prone to competitive position taking. The final decision, however, would not be made until after consensus is reached on what interests are held in common—interests on which serious discourse might center. I maintain that at this time, when folk artifact scholars seem to be spreading thinly across the terrain of many theories, it might be wise to recommit to basic principles and consider once again the intellectual heritage of material culture and folklife research.

Notes for Chapter 3

1. Dan Ben-Amos, "Toward a Definition of Folklore in Context," *Journal of American Folklore* 84 (1971): p. 13; emphasis added.

2. See Sergei A. Tokarev, "Toward a Methodology for the Ethnographic Study of Material Culture" in this volume; emphasis added.

3. Américo Paredes and Richard Bauman, eds., *Toward New Perspectives in Folklore* (Austin: University of Texas Press, 1972).

4. Henry Glassie, "Archaeology and Folklore: Common Anxieties, Common Hopes," in *Historical Archaeology and the Importance of Material Things*, ed. Leland Ferguson (Special Publication Series No. 2, Society for Historical Archaeology, 1977), p. 26.

5. I refer here to his oft-quoted *Folk Housing in Middle Virginia* (Knoxville: University of Tennessee Press, 1975), *All Silver and No Brass: An Irish Christmas Mumming* (Bloomington: Indiana University Press, 1976), and *Passing the Time in Ballymenone: Culture and History of an Ulster Community* (Philadelphia: University of Pennsylvania Press, 1982).

6. See Beatrix T. Rumford, "Uncommon Art of the Common People: A Review of Trends in the Collecting and Exhibiting of American Folk Art," in *Perspectives on American Folk Art*, ed. Ian M.G. Quimby and Scott T. Swank (New York: W.W. Norton, 1980), pp. 13–53.

7. Kenneth Ames, *Beyond Necessity: Art in the Folk Tradition* (New York: W.W. Norton, 1977), p. 21.

8. See Nina Fletcher Little's comment in "What is American Folk Art?—A Symposium," in *Folk Art in America*, ed. Jack T. Ericson (New York: Mayflower Books, 1979), p. 19.

9. James Deetz, *In Small Things Forgotten: The Archaeology of Early American Life* (Garden City, N.Y.: Anchor Books, 1977), pp. 38–39.

10. These old paintings often depict scenes in which the traditional uses of folk artifacts are demonstrated. Thus these works can prove to be valuable documents of folk life. It is important to note however, it is the content, not the format which is traditional. See Beatrix T. Rumford, "How Pictures Were Used in New England Houses, 1825–1850," in *Folk Art in America*, pp. 40–48.

11. John Michael Vlach, "American Folk Art: Questions and Quandaries," *Winterthur Portfolio* 15 (1980): pp. 345–55.

12. Alan Dundes, "Who Are the Folk?," in *Frontiers of Folklore*, ed. William R. Bascom (Boulder, Colo.: Westview Press, 1977), p. 34.

13. See, for example, Michael Owen Jones, *The Hand Made Object and Its Maker* (Berkeley and Los Angeles: University of California Press, 1975); Simon J. Bronner, *Chain Carvers: Old Men Crafting Meaning* (Lexington: University Press of Kentucky, 1984).

14. John Michael Vlach, "Quaker Tradition and the Paintings of Edward Hicks: A Strategy for the Study of Folk Art," *Journal of American Folklore* 94 (1981): pp. 145–65; idem, *Charleston Blacksmith: The Work of Philip Simmons* (Athens: University of Georgia Press, 1981).

15. Vlach, *Charleston Blacksmith*, p. 119.

16. Robert Redfield, *The Little Community* (Chicago: University of Chicago Press, 1953).

17. Roger D. Abrahams, "Folklore in Culture: Notes Toward an Analytical Method," in *Readings in American Folklore*, ed. Jan Harold Brunvand (New York: W.W. Norton, 1979), pp. 390–403.

Toward a Methodology for the Ethnographic Study of Material Culture

S.A. Tokarev
Translated and Introduced by Peter Voorheis

Sergeij Aleksandrovič Tokarev (b. 1899) has gained recognition in Europe and the Soviet Union as a leading figure in ethnographic science. Although the following essay stresses the study of material culture, a number of his illustrations reflect the many years of research he has devoted to another of his primary fields of interest, comparative folk religion. This essay also reveals a major thrust of study in the later part of his career—the history and methodology of international ethnography.

In dealing with scholarly material presented from a Soviet perspective, Westerners may allow their attention to potentially useful ideas to be diverted by their political prejudices. To be sure, Russian and Soviet scholarship has set precedents for many of the major movements and trends in folk studies. There is, for example, the profound impact of Vladimir Propp on structuralist analysis, Mark Azadovskij on personality and culture (and performance centered) methodology, and Petr Bogatyrev on folklore and linguistics (and functional) theory.

To avoid diversion among readers of Tokarev's notable essay, a few remarks on his ideological approach are in order. Reflecting the Marxist theory of history, Tokarev repeatedly refers to various "stages" in social development and to the transitions between them. Although in Western scholarship we tend to treat the evolution of societies on an individual basis, the Soviets for the most part adhere to a model of unilateral development, with each society at a different level. Second, Tokarev's argument that ethnographers should take the

initiative in the design of clothing (and presumably in other areas of material culture as well) is a form of "applied folklore" which may strike the Western social scientist as an example of elitist interference with culture. Tokarev's reference to this "practical" (as opposed to theoretical) work to be accomplished by ethnographers typifies one of the main differences between Soviet and Western ethnographers and folklorists in their approaches to the societies they investigate, for in our attempts to avoid the label of interloper or cultural contaminant, we have, in contrast to our Soviet counterparts, generally played the role of observers rather than advisers. Finally, Tokarev's rather impassive observations on the historic inevitability of the assimilation of the family role by the state should not be taken as indicative of any "antifamily" predilection in Soviet ideology. Rather, his implicit acceptance of this process reflects a concept which is more pronounced in Soviet society than in the West: the notion of society and the state as extensions of the nuclear family.

It is tempting to criticize Soviet scholarship for its surfeit of official ideology, but such criticism does not obviate the significant contributions of Soviet scholars to the study of human behavior and culture. Felix J. Oinas and Stephen Soudakoff's *The Study of Russian Folklore* (1975) has demonstrated Soviet contributions to the area of verbal folklore; Tokarev's well-recognized work should make it plain to those of us in the West that the Soviets have already offered much within the field of material culture as well, and what they have offered can richly inform our contemporary ethnographic research and our thinking about material culture study's methods and theories. In fact, Tokarev's sociohistorical evolutionary ideas on material culture address issues recently raised by American neo-evolutionist anthropologists concerned with folk technical culture. His positing of material culture's social functions raises a central issue in folklife research: the relation of people to one another revealed in the appearance and use of traditional objects.

In studying the object we must be aware of the world of objects, and the world of scholarship that touches on us as Americans and members of the global village. But because translations are not usually readily available, especially from the Russian, we as Americans miss significant contributions to folklife study. Tokarev, in the tradition of major Soviet ethnographers, has profoundly influenced European folklife study, and he offers implicitly in this essay insights on the assumptions presented later in the volume. Tokarev's article appeared originally as "K metodike ètnografičeskogo izučenija materil'noj kul'tury," in *Sovetskaja ètnografija* 4 (1970): pp. 3–17. It has also

appeared in German in *Ethnologia Europaea* 6 (1972): pp. 163–78. Its first English translation here is published by permission of the All-Union Agency for Authors' Rights, Moscow.

* * *

The Social Existence of Objects

It is generally recognized that the study of material culture became a focus of interest for ethnographic science later than such areas as verbal folklore, religious beliefs, customary law, and family and marriage customs. Its systematic investigation began only at the very end of the nineteenth century. Our native ethnography can boast of great successes in this field, for our foreign colleagues recognize the especially high scientific level of Russian and Soviet work in this area.[1] Most important in this respect is that our ethnographers (V.V. Bogdanov, B.A. Kuftin, N.I. Lebedeva, E.E. Blomkvist, G.S. Maslova, and others) were able to discern the correct perspective from which to investigate material culture phenomena: the ethnographer is not interested in things per se, but in their relationships to people, for ethnography is a science of people, not of things.

Indeed, although the ethnographic researcher must be able to describe with the utmost precision and completeness the phenomena of material culture (dwelling, clothing, ornamentation, utensils, and so on), supplementing his description with graphic pictures, diagrams, drawings, sketches, and photographs, and with the same precision and completeness describe the technical processes in the manufacture of various objects and their uses, these technical descriptions nevertheless have always been and will remain only auxiliary methods, and not the goal of scientific ethnographic research. Otherwise, the ethnographic analysis of clothing would turn into a manual for dressmaking courses, the study of foodways into a collection of culinary recipes, the study of folk dwellings into a chapter of an architectural textbook.

For the ethnographer, "an object does not exist (save perhaps in the physical sense) outside its significance for man," as the French ethnographer Marcel Maget correctly observed. When studying an object, he said, one must take into account all those people who "have the ability, even the responsibility, of making, disseminating, buying, or using this object."[2] A material object cannot interest the ethnographer unless he considers its social existence, its relationship to man—to the person who created it and the person who makes use of it.

Furthermore, it is not so important for us to be aware of the relationship of the object to the person or that of the person to the object as much as it is to be aware of the relationships among people in regard to a given object. Here a close analogy exists with the economic category of property. From the Marxist point of view property is not the relationship of a person to a thing, but relationships among people concerning this or that thing. And it is absolutely essential that the

ethnographer examine every type of object and phenomenon of material culture; this is usually understood by all serious ethnographers.

But it seems to me that while they recognize the specific principles of such an approach, our ethnographers, as well as those in other countries, are not drawing all possible inferences from it. The problems and possibilities in the investigation of material culture are far from being solved by that range of questions which are usually limited to the study of folk dwelling, folk clothing, foodways, and transportation.

If we survey the rather large number of master's theses, doctoral dissertations, and articles devoted to the material culture of one people or another, it is not difficult to discern in them recurrent themes which represent the theoretical basis of this field of research. The themes most often encountered are:

1. The dependence of the objects of material culture (food, dwelling, dress, and so on) on the natural environment and economic pursuits.

2. Their dependence on ethnic traditions; the manifestation of ethnic features, of similarities and differences in material culture, and hence, the use of material culture phenomena as a source for the study of questions of ethnogenesis, the ethnic history of a people, cultural connections among people.

3. Another aspect of this same problem is the assignment of certain forms of material culture to one or another historical-ethnographic area, regardless of the diverse origins of the bearers of these forms of culture.

4. The connection of the forms of material culture with differences in the domestic status, sex, and age of their bearers; this applies especially to clothing and ornamentation, and to a lesser extent to food and dwellings.

5. The dependence of material culture elements on social structure and distinctions of class.

6. The connection of material culture forms with religious beliefs and ceremonies; in particular, the study of ritual food, ritual clothing, and more rarely, the ritual purpose of buildings or parts or them.

7. The connection with art: the artistic aspect of folk architecture and clothing, architectural adornment, embroidery and patterned fabric in clothing, styles of design, and so on.

8. Changes in the material culture of people during the epoch of capitalism, under the influence of the penetration of trade relations, an urban mode of life, and the effacing of traditional ethnic traits.

9. Changes in the form of the material mode of life in the contemporary epoch in connection with socialistic reorganization....

There is certainly no doubting the topicality of these questions. Of course, it is always important for us to know to what extent the type and form of this or that complex of clothing or its separate parts, of this or that type of building, and so on, have been conditioned by ethnic tradition, by the influence of neighboring

peoples, by natural conditions, by the class affiliation of the bearers. It is especially important and necessary to elucidate the interaction of all these "factors" which are often pointed in different directions. For example, a change in the natural environment gives rise to improvement or change in a particular form of traditional dress or building, but ethnic tradition strives, on the contrary, to preserve it.

But while recognizing the great importance of the customary range of problems in the study of material culture, it is still necessary to repeat that it far from exhausts the aspects of this study which arise from the specifics of ethnography as a science. I would now like to turn my attention to those aspects of material culture as an object of ethnographic investigation which up to now have remained in the shadow or have been altogether surrounded by silence in our studies.

As indicated above, a material object interests the ethnographer not only in itself, but in its relationship to man or in the relationship of man to this object. But still more important for the ethnographer are the relationships among people in regard to a given object, that is, broadly speaking, the social relationships mediated by material objects. What does this mean? I will explain by examples.

Foodways

When studying the foodways of a particular people, one must above all proceed from the assumption that the functions of food in human society are highly diverse. Food and drink serve man not only for purely physical satiation, that is, not only for the satisfaction of the fundamental biological requirement of nourishment which has a place in the entire organic world, among plants as well as animals. Foodways play another role as well, that of a form which mediates social relations. The manifestations of this role of food are many and varied. The sharing of meals in all stages of historical development has been and remains one of the most important forms of domestic interaction among people. From the collective eating of wild animals in the Paleolithic epoch, from the traditional obligatory law of dividing the hunter's catch, from the hunter's communal feasts, right down to the periodic *bratčiny* of the Slavic peoples, to the formal family dinner in English aristocratic and bourgeois circles, and to diplomatic breakfasts, dinners, and "receptions" where important questions of international politics are considered, we can point to dozens, if not hundreds of diverse occasions in the social life of humans when the shared partaking of food or drink is considered obligatory: the reception of guests, dinner and evening parties, friendly carousing, births, baptisms, weddings, funerals, jubilees, festivals, religious and secular holiday festivals, and so on. What kind of functions do eating and drinking fulfill on these occasions? In the majority of cases their fundamental biological purpose—the satiation of hunger and thirst—is pushed far into the background, or disappears altogether.

Furthermore, the very act of sharing food or drink is often not only an expression of friendship or kinship among people, but in many instances itself creates such attitudes. In ethnographic and historical literature many descriptions exist of customs of swearing fidelity during the course of a meal. To eat a slice of bread in the home of an enemy is to signify the end of the quarrel and the restoration of peace; the sharing of food by the bride and groom (in Latin, *confarreatio*) is an essential part of the wedding ceremony.

The ritual significance of shared meals is underscored in certain instances by the use of special "ritual" foods. Ethnographers typically pay sufficient attention to such foods, but they do not always see in them the manifestation of the same general law. The ritualization of the food is only a means of strengthening the symbolic meaning of the shared meal as a form of social interaction. At the same time, a deity, the spirit protector of the family, the ancestral spirit, is included in the circle of human fellowship in this case, and he takes part in the ritual meal.

These facts inspired Robertson-Smith's theory of "communion-sacrifice," which holds that the object of sacrifice was originally the deity himself, the totem of the clan, whose flesh was ritually consumed as a symbol and confirmation of the unity of the clan members. [3]This phenomenon is the origin of the entire chain of "god-eating" rituals, culminating in the Christian mystery of the Eucharist, the partaking of the body and blood of Jesus Christ.

From the foregoing it is apparent that so-called "ritual" foods are ritualistic not because of their material composition but because of their fulfillment of a social role. But food not only unites people, it divides them as well. Along with its function of social integration, food serves the opposite function, that of social estrangement.

Among all peoples of the world there are customs prohibiting or restricting one individual from eating with another. Perhaps the most ancient form of this type of dissociation was the segregation of the sexes at the meal, a practice which may be partially connected with the division of labor on the basis of age and gender. The male hunter dined primarily on meat, his catch, which was not always provided for the women. The segregation of the sexes at meals later became more marked; it is particularly connected with marital-sexual relationships. Contemporary French researchers, R. and L. Makarius, brought to light and analyzed the characteristic customs of marital and eating relationships. "Whomever we eat with, we don't marry; whomever we marry, we don't eat with." This phenomenon occurs in the widespread prohibitions on women to take food with men, particularly true for wives and husbands. Such prohibitions took on especially harsh forms among the peoples of Oceania, less harsh in North America and Africa. Vestiges of such a prohibition have been preserved up to the present day among the peoples of the Caucasus, the Balkan peninsula, and in other countries: the women in the family eat after the men and apart from them.[4]

Social estrangement at the meal also involves differences in estate, caste, and class. In some areas, such as India, the interdiction on communal meals among people of various castes has reached its most sharply expressed forms. "And faith does not eat with faith, does not drink, does not marry" wrote Afanasij Nikitin on this subject as far back as the fifteenth century. The connection of mealtime segregation with denominational differences is seldom seen in modern times, but even now the Russian Old Believers will not eat from the same dish with *mirskie*.[5] Even in the modern developed countries of Europe and America, the dinner table is the definitive place where class segregation is retained: the master does not sit at the same table as the servant, nor the factory supervisor with the workers, the people of *beau monde* with the common folk.

From this point of view we must survey all prohibitions and limitations on eating and drinking as both constant (religious asceticism, Nazaritism, monasticism) and temporal (fasts). At first glance it would seem that when temporary or permanent prohibitions are attached to a particular food, a relationship of man to this food is expressed, that is, a relationship to a material object. Where then is the social relationship here? In reality, just as ownership is not the relation of a man to a thing, but the relation of people to each other mediated by the thing, so is an eating prohibition a symbol of some kinds of social relationships. A people who observe a certain eating prohibition set themselves off from those people who do not observe this prohibition. By not eating swine, the Moslems manifest their distinctiveness from all who are not Moslems. In contrast, for the Russian peasant it is horsemeat which signified *basurman* or "non-Christian."[6] Monks, who abstain from the use of meat, milk, wine, and so on, dissociate themselves by this act (as well as by other "vows") from laymen, who do not observe these vows.

But eating prohibitions and limitations, especially when they involve an entire people (or groups of peoples) may also be viewed as an expression of some intrinsic tie which unites a given people, like some ethnic sign. But this negative sign, so to speak, has its positive equivalent well known to ethnographers: ethnic peculiarities in food, or "national dishes." We don't eat such and such food, but we love such and such dishes. The national aspects of food is one of the habitual themes of ethnographic research.[7] It must not be forgotten that for the ethnographer it is not the method of preparation of a particular national dish, its material content, which is so important, as the very existence of the dish, its social function. Devotion toward a traditional national food is a sign of ethnicity, a social manifestation in the same measure as prohibitions or limitations in regard to other types of food. Both one and the other serve as a connecting link for the members of a given ethnic group, simultaneously differentiating it from other groups.

Thus the theme of "national food," "national dishes," that is, the ethnic features in food, should be included in a wider thematic frame, the study of the social existence of food and all its social functions—in the final analysis, food which unites people and divides them. All sorts of customs connected with food and with the methods of its preparation and consumption, beliefs and rites involving food, its reflection in folklore—all of this is engendered not by the material properties of food substances, but by their symbolic meaning as forms of human integration or estrangement....

Clothing

The functions of clothing, like the functions of food, are diverse. Its primary and basic function is the protection of the body from cold and other unpleasant influences of the environment. In warm areas another function of clothing, also primary, is made apparent: the adornment of the body. Both these primary purposes of clothing, while not rooted in the prehuman past, nevertheless have their analogues in the animal world, where one finds a protective thermal covering for the body (hair, feathers) and attractive coloration. But even from the very earliest times there appear other, secondary functions of clothing: gender distinction and social distinction. The latter includes in particular the ritual and cult role of clothing. We must dwell at some length on these derivative but important functions of clothing, for in this specific area we will encounter much which has not been investigated.

First of all, the role of clothing in the earliest stages of its development in the interrelationships of the sexes is far from clear. Evidently, clothing had a twofold significance from the very beginning. First, it is a means of protection from a "sexual taboo" by covering the reproductive organs; second, it is a means of sexual attraction through adornment, emphasizing, and exhibition of these parts of the body. Ethnographies contain numerous examples of both one and the other, and one could scarcely even raise the question of which came first, concealment or exhibition.[8] It is apparent that we are dealing with two inseparable aspects of the same phenomenon, specifically the "ambivalence" in the realm of interrelationships of the sexes: they simultaneously attract and avert each other.

In the course of its development of the sexually differentiating function of clothing, which is bound up with the general social and cultural evolution of mankind, there is displayed a singular tendency: it increases from the start, and later begins to diminish. Beginning with the period of "savagery" and right down to the precapitalistic social structure, and even partly into the epoch of capitalism, clothing gradually becomes more abundant, completely hiding the body. This sometimes occurs even without regard to climate; therefore, it cannot be said that the quantitative development of clothing resulted only from the need for more effective protection of the body from cold. On the contrary, the main purpose here

(or one of the main purposes) was a different one: a stricter upholding of the "sexual taboo," a stricter segregation of the sexes through clothing. Analogues exist in eating, the household, and other domestic spheres, and they are undoubtedly connected with the transition from group to conjugal, and later to polygamous and monogamous marriages with the strengthening of the patriarchal principle in the family and society. Occasionally this urge toward concealment of the whole body led to hypertrophic and cruel usages, such as the obligatory wearing by Moslem women of the unbecoming *paranja* (a veil), which covers the entire body along with the head and face. Parallel to this circumstance, and under the influence of the same causes, there developed an intensification of "sexual dimorphism" in clothing and the growth of its role as a sexual attracter. This was especially so in regard to female attire, where more refined forms began to emphasize femininity and to delineate and reveal to a greater extent the most attractive contours of the body.

But already in the capitalist epoch, as a measure of the general democratization of the social structure and mode of life *(byt)* in European countries, and as a measure of the technical progress which generated more rational forms of clothing, there developed an ever-increasing tendency, exactly opposite to what we have stated: the simplification of clothing and its standardization. To some extent, especially in the most recent times, sexual dimorphism in clothing has diminished; it has nearly disappeared in certain types of professional clothing—among pilots, combine operators, steeple jacks and so forth—where there is already no difference between masculine and feminine clothing. And even in everyday life women increasingly wear pants, jackets, and male hats, blurring even more the differences in masculine and feminine clothing. It is not certain, however, how far matters will go in this direction....

The sexually differentiating function of clothing is only a manifestation of its more general socially differentiating role. Clothing is a social sign, a marker designating the place of a given individual in the social system. Probably as far back as the Upper Paleolithic epoch, and in any case in the Neolithic, the first signs of differentiation within the primordial society arose, though in the beginning only in regard to age: scars on the forehead and other marks of passage in age initiations—marks also signifying perhaps the family, totem, and tribal affiliation of the bearer. From scars, "ineradicable" adornments, to primitive forms of clothing, this process was only the external manifestation of the growing internal stratification of society. Even today the authority figures among the people of Oceania, the leaders and the aristocracy, set themselves off markedly from the rest of the population by their more complete costume. The same holds true in America and especially so in Africa. In accordance with the increasing complexity of the social structure, there was more diversity in clothing corresponding to the various social strata. In Eastern despotisms, ancient and modern, in the European feudal period, differences in the clothing of the nobility

and the commoners, aristocrats, townspeople, and peasants reach their peak. In medieval Europe the peasants often went around in pitiful rags, while the nobility sported expensive and luxurious attire. Everyone was prescribed his own attire; townspeople dared not wear the clothing of the nobility and this was even more true for peasants. The clergy and the military had its own mode of dress. Of course, there were also national differences in costume, and not only national but regional as well. Not long ago, within Breton alone (in France) more than twenty varieties of female attire were counted. Among the Moravian Slovaks in the recent past there were several dozen local complexes of female dress. But all these regional and national differences in clothing were insignificant compared to the sharp class distinctions of clothing.

Clothing in the feudal epoch bound man, so to speak, to his class, his profession, his place of birth, his nationality. It was not just an external mark of all these social and territorial ties of the individual. Clothing itself gave rise to, or intensified, the subjective awareness of these ties. Clothed in the costume of his own class the French nobleman of the seventeenth century acknowledged himself specifically as a French nobleman, and not a Spanish nobleman (let alone a member of the French bourgeoisie). In both the class and national self-perception of this period, clothing played no small role. The well-known expression *čest' mundira* (literally "honor of the [military] coat" or figuratively "honor of the regiment") conveys this very idea. In other words, the socially differentiating function of clothing also has a converse function: clothing unites people of a particular social (or ethnic) status and serves as an integrating factor within a given group, simultaneously differentiating it from other groups.

It is readily apparent that the socially differentiating and integrating function is the basis of ritual and cult clothing, isolating a particular group (or even an individual) which dresses differently from other people. The shaman's costume, so radically different from the everyday clothing of a given people, may play a subjective role, at least in the eyes of the shaman and his adherents, of attracting spirits or frightening them away: it is a bird or a reindeer on which the shaman flies to the spirit world. But objectively the shaman's costume is only the external means by which he is transported from the people of his own environment, underscoring his superiority over them and his separate status. This costume is not necessary for the spirits, but for the people. It is exactly the same with the robes of the priest, the bishop, the Buddhist lama, and the Moslem muhla, whose clothing plays the subjective role of bringing the wearers closer to the god. In fact, this is a means of separating the wearer from the people, of placing him above them. But from another perspective, by distinguishing a spiritual figure from the midst of the larger society, ritual vestments affiliate him with his own estate, order, and profession. These examples show that so-called ritual or cult clothing plays the same role we discussed above—the role of a social sign or marker indicating the affiliation of a person with a certain group and differentiating him from all who do not belong to it.

These differences in clothing, delineating people into groups according to profession, class, country, nationality, and so forth, reached their peak in the epoch of feudalism. This is understandable, since feudalism was characterized specifically by a predominance of heightened corporate authority, the hierarchical subordination of the classes, and the rise of traditional regionalism.

In the capitalistic epoch, and especially in recent decades, there has been, conversely, a standardization of clothing. A primary influence on this process has been simply the penetration of manufactured fabrics and then ready-made clothing into the life of the population, not only in the cities, but in the countryside as well, where this purchased clothing displaced the domestically produced homespun. The growth of a mercantile economy along with the general democratization of everyday life were chiefly responsible for the mitigation of the earlier contrasts in clothing.

On the streets of modern European cities one cannot always distinguish the wealthy banker or manufacturer from the worker or minor official by his dress. Female clothing varies somewhat more, but the differences have more to do with fashion than with the social position of those wearing it. Fashion tends to be an equalizing rather than a diversifying factor. Only spiritual figures, servicemen, and police, and occasionally artists, magistrates, and professors, retain professional dress. National features in clothing are gradually becoming normalized and are disappearing, partially surviving only in a few countries.[9]

In short, clothing is gradually losing its socially differentiating function. It is becoming increasingly difficult to identify a person with a particular class, profession, religion, or nationality according to his clothing. And this is nothing more than an external manifestation of the general growth of social mobility that characterizes contemporary society.

The ethnographer who studies the national or ethnic aspects of clothing must not overlook the more general problem of which this theme is a part. The ethnic aspect of clothing is only one of the manifestations of the general function of clothing as a socially differentiating factor. For this reason interest in the ethnic traits of clothing should not be exhausted by the significance of clothing for the problem of ethnogenesis and interethnic connections, as has occurred among many investigators. No, this interest is broader and more varied: it touches on the general question of the means of uniting and dissociating people, the question of trends in the development of these means, of future limits in the social life of the people.

And finally, there is an even more general and essentially practical question relating to the area of social prognostication: will there come a time—and how can its approach be accelerated—when the forms of our clothing will be determined solely by practical expediency and consideration of attractiveness? When will clothing stop submitting itself to the preposterous whims of fashion and to sanctimoniously philistine prejudices?[10] All of the very feeble and sporadic attempts now being undertaken to reform our clothing, attempts forged by a fear

of deviating from European standards, will come to nothing if ethnographers are not enlisted in this work, or to state it better, if they do not take the initiative themselves in this matter. Ethnography has available an enormous stock of facts attesting to the fundamental experiment of all peoples. This eternal experiment results in clothing which is adapted to the conditions of environment and labor. Among the clothing forms, along with the foolish and antiquated ones, are some which are well adapted to the climate and way of life of the people, and characterized by simplicity and beauty. The supplanting of these national types of clothing by the European urban costume and by fashionable garments can by no means always be considered a fact of progress. In this area there is no end to both scholarly and practical work for the ethnographer.

Dwelling

The third area of material culture which customarily concerns the ethnographer is the dwelling. In the study of the peasant dwelling and agricultural buildings a great deal has been accomplished by our native ethnographers, especially in the modern period. The literature on this subject is extremely rich in other European countries as well. And again, ethnographers, the Soviets in particular, always strive to avoid limiting themselves to the formal description of buildings; they survey the dwelling's social aspect as well: the cooperation and division of labor during construction of a house, hiring of labor, class differences reflected in the dwelling, delineation of the parts of the house in regard to family life, ritual purposes of other sections, beliefs connected with the dwelling—extremely important and altogether ethnographic questions.[11] Even so, they do not reflect the entire depth of the ethnographic approach to the subject.

Like clothing, the human abode fulfills the fundamental function of protection from the external environment, a function fully analogous and even identical to parallel phenomena in the animal world. The Paleolithic cave, the windbreak, and the dugout or hut of ancient man are no different in their primary function from the burrow and den of the wild beast, or the birdnest. But from this generally recognized and elementary fact there follow purely social consequences which reduce the human dwelling to a historical category, wide ranging and highly protean in content.

First of all, even the most primitive human dwelling has a demonstrable influence on human psyche and the individual's perception of the reality surrounding him. The demarcation of the "microspace" (the interior of the dwelling) from the limitless universe is the first step towards the formulation of the understanding of *space* in human consciousness. This circumstance was correctly pointed to by André Leroi-Gourhan who was the first to raise the question of the "domestication" (or "humanization") of space as the first stage in man's cognition of the surrounding world.[12] And this "humanization" of space in

the boundaries of the dwelling, as a "perimeter of safety," was a matter of social rather than individual cognition, and, one must add, not only of cognition, but first and foremost, of social existence. It immediately led also to the practical organization of the microspace—the dwelling. Even in the most ancient remains of dwellings, in the Paleolithic Maltese site investigated by M.M. Gerasimov, for example, traces of the organizational distribution of its parts are apparent; masculine and feminine inventories are found in different parts of the dwelling.[13]

All the subsequent history of the human dwelling may be viewed as the development of these two primary relationships (or two oppositions): (1) the correlation, or more precisely, the opposition of "home" and "everything outside the home,"; and (2) the allocation of the parts of the domicile to its various inhabitants. Both are aspects of purely social relationships and functions within the collective "we."[14] In other words, like food and clothing, the dwelling fulfills a twofold, strictly social function: it unites people on the one hand, divides them on the other.

The opposition of the domestic microspace, that is, the interior of the abode, and the entire outside world, although existing in all stages of human history, varies geographically and historically. It is apparent that the very sharpness of this opposition is a function of some importance, expressing the correlation of time spent by man in his home and outside it. And this importance in turn depends on climatic conditions, on forms of economic activity, on the mode of living, and on various social factors. In hot and warm countries, especially in those characterized by migratory or nomadic ways of life, the man frequently only sleeps in a dwelling, and they do not even always do even that. Almost all of his work and leisure activity takes place outside the home. It is outside that he lights his fire and prepares food. In this case the opposition "home/outside the home" is understandably reduced to a minimum, almost to nothing. The tribes of Australia, and other hunting peoples of subtropical and tropical countries as well, may serve as examples, for they have practically no customs, beliefs, rites, prohibitions, or restrictions pertaining to the dwelling; furthermore there are no beliefs or rites associated with the domestic hearth, nor any family or tribal "fire cults."

The situation is different in the North, where the dwelling plays a materially more vital role and where even in undeveloped hunting, fishing, or reindeer breeding societies it serves as an essential focus of family life. Here the dwelling (e.g. *čum, jaranga, igloo*) as well as the domestic fire, the hearth, and the tallow lamp are objects of various beliefs, prohibitions, and customs. A typical example is the Čukot dwelling, the *jaranga* (a skin tent). In the view of V.G. Bogoraz, all parts of the *jaranga*—the support pole, the covering, the partitions, and so on—constitute a united and entirely interconnected whole. Even during the construction of a new dwelling a sacrifice is made to the support poles, they are rubbed with the blood of a sacrificial reindeer, and this ceremony is repeated

yearly. No part of another dwelling may be brought into the *jaranga* for any reason. Everything connected with the domestic hearth (or tallow lamp) is considered especially sacred. To borrow fire from a neighbor is a paramount sin, as is to place on the fire cookware previously in contact with another fire or even to heat up a piece of meat cooked elsewhere.[15] Parallel customs and prohibitions exist among the Korjaks, Eskimos, and others....

At higher stages of historical development customs and beliefs connected with the dwelling become significantly more complex. But it is characteristic that in some measure the differences in these customs among southern and northern peoples are retained, even within Europe alone. The inhabitant of southern Italy or Greece spends a great part of his time outside the home; the entire mode of life of the village or city is constructed so that indoor life, at least for men, is reduced to a minimum. Not only labor activity, but also the taking of food (in the cafe, or simply on the street), as well as leisure and entertainment occur largely outside the home. Even the architecture of the house is usually such that it is exposed to the outside world through doors, windows, balconies, outside staircases and passageways; so that it is often difficult to see a clear boundary between the interior of the home and the surrounding environs. Conversely, in northern European countries (England and Scandinavia) the dwelling place is always sharply differentiated from the outside world; it is closed off both materially and ethically. The life of the inhabitants occurs behind its walls, and is inaccessible to outsiders. "My home is my castle," says the Englishman. It was in England that the legal concept of the inviolability of the home was developed, and it is most consistently adhered to there.

Along with this geographic factor exist others which are sometimes even more important, such as religious traditions. In many Moslem countries the custom of tightly sealing off the dwelling from the external world was strictly observed, and in some cases continues to be so. The streets and alleys of old Moslem cities and villages are often lined by the blank walls of houses without windows and doors or by the fences of a farmstead. All the windows and doors look out on an inner courtyard, with only a small gate to the street.

But these differences should not be exaggerated. For the vast majority of peoples a home is a home. The opposition "home/outside the home" retains its significance in one way or another for everyone, and manifests itself in diverse customs, laws, norms, beliefs, and rites. Certain unwritten laws of decency impose on an individual separate norms of behavior in his own home and outside it. At home one may not dress as he would in outside company (clothing types are either for staying at home or for going out) or perform activities considered indecent outside it. Not infrequently, certain aspects of a person's character are revealed in the home and family, traits which outsiders would hardly expect. So acts, at times, the psychological atmosphere of "one's own home." Even a religion may draw such a distinction: according to the Talmudic principles of Judaism, for instance,

one may not carry things from place to place on Saturday, (this is *work*), but within the limits of one's own dwelling this may be done.

Another aspect of this same ethic of the dwelling can be discerned in customs pertaining to hospitality. They exist in various forms among all peoples, and in the majority of cases the customs concern the special position of the guest who comes to the home, with the safeguarding of his person, and with his rights and privileges. . . . Even in modern developed countries where many old customs have become a thing of the past, the guest enjoys special rights upon entering a home. He is under the protection of a special moral code, and to insult a guest or drive him from the home is a serious breach of a generally recognized ethic.

The opposition "home/outside the home" is often underscored by additional measures for safeguarding the home as a "perimeter of safety," measures which are not purely material. Besides the locks, bolts, bars, chains, and shutters which bar the access of uninvited visitors, there are superstitious methods for defending the dwelling, even among developed peoples. Magical protective signs are placed on windows, doors, and on the threshold of the home (or by the entrance to the cattle shed or stable). Among such signs are crosses on lintels, either engraved or drawn in with the soot of an Easter candle, a horseshoe nailed by entrances, a magic pentagram on thresholds, window platbands with motifs designed to ward off evil influences. All of these are methods for turning the dwelling into a bastion, inaccessible for thieves and burglars, but also for unclean powers and harmful spells. . . .

Are all these customs, regulations, and beliefs relevant to the dwelling itself as a material construction, or to the human collective dwelling within it? They are relevant to both one and the other. For the ethnographer the dwelling is a dwelling only insofar as someone lives in it (or at least has lived or intends to live in it). The dwelling, just like any other object of material culture, does not exist for the ethnographer outside of its social existence. If this is the case, what is the social equivalent of the dwelling? What kind of human collective inhabits it?

In a class society it is usually a family. Home, household, family are synonymous concepts. The family is an economic unit of society, sometimes a producer, almost always a consumer. Hence the opposition "home/outside the home" is equivalent to the contraposition of the family to the entire surrounding world. The sharper this contraposition, the more clearly the family unit is differentiated in the system of the "folk economy," and the more noticeable is the opposition "home/outside the home." Every manifestation of this dependence is a subject deserving special study.

Here is just one example. In ethnographic descriptions of various non-European peoples who retain features of the communal-tribal structure, we often encounter this particular detail: if one of the village inhabitants is hungry, he may freely enter any hut and take victuals there without asking the owner. In other words, the absence of a sharp differentiation of the family as an economic unit

lessens the inviolability of the dwelling for all outsiders; here the stranger's home is to a certain extent a common home.

What constitutes a family? Along with the conjugal family, which was conceived even within the primordial society, and has now almost everywhere turned into the "small" monogamous family, there has existed (and sometimes even prevailed) during the course of human history the "large family" (family commune) which was obviously preceded by the tribal commune. In ethnographic literature there are numerous examples of the large family: the Iroquois *ovačira,* the Sumatran *sabuax parui* (or *džurai*), the south Slavic *zadruga,* and so on. It would naturally be supposed that the type—or more precisely, the size—of the dwelling occupied by a family would correspond to the type and size of the family itself: a small family would have a small home, a large family a large one. Evidence in some cases comfirms the presence of this correspondence. The Iroquois *ovačira* lived in a "long house," the *džurai* of the Menangkabau people in one communal home. The enormous *izbas* of the northern Russian inhabitants are patently adapted for a large family. But one does not always see such correspondences. Among some peoples the entire tribal or village commune is lodged in a single large house where the individual families have their own area for sleeping. Such a system prevails in certain remote parts of New Guinea and South America. In modern Europe, in the vast buildings of the Lower Saxony or Alpine type and in the large homes of the Basques live the customary small families; extra space is rented to lodgers. One can only suppose that these houses were only built for large families. But in my view, even this is not indicative. Among the Moldavians and some other peoples, owning a large home, one totally unnecessary for the size of the family, has been considered a matter of social ambition. Motivations for building a large home may not even be connected with the size of the family. On the other hand, the south Slavic *zadruga* was often distributed among a few small buildings for married couples, and grouped around a central house with a common fire inside the farmstead. The same is true among the Kxasi tribe in Assam. The failure to take into account such ethnographic data causes the hasty, unreliable conclusions of some archaeologists who formulate hypotheses concerning the characteristics of the family exclusively by the size of the surviving remains of buildings.[16]

No matter what kind of family or other collective inhabits a dwelling, it always has its own structure, and this structure has a material effect on the type of building, the correlation of its parts, the arrangement of furniture, and the function of the various rooms and corners. This aspect of the study of the dwelling is well known to ethnographers and folklorists. We have available detailed descriptions of the organization and purpose of the peasant dwelling's parts; but we still lack broad generalizations and general laws of conformity remaining to be ascertained.

Even a common dwelling, while uniting a particular group of people (the family), dissociates them in some way at the same time. I have mentioned evidence of the division of the dwelling into female and male halves as far back as the upper Paleolithic epoch. This tradition of "division by sex" becomes more intense through time, as is the case with clothing and food. Many non-European peoples even have separate homes for males and females, and there can be no "family" homes in the proper sense. This is the case, for instance, among the Marind-anim of New Guinea[17] and the Palau Islanders of Micronesia.[18] The nomadic peoples of northern and central Asia almost always strictly observe the division of the *yourta* (tent): to the right of the entrance is the female half, to the left the male. At later stages of historical development we often see a sharp division of the dwelling into two halves, one of which, the inner part, was set aside for women with children (the *gynaeceum* in ancient Greece, the *ičkari* or "harem" in the Moslem East).... In Russian society, as in Western Europe, there was no such sharp segregation of the sexes, but there was a strict differentiation of the parts and corners in the *izba*: the *babij kut* (the corner near the stove chimney) and the *čulan* (pantry) were sometimes set apart by a curtain or partition.

Among many peoples the dwelling serves another sexually differentiating feature in its social existence: it is a place of habitation for women more than for men. As the more mobile element, men spend a great deal of time away from home. During work, journeys, and during leisure time in public cafes, taverns, clubs, and so on, the women and children usually stay at home. Domestic comfort is typically a matter of feminine hands and feminine taste.

Along with the sexually differentiating purpose of the separate parts of the dwelling, the delineation of its parts reflects other aspects of family structure (and to a certain extent the public structure). A place is always set aside for the head of the family and for distinguished guests. In nomadic tents this place is along a diameter opposite the entrance and slightly to the left. In the Yakut dwelling it is the *bilrik*, which consists of a platform of planks near the walk diagonally opposite the fireplace. In the Russian *izba* and the Ukrainian and Belorussian *xata,* it is in the "holy" corner, along a diagonal from the stove. Among many peoples, in the nomadic dwellings of Central Asia and Siberia for instance, the degree of honor for a spot depended on its distance from the entrance. The most honored place was opposite the entrance, while servants and poor people took their seats by the threshold. Among some peoples of the Caucusus the most honored place is considered the chair by the wall opposite the fire. In houses with complex layouts divided into rooms (especially in Europe), the apportionment of the rooms also answers to the social hierarchy of the inhabitants. Separate rooms exist for the master, mistress, young couples, workers, servants, and so on.

The chief goal of the comparative ethnographic study of the folk dwelling should be to establish the general laws of the historical changes in the function of the dwelling and its individual parts, and the general tendency in its development. This general tendency should without question reflect not only technical progress and the growth of urbanization (new construction materials, mechanization and electrification of domestic services), but also the general dimensions of the historical process, and above all, the current and future changes in the composition of the family.[19]

Just as we noted changing social differences over time in food and clothing, one would suspect that to an even greater extent the evolution of the dwelling would correspond first to an increase and then to a decrease of social differences in everyday life (means by which such a decrease occurs, whether through cataclysmic revolution or gradual democratization, is another question). Up to a particular moment in the past the differentiating function of the dwelling by sex and class gradually increased. Starting at one point, let us say during the capitalist era and the beginning of widespread democratic movements, both these functions began to die out. This is especially notable in the sexually differentiating function of the dwelling; such differentiations remain only in certain examples of sleeping quarters. Of course, class differences remain in the dwelling, as in clothing and food, and they will remain so long as classes exist. They are even more pronounced here than in clothing and other areas of material culture: the luxurious mansions of American billionaires and the slums of New York's Lower East Side are polar opposites.

In speaking of trends in the future development of the dwelling—and this question is especially important in connection with problems of town building and the planning of new cities and rural settlements—we should pattern our work on a prognostication of the development of the family. Even today in the planning of new homes and living quarters, increasing attention is being focused, especially in the socialist countries, on a number of the earlier functions of the family being fulfilled elsewhere. The increase in public dining, the broadening communal sharing in domestic life (especially in apartment complexes), the expansion of the network of preschool establishments, the growth of collective aspects of sports and entertainment, and youth and other clubs, gradually shatter the hard shell of the family-domestic way of life and at the same time lessen the significance of that "perimeter of safety" which is the dwelling, or was in the past. One would think that future developments will proceed in the same direction and that together with the evolution of the very form of the family, the future dwelling will scarcely resemble the traditional, centuries-old family nest, the bastion of a family way of life based on private ownership.

Summary

In ethnographic research on material culture the chief importance should be attached to its social aspect. It is not material objects as such that should undergo research but their relation to people and particularly human relations as realized through material objects. Objects of material culture serve as a means (a form) both of uniting and of segregating people. Various forms of both these functions are seen in three phenomena of material culture: food, clothing, and dwelling. All these objects carry functions of integration and conversely of dissociation (segregation). But this dissociating function dwindles steadily in the course of history and shows a tendency towards complete disappearance.

Notes for Chapter 4

1. A. Leroi-Gourhan, *Le geste et la parole. I. Technique et langage* (Paris, 1961), p. 210.

2. Marcel Maget, *Guide d'étude directe des comportements culturels* (Paris, 1953), pp. 15, 16.

3. W. Robertson-Smith, *Lectures on the Religion of the Semites* (London, 1907), pp. 345 ff.

4. R. and L. Makarius, *L'origine de l'exogamie et du totémisme* (Paris, 1961); S.A. Tokarev, "Novoe o proisxoždenii èkzogami i o totemizme," *Problemy antropologii i istoričeskoj ètnografii Azii* (Moscow, 1968).

5. Literally "those of the world." The Old Believers *(staroobrjadcy)* repudiated the seventeenth-century Nikonian reforms in the Russian Orthodox faith and adhered to the old rituals which the Church modified. Like many conservative religious groups, they live "apart" from the larger society.—Trans.

6. The term *basurman* is Arabic in origin and signifies "Moslem." Through a Turkic intermediary it entered Russian where it came to mean "infidel" (from the standpoint of an Orthodox Russian).—Trans.

7. See I.P. Korzui, "Pišča i pitanie kolxoznogo kres'janstva Belorussii" [Ph.D. diss.] (Kiev, 1963); V.K. Miljus, "Pišča i domašnjaja utvar' ligovskix krest'jan v XIX–XX vv." [Ph.D. diss.] (Moscow, 1954).

8. See, for example, E. Grosse, *Proisxoždenie iskusstva* (Moscow, 1899), pp. 87–94; E. Westermarck, *History of Human Marriage* (London, 1901), pp. 186–201, 206–12.

9. Cf. A. Leroi-Gourhan, *Le geste et la parole. II. La mémoire et les rythmes* (Paris, 1965), pp. 186–95.

10. The question of fashion as a social phenomenon and the evaluation of its communal and social role in the past and present is a special and very important theme which up to now, unfortunately, has been scarcely touched upon in ethnographic literature.

11. The first to solidly and fundamentally undertake the sociological study of the folk dwelling was Lewis Henry Morgan. In his last (comparatively little-known) work he undertook a survey of the types of family and communal buildings among Indians of various parts of America as an expression of the types of their communal life, and particularly as an expression of traditions of "the communism of domestic life" and of hospitality customs. See L.H. Morgan, *Doma: domašnjaja žizn' amerikanskix tuzemcev* (Leningrad, 1934, pp. 68–69 ff.). [Originally published as: *Houses and House Life of the American Aborigines,* 1881.—Ed. note]

12. Of course, this assimilation of the microspace went parallel to the reconnoiterings of the primordial hunter in the outside world. For discussion of a similar concept, see A. Leroi-Gourhan, *Le geste et la parole, II.,* pp. 139–57.

13. M.M. Gerasimov, "Paleolitičeskaja stojanka Mal'ta," *Paleolit SSSR* (Moscow, 1937).

14. See B.F. Poršijev, *Social'naja psixologija i istorija* (Moscow, 1966), pp. 78–84.

15. B.G. Bogoraz, *Čukči. II. Religija* (Leningrad, 1939), pp. 54–55, 62–63.

16. I have left aside various types of "male domiciles" and other common buildings of the communal-tribal epoch. The length of the essay does not allow a survey of them here.

17. P. Wirz, *Die Marind-anim von Holländisch-Süd-Neu-Guinea,* Bd. I (Hamburg, 1922), pp. 41, 79, 92; Bd. II (Hamburg, 1925), p. 178.

18. K. Semper, *Die Palau-Insel im Stillen Ozean* (Leipzig, 1873), pp. 51, 75, 318.

19. I am limiting myself here to the study of the individual dwelling. Of course, the dwelling almost never exists in isolation, and we must investigate all aspects of the grouping of buildings. And sometimes the boundary between an individual dwelling and a complex of dwellings is almost imperceptible, an example being the Pueblo Indians of the southwestern United States. But this question requires a separate study.

(Wendy Rogos, Courtesy of Humanities Division, Penn State-Capitol Campus)

Part III: Dialogues on Analytic Approaches

Contributors to this section employ various approaches to, or "ways of thinking" about, material culture and folklife study. One important way of thinking about the folk artifact is to treat the object as one would a text. The researcher isolates many versions of an object to make historical or geographical comparisons. The object's formal features—its shape, dimensions, texture, for instance—are read for clues to diffusion and use. Classes and categories based on *similarities of objects* are then constructed as an aid to interpreting the repetition and variation of artifacts.

Another basic way of thinking ties objects to people or places. The setting or maker of the object becomes the central concern. If you document all the folk artifacts of an area, for example, you can organize the findings into patterns of form and function. Practitioners of this method, especially cultural geographers, thus map cultural areas of folk regions. Sometimes ethnographers seek smaller units than the region for studies of folk patterns and social structure. They commonly choose a community or neighborhood. Recently, some researchers have claimed that specific events are so complex, that they deserve separate treatment. So we find analyses of the social use of objects in one particular ceremony, festival, or transaction. The event as well as the place can be a setting.

When objects are tied to people, consistency of use and function within a group is often stressed. It is common to find work on Afro-American art, for example, to draw attention to Blacks as a folk group. Ethnic and religious categories also abound. Find a number of people with an interest in common, whether occupational, ethnic, generational, or regional, and you have a basis, according to researchers using this model, for determining the nature of cultural pluralism.

Others argue that an individual is not merely a member of one group, but has multiple identities that are expressed differently in different situations. Hence, a model is often used that examines expressive *variations among individuals*. Life histories are taken, actions are observed, motivations are described. The researcher might interview one craftsworker in depth to learn the personal story behind the creation of objects. If effective, the researcher will

reveal aesthetics, symbols, and values embedded in the making and apprehension of objects.

Thomas A. Adler provides an example of a concern with individual experience in material culture. In his essay he plies a "phenomenological" approach. He examines the experiential element in the use and performance of woodworking tools and musical instruments. He goes on to question the impact of this approach on fieldwork and analysis. At the core of the ensuing discussion with the commentors is the sensitive issue of the observer's role in investigating the observed, or whether the distinction is valid; for what happens when the observed is the observer? Going further, how can we judge our objectivity, since whenever we observe and document an object or event we bring certain biases and standpoints to bear on the analysis?

Elizabeth Mosby Adler follows by reporting her research on the experiences of people with one particular class of objects—the pie safe—and she adds a linguistic model to elucidate formal aspects of the pie safe's appearance and usage. Underscoring the change in function of objects over time, and that such change profoundly influences the conception and apprehension of the objects' meaning, she traces differences among different groups of people in their use, and attitudes toward, the safes. Although recognizing the significance of experience in folk artifact analysis, her commentors wonder whether quondam comparative questions stressing textual similarities are not, after all, crucial to answer first if one is to explain material culture.

Warren E. Roberts is also concerned with the role of the individual in material culture, but in his investigation of "folk art" he employs what he calls a "folklife research" approach based on a European ethnographic model of study. Specifically, he contrasts his findings on the social role of the stonecarver to Roger Welsch's conclusions about the woodcarver in another region. Welsch comments on Roberts's findings, but the task of critically evaluating Roberts's folklife research methods is taken up by Michael Owen Jones. Jones distinguishes the folklife research approach from a behavioristic conception of "folkloristics," which he finds more tenable.

A form of cultural analysis which may qualify as the cynosure of the 1970s in folklore scholarship is performance-centered theory. Bernard Herman presents a performance-centered approach to a study of historic architecture, and he supplements the typically synchronic analysis of performance with a historical assessment of cultural and architectural change. His essay follows on the heels of Roberts's remark that performance-centered approaches are applicable to oral folklore genres but are inappropriate for material culture research. Is Roberts right? And what other challenges can be put to the "architecture as performance" advocates? Dell Upton and Tom Carter have surveyed architecture extensively in Virginia and Utah, respectively. With their experience in mind they assess the sticky question of applying a theatrical metaphor to inactive objects.

In the dialogues the reader can detect basic differences of assumptions and presuppositions, indeed of philosophies of cultural analysis which characterize much of the recent work in material culture and folklife. Such interchanges are meant to impel readers to evaluate the arguments and ideas presented. Draw comparisons to your own observations and experiences. Look for the rationales and justifications of the standpoints presented.

Further Reading

For critical literature on analytic approaches to the study of material aspects of American folk culture, consult Simon J. Bronner, "'Visible Proofs': Material Culture Study in American Folkloristics," in *American Material Culture: A Guide to Current Research*, ed. Thomas Schlereth (Lawrence: University Press of Kansas, 1985); Richard M. Mirsky, "Perspectives in the Study of Food Habits," *Western Folklore* 40 (1981): pp. 125–33; Henry Glassie, "Folkloristic Study of the American Artifact," in *Handbook of American Folklore*, ed. Richard M. Dorson (Bloomington: Indiana University Press, 1983), pp. 376–83; Norbert Riedl, "Folklore and the Study of Material Aspects of Folk Culture," *Journal of American Folklore* 79 (1966): pp. 557–63; Simon J. Bronner, "Concepts in the Study of Material Aspects of American Folk Culture," *Folklore Forum* 12 (1979): pp. 133–72; Henry Glassie, "Structure and Function, Folklore and the Artifact," *Semiotica* 7 (1973): pp. 313–51; Henry Glassie, "Meaningful Things and Appropriate Myths: The Artifact's Place in American Studies," in *Prospects 3*, ed. Jack Salzman (New York: Burt Franklin, 1978), pp. 1–49; Thomas Schlereth, ed., *Material Culture Studies in America* (Nashville: American Association for State and Local History, 1982); Harvey Green, "Exploring Material Culture," *American Quarterly* 32 (1980): pp. 222–28; Michael Owen Jones, *The Hand Made Object and Its Maker* (Berkeley: University of California Press, 1975); Michael Owen Jones, "The Study of Folk Art Study: Reflections on Images," in *Folklore Today: A Festschrift for Richard M. Dorson*, ed. Linda Dégh, Henry Glassie, and Felix J. Oinas (Bloomington: Research Center for Language and Semiotic Studies, Indiana University, 1976), pp. 291–304; Kenneth L. Ames, "Folk Art: The Challenge and the Promise," in *Perspectives on American Folk Art*, ed. Ian M.G. Qumby and Scott T. Swank (New York: W.W. Norton, 1980), pp. 293–324; William N. Fenton, "The Advancement of Material Culture Studies in Modern Anthropological Research," in *The Human Mirror: Material and Spatial Images of Man*, ed. Miles Richardson (Baton Rouge: LSU Press, 1974), pp. 15–36; Austin Fife, "Folklore of Material Culture on the Rocky Mountain Frontier," *Arizona Quarterly* 13 (1957): pp. 101–10; Ants Viires, "On the Methods of Studying the Material Culture of European Peoples," *Ethnologia Europaea* 9 (1976): pp. 35–42; Jules David Prown, "Mind in Matter: An Introduction to Material Culture Theory and Method," *Winterthur Portfolio: A Journal of American Material Culture* 17 (1982): pp. 1–20.

Simon J. Bronner

Musical Instruments, Tools, and the Experience of Control

Thomas A. Adler

The Need for Perspective

It is no longer too radical a move for folklife researchers to try to cope with the more subtle aspects of traditional material culture. We are beginning to get a good idea of the distribution of folk houses on the land, and we can mostly agree about how baskets are made, bread is baked and quilts are put together. We are now in need of some perspectives that can help us to elicit and generalize about the traditional meanings that underlie and are embedded in traditional artifacts. The hardest core of meanings to get at may be those that arise directly from the phenomenal stream, from the actual experiences a person has with an object.

The study of such experiences necessarily involves the taking of an internalized view. In conducting a phenomenological investigation an analyst sets aside the referential knowledge he already has and momentarily divests himself of his memories of an object, recognizing crucial distinctions to be made between direct experiential knowledge, the memories of experience, and referred knowledge from others.[1] Whether or not historical and personal knowledge can actually be set aside is a moot point; the phenomenologist makes the attempt, because experiences are by their very nature things of the here and now. All we have, experientially speaking, is the present, and each moment of our experience is filled, in part, by material presences that are loci of denotational and connotational meaning. If we can create an appropriate language in which to speak of the ways we all experience artifacts, we may be able to add discussion of the significance of objects to descriptions of their distribution and construction.

Experience and the Artifact

Provisionally, at least, an experience can be defined as a mental event consisting of data perceived and ordered by a mind and assimilated to the intricate patterns of knowledge already manifest in that mind. Our experiences may stem from either external data—the events of physical, cultural, and biological existence— or internal data—the events produced by the mind and reintegrated with the cognitive system as a whole. Our experiences, taken *in toto,* presumably form the basis of all knowledge; they are the mind's own first-order integration of the raw data of perception and reflexive cognition.

The experiences that come from encounters with traditional artifacts, including those of importance to me—musical instruments and woodworking tools—can be analyzed into a series of discrete types and levels. The lowest imaginable level of experience in a simple quantitative sense would be no experience at all. The object in such cases lies completely outside the individual's epistemology. This is a level that is common indeed; there are many of us, and not all of us have knowledge of all the types of artifacts that manifest traditional values or forms in our own culture.

The transition to higher levels of experiential involvement with an artifact is usually irreversible. From a state of no knowledge one might first come to know a traditional artifact referentially through indirect reports or simulations. Such referred knowledge typically takes the form of communications about the artifact; in every instance of referential knowledge the information conveyed to the individual has been selected and reduced by another person. Such reduction is also describable as mediation,[2] but a person may feel he has a profound knowledge of a given type of artifact, even though it all has come to him referentially. We may have been told in classes about Creole houses, or seen pictures of pie safes, or listened to the personal experience stories of others that center on unfamiliar traditional artifacts.

Referential knowledge about an object is, of course, insufficient as a basis for achieving the same order of understanding achieved by those who actually bear the tradition and use or make the objects of our interest.[3] An object is traditional only to the extent that it arises in, and functions for, a definable folk group. We do not usually define tradition so as to include those who have learned about making quilts solely from magazine articles. We are happier if our informants tell us they learned about, say, traditional paper cutting from stories told by the grandmother, since oral communications are our stock in trade. But as long as the artifact is only referentially experienced, the distinction between direct face to face communications and mass communications is of dubious importance. Both the oral account of an object and the published photo of it are mediated; they are both, therefore, experientially less direct than an actual encounter with the artifact.

The next level of experiential involvement could be that in which the individual actually encounters the traditional object for the first time. Normally this means the object is seen, but it might also be significantly encountered by being felt, held, hefted, smelled, tasted, balanced, or touched. First encounters are unquestionably of special significance. Warren Roberts, for instance, has pointed out a large group of personal experience narratives in which first encounters with objects form the unifying framework of discourse.[4] In most such cases, the individual's story highlights an incident of cognitive dissonance, in which the unfamiliar object's significance is misconstrued and later redefined by the experience of encounter.

The first encounter with an artifact may occasionally constitute what some humanistic psychologists have called Minerva experiences.[5] Minerva experiences are those which ramify and shape the development of an individual's own language of thought. They are of crucial importance in the cultural and social development of individuals, since they are seen as the heightened incidents which specifically and directly define and redefine personality. It may be that a good many of the most important positive experiences an individual has in his life are Minerva experiences. It seems worthwhile to note here that many folkloric experiences are at least potential Minerva experiences; I would suggest, for likely examples, those experiences that inspire the passive bearer of a tradition to become an active bearer.[6] Many people involved with traditional artifacts are able to clearly remember and recount in great detail the circumstances in which they first encountered the artifact that changed their lives. A good number of bluegrass musicians have told me of their first exposure to a five-string banjo or flat-back mandolin; their accounts show both the characteristic intensity of Minerva experiences and concomitant inability to clearly articulate the emotional turmoil felt at such times. One often hears something like the following: "Man, I was so excited when I heard that banjo, I thought I'd explode! I knew right then and there I had to play one."

It should be noted that the first encounter with an artifact, as well as subsequent encounters, may present the artifact either in or out of its functional context. In those cases where the object is met in a state of functional isolation, the experience is usually not profound. Typically, all that happens in such cases is the formation of an association between an artifact's name and its general appearance. "Oh, so that's what a zax looks like," we say, seeing one for the first time in an outdoor museum's display of slate-working tools.

A higher level of artifactual experience would bring together the individual and the traditional object in its functional context. We may truly begin to feel we know about a traditional tool after we have seen it being used and appreciated by another person. The object that has a specific use must be experienced in use, if we are to have any sort of reasonable understanding of it. The object in use is an experiential whole; the object unused is not a significant presence for those who would study viable conduits of material culture tradition.

Objects studied by material culture researchers are not all of equivalent types. Some artifacts present themselves in ways that demand a human user or interpreter, who will interact functionally with the object and explicate its design principles for the onlooker. Other artifacts may be capable of being significantly experienced by a lone observer; the artifacts that seem free of the need for a functional context are those that are appreciated as aesthetic or artistic objects.[7] A painting is experientially appreciable all by itself. Its frame even serves to cut it off from its immediate physical context—the context of viewing—to ensure that one's experience with the painting is focused on the painting itself. No frame exists around a woodworker's plane, however; though it may or may not be a well-designed plane, the emotional appreciation of its existence cannot be complete until the viewer has seen and internalized the functional linkage that unites a man, a plane, and a piece of wood held in the vise.

The opposition presented here between aesthetic and nonaesthetic objects is, of course, not absolute.[8] Artifacts exist in a continuum ranging from practical utility to design integrity, and the experience of both is subject to individual variations in interpretation. But in all cases the need for contextual encounters with traditional artifacts is paramount. We understand all objects better if we see them presented as their designers intended, and we can be sure about our reading of intention if the designers tell us themselves; the post facto reconstruction of intention is a precarious game indeed.

The last sort of involvement with traditional artifacts that falls within my system of experiential levels is that in which an individual encounters artifacts and uses them to engage in culturally coded systems of expression. Expressively useful artifacts form a large group, including two special categories of personal interest to me: musical instruments and woodworking tools. Such artifacts offer a possibility for human experience transcending that provided by most other objects, for they can actually enable the realization of expressive culture. A bluegrass banjo is more than a designed object, more than a vehicle for showing off the builder's inlaying technique and good sense of balance. It is even more than a device for making sounds that resonate for so many microseconds at so many cycles per second. It is a tool for musical expression, and its function as a tool encompasses and supersedes its other functions, all of which could be relegated to referential or mediated forms without doing great violence to the phenomenal experience of the object.

One can see photographs of banjos that reveal their design features; the weight and size and shape and decorative details of a banjo can be written down and printed, or circulated through a group orally. Even the music produced by a banjo can be simulated or recorded with great precision. But a record of banjo music is a different sort of artifact indeed than a banjo itself. The record has little expressive potential; it is an encoded simulation, a mediated message made concrete, whereby sounds much like those that come from a banjo can be played

or not played. The record is not usually a means whereby such sequences of sound can be generated, selected, transformed, and reordered in an aesthetically meaningful way. Only a banjo can actually enable banjo music, and then only in the hands of a human agent who has acquired a traditional or idiosyncratic competence (fig. 5-1).[9] Since the production of the intangible sonic object we call "instrumental music" requires both the human agent and the instrument, it seems reasonable to suppose that the two will stand in a special experiential relation to each other. Clearly, each competent banjoist experiences a continuum of relationships to the instrument. Artifacts exist in both categories and, experientially, in individual instances; so there will be at least three experiential levels of specificity: I can phenomenally interact with, first, my banjo, which is so well known to me as to almost have a personality of its own; second, with other banjos and types of banjos I have routinely played; and third, with all others of the same categorical type, including those that I have never seen but which I may be competent to play.

The banjo has an expressive potential that is realized when a banjo player uses motion to impose order on time. Similarly, a woodworker's plane has an expressive potential, but it is realized when the woodworker uses motion to impose order into space (fig. 5-2). The plane is much less rich than the banjo in terms of its immediate articulatory possibilities; one can only adjust the blade up and down, open and close the throat, and go with, across or against the grain. The plane is designed to ensure a predictable outcome, to a certain degree; so is the banjo, in the sense that the frets are correctly spaced and the strings properly tuned. Both the banjo and the plane, however, are employed in expressive systems that are capable of infinite combinational complexity. The banjo gives its player a wider range of articulatory choices and an obligation to make them quickly in the course of performance. The plane gives its user a narrower range of articulatory choices, but allows, in theory, infinite time in which to make them.[10] From an experiential point of view, in the frame of reference of the competent user, both planes and banjos are enabling instruments in expressive systems that are satisfyingly rich in artistic possibilities.

The most profound and sensitive experience of instrumental artifacts—those that enable expressive communication—is only available to those who attempt to engage those instruments in expressive acts. The consequences of this conclusion are profound, indeed, for folklorists, curators, and other scholars who would deeply understand traditional instrumental tools. If we are to understand the experiences of traditional users of banjos and planes, we must be willing to explore those experiences in the only way that is experientially possible: by ourselves.

As a banjo player and occasional woodworker, it seems clear to me that the experiences of playing a banjo or guiding a plane are special experiences of at least partially conscious control; in general, control experiences are all those in

Figure 5-1.
Ralph Santinelli Playing Banjo.
Binghamton, New York, 1973.
(Simon Bronner)

which a person must feel a strong sense of being in or out of control of an expressive object. The individual, having established a connection between material and mind by allowing an encounter with the instrument in its functioning context, first explores and builds an understanding of workable control principles, often (but not always) with the aid of traditional lore or instruction. Then he reverses the process, exerting mind on material to reach other minds in affective as well as rational semantic ways. The instrumental control experience makes it clear that the person engaging an instrument is one part of a cybernetic loop. We cannot forget that our analytic system encloses not just the banjo and its music, or the plane and the smoothed board, but also the mind that uses one to express the other.

The feelings that an individual has while he is in articulatory control of an instrument are the whole point here. A bluegrass banjoist does not just hear his own music; he will sense the weight of the instrument, the feel of steel and plastic picks sliding over steel strings, the resistance of each string as it is plucked. He feels, in a way that does not translate well into speech, a link between the kinesthetic movements of his own hands and the resultant sound, which was intended sound both before and after it became realized. The rhythm, pulse, and syncopation that characterize the emergent music will also have been experiences as rhythmic motions and pressures which play important feedback functions into the physiological processes of musical execution. There is no unambiguous way to say how it feels to play an F-chord or a thumb-lead forward

Figure 5-2. Floyd Bennington Carving a Caged Ball
with Pocket-Knife and Carving Tools.
Dubois County, Indiana, 1979.
(Simon Bronner)

roll. But there is a good deal of evidence to suggest that the experience is a
phenomenologically important one for those who undergo it. It feels good to play
bluegrass music on the banjo, and not all the goodness is attributable to the
aesthetic worth, to anyone, of the sound that results. The pleasures arising from
social and musical interactions with others are likewise insufficient as an
explanation of the bluegrass banjoist's motivation. The feeling of attempting to
exert control over an instrument is pleasurable in and of itself. The production of
artworks in tradition always involves the selection, transformation, and ordering
of elements in an abstractable set.[11] While playing a banjo one moves into a
created universe of synthetic or virtual time, a universe in which our perception
of time itself is mysteriously altered from the classical Heraclitean model of a
river, flowing smoothly and unalterably by, to an experiential happening that
arrives in conceptual and articulatory bursts. Manipulating virtual time

phenomena, a selection of musical elements is made from a traditional vocabulary; if the transformations and reorderings are not incompatible with traditional tolerances, then the sounds produced are heard as music. The same sounds, heard by the musician, are simultaneously an aesthetic message to others, feedback data for competent execution, and a phenomologically appropriate statement of what it felt like to play it.

Clearly, a scholarly interpreter who would speak of bluegrass banjos or traditional woodworking tools or any other traditional instruments is on the strongest possible ground if he can bolster his referential and mediated knowledge with the knowledge gained from actually trying to engage instruments in expressive acts. He needs to do not only fieldwork, but artifactually involved fieldwork. It is certainly not necessary that we all become great performers, but it is essential that we pay attention to the importance of experience as a force operating on tradition. That can best be accomplished by recognizing our inevitable personal involvement with our objects of study.

Notes for Chapter 5

1. For discussions of phenomenology's relations to time and history, see Edmund Husserl, *Cartesian Meditations: An Introduction to Phenomenonology,* translated by Dorion Cairns (The Hague: Nijhoff, 1960), pp. 33–43; Donald M. Lowe, "Intentionality and the Method of History," in *Phenomenology and the Social Sciences,* ed. Maurice Natanson (Evanston: Northwestern University Press, 1973), pp. 11–14; C.D. Keyes, "Art and Temporality," *Research in Phenomenology* (1971), pp. 63–73.

2. Claude E. Shannon and Warren Weaver, *The Mathematical Theory of Communication* (Urbana: University of Illinois Press, 1964).

3. See Henry Glassie, "At the Mouth of a Cavern Measureless to Man: Intention in Folk Production" (Paper read at the American Folklore Society meeting, 1970, Los Angeles), p. 3; idem, *Folk Housing in Middle Virginia* (Knoxville: University of Tennessee Press, 1975), pp. 13–18.

4. Roberts noted the special impact of new foods and new types of vehicles on humorous narratives and traditional proverbs in folklife lectures given at Indiana University, Bloomington, 9 February 1972.

5. Herbert A. Otto, "The Minerva Experience: Initial Report," in *Challenges of Humanistic Psychology,* ed. James F.T. Bugental (New York: McGraw-Hill, 1967), pp. 119–24.

6. See Carl W. von Sydow, "On the Spread of Tradition," in *Selected Papers on Folklore* (Copenhagen: Rosenkilde and Bagger, 1948).

7. Robert P. Armstrong, *The Affecting Presence: An Essay in Humanistic Anthropology* (Urbana: University of Illinois Press, 1971), pp. 3–11.

8. I find Henry Glassie's suggestion that any artifact is "art to the extent that it is an expression of an intention to give and take pleasure" particularly appropriate to this essay. The quote is from his "Folk Art," in *Folklore and Folklife: An Introduction,* ed. Richard M. Dorson (Chicago: University of Chicago Press, 1972), p. 253.

9. I have explored the specific notion of instrumental competences in "The Acquisition of a Traditional Competence: Folk-Musical and Folk-Cultural Learning Among Bluegrass Banjo Players" (Ph.d. diss., Indiana University, 1979), pp. 11–15. For a basic statement on competence, see Noam Chomsky, *Aspects of the Theory of Syntax* (Cambridge: M.I.T. Press, 1965), p. 4.

10. The banjo and the plane exemplify several additional systematic contrasts in their possibilities for instrumental expressiveness. For example, the banjo creates by addition, the plane by subtraction; the product of one is ephemeral, the other enduring. Still, the expressions formed through any instrumental system reveal deep regularities in cultural, community, and personal styles: cf. Armstrong, *The Affecting Presence,* section on "Trope," pp. 64 ff.

11. Larry Gross, "Art as the Communication of Competence," *Social Science Information* 12 (1973): pp. 115–41.

Comments

The Most Important "Thing"

Adler and I part company in his opening paragraph when he suggests that adequate folklife collections already exist. No genres of oral tradition that are adequately collected throughout an entire community and some aspects of folklife cannot even boast even preliminary collection. True, regions such as the Ozarks and states like North Carolina are extensively represented in published collections but, even here, coverage is spotty and, in most cases, merely a compilation of survivals. Most states, however, are like North and South Dakota, Montana, Wyoming, and Nevada—they are not represented even by a badly printed collection. Despite Adler's statement that we have a "pretty good idea of the distribution of folk houses on the land," the truth is that we only know about their distribution in certain regions, not in all.

One reason many folklorists downplay collections is that they find them inherently unscientific; for them theory is a sacred cow and the opposite of "mere fieldwork." They view the discipline of folklife as an inferior field of study that needs to be made important by hypothesizing, a lack they often attempt to fill by speculating on the basis of faulty collections. Adler certainly does not go that far but he does suggest that up until now no one has considered the ways in which informants regard and shape their lore, or how they feel about the items with which they create and pass on their traditions. Any good collector seeks texts and "the traditional meanings that underlie" them. Even such an early figure as Henry Rowe Schoolcraft (1793-1864) tried to elicit, albeit in an elementary way, such data.[1]

My concluding remarks are restricted to one of Adler's suggestions I consider particularly erroneous: the idea that one cannot do good fieldwork unless one performs. That is like arguing that one cannot be a good cancer specialist unless one has cancer. There are, of course, some instances where the only way to elicit folklife data is by demonstrating or performing. In certain circumstances those who play the banjo may be the only persons able to collect from specific traditional banjoists. But, of course, the reverse is also true; many

situations arise when performing gets in the collector's way. On these occasions the fieldworker who is not a performer has the advantage over those who are. The point is that each person brings a unique perspective to recording folklife and there is hardly any perspective that is not useful and successful in certain circumstances. Likewise, there is no perspective that is always successful.

Adler does a good job of pointing out that there are many levels of meaning that informants have regarding not only folklife but items associated with those traditions. Adler also demonstrates that it is not always easy to get at the several types of meaning involved with any folklore item. Too often those outside folklife, and sometimes those in the field, assume that a text is just a text, a basket is just a basket, a fiddle tune is just a fiddle tune. Once you have seen or heard one you have seen or heard all. Recently I participated in a panel at a regional meeting where a representative of a university press that has published numerous folklore volumes made exactly this assertion. Perhaps superficially items are identical, but it is the "personal involvement" that Adler mentions which makes them different.

Finally, Adler correctly calls for collectors to record not only bits of lore but also the attitudes that informants have about them. Good fieldworkers have always paid attention to such matters, but the point cannot be overemphasized. Nevertheless, there is one concept that must be kept in mind: experiences and attitudes toward folklore should never become more important than the lore. To slightly revise an oft-quoted line: the text is not the only thing, but it is the most important thing.[2]

W.K. McNeil

Notes

1. For further discussion of Schoolcraft and his methods, see Rosemary Zumwalt, "Henry Rowe Schoolcraft, 1793–1864: His Collection and Analysis of the Oral Narratives of American Indians," *Kroeber Anthropological Society Papers*, Nos. 53 & 54 (1978), pp. 44–57; W.K. McNeil, "History of American Folklore Scholarship Before 1908" (Ph.d diss., Indiana University, 1980).

2. See, for example, D. K. Wilgus, " 'The Text is the Thing,' " *Journal of American Folklore* 86 (1973): pp 241–52.

Phenomenology and Folklife Research

The underlying premise of phenomenology—and it is a premise to which Thomas Adler gives many signs of support in his essay—is that experience is the best teacher. Despite the proverbial strength of this assertion, we continue to prefer the opinions of the criminologist to those of the criminal, the chronicles of the historian to the memoirs of the General, and the analysis of the psychiatrist

to the proclamations of the patient. To be sure, we sense a special quality of learning embedded in personal experience, but that quality has not diverted cultural scientists from investing most of the last century in the perfection of experimental, interview, archival, observational, and other nonparticipatory methodologies. The literature of participant-observation is an exception to the rule just stated, but even here, participation is valued for the point of view it affords the observer, not for its intrinsic value in the research.

That personal experience has earned scant official endorsement in the study of human culture, folk or otherwise, is a fact. Although the explanation for this neglect may partly reflect the celebrated unwillingness of academic investigators to grapple with reality, this criticism is too easy. Other, more substantive concerns are operating. Susanne K. Langer in *An Introduction to Symbolic Logic* points out that there are two different kinds of knowledge.[1] She calls these "knowledge of" and "knowledge about." A baby crawling around on the floor of its nursery may very well have the most intimate, complete, particular knowledge *of* that room. The ethnographer who observes the room, the baby behavior's in it, and the systematic relationship of the room to the rest of the house and the other people who live there also apprehends a substantial body of knowledge, but it is knowledge *about* the room.

The two kinds of knowledge are derived by different means from different perspectives and are fundamentally different with regard to that central matter of epistemological concern, communicability. Thus the baby's knowledge of the room communicates by the inferences that adult observers may draw from the sign characteristics of the child's behavior, or perhaps by figurative expressions made in recollection after the child has achieved full use of language. The ethnographer's account of the room, on the other hand, is subject to immediate denotative transcription which, despite inevitable moments of imprecision, is capable of being tested against the knowledge other ethnographers might derive in the same way from the same room. It is, in short, *public* knowledge, and this is, in one word, why it is cultivated by the scientific community to the neglect of knowledge derived from subjective experiences. As Adler himself points out, "There is no unambiguous way to say how it feels to play an F-chord or a thumb-lead forward roll," and if there is one overriding aspiration of scholarship, it is to eliminate ambiguity.

It may be, however, that scholars of the social-scientific persuasion have been so assiduous in eliminating the ambiguity from their work that they have nearly succeeded in eliminating reality as well. This complaint, long voiced by the layman, is being heard more and more from persons whose credentials cannot be ignored. The authors of the excellent book *Unobtrusive Measures* discuss the insidious way in which the search for methodological refinement ("operationism") has preempted the search for truth in social science.[2] In short, the study of human culture now rests on the horns of a dilemma: on the one side—ambiguity, on the other side—irrelevance.

In Adler's essay, he turns our attention to a way to get off these horns. With special reference to the participant-observer methodology, he calls upon us to pay long overdue attention to what one might learn *as* a participant, rather than to what one might learn *because* participation provided a front row seat for the observer. In other words, Adler would have us use our knowledge *of* a given cultural setting to improve the quality of the knowledge we have *about* it. It is both a dangerous and powerful idea.

The danger is that the sensation of forming an F-chord, so to speak, may come to be viewed as an element of scientific knowledge just because the musician is also a social scientist. On the contrary, the personal experiences of a fieldworker remain personal experiences even when they are later recollected in print between hard covers. Because these recollections may be characterized as knowledge *of* cultural phenomena, they remain of little interest to the scientific community. What is of interest, what can be communicated in the language science speaks, and what the world waits to hear, is a testable statement that names a feature of experience common to, say, bluegrass banjo players and asserts that feature to be important to these musicians for certain reasons and to a particular degree. But how does the fieldworker make the transition from experiencing the heft of the instrument, the texture of the instant when pick meets string, the antagonisms that emerge in rehearsal, the glare of the stage lights, from, in fact, all the myriad ripples, waves, eddies, and channels of the phenomenal stream to the writing of meaningful ethnographic statements? This is a territory that needs to be carefully mapped if those of us who are persuaded by Adler's argument are going to do more than replace one sort of irrelevance with another.

The power of the idea emerges when we consider that an ethnographic account is the product of a complex effort to relate the living concerns of one group of people to the professional concerns of another. The process has a beginning, a middle, and an end, and just as there is danger in mistaking the beginning for the end, there is an enormous advantage in gaining a good beginning. This advantage is realized when the fieldworker who is also a participant uses his knowledge *of* the cultural setting to choose the most promising and significant issues for investigation. An understanding of the principles of phenomenology will provide this fieldworker with both the disciplipne and the heightened sensitivity needed to exploit the moment of experience for all of its value as a guide to fundamental, worthwhile issues. These he must still explore with the familiar tools—interviews, questionnaires, observation, archival record analysis, physical trace surveys, and experimentation. The phenomenological approach offers no short cuts for our trade. What it does do is consciously, confidently, bring into the cultural sciences a role for inspiration born of real experience. A more powerful or a more needed addition to the armamentarium for the study of culture can scarcely be imagined.

Gerald E. Parsons, Jr.

Notes

1. Susanne K. Langer, *An Introduction to Symbolic Logic* (rpt. ed., New York: Dover Publications, 1967), p. 22.

2. Eugene Webb, Donald Campbell, Richard Schwartz, Lee Sechrest, *Unobtrusive Measures* (Chicago: Rand McNally, 1966).

Reply: The Dimension of Phenomenal Experience

I am happy to note and declare my general agreement with the critical suggestions of W.K. McNeil and Gerald E. Parsons. Each of these commentors augments and refines the thrust of my argument in useful ways. Still, I must correct minor misinterpretations of my thesis.

For example, McNeil evidently read my opening paragraph as a polemic against the collection of folklife. In fact, I am a strong supporter of the varied efforts and techniques of serious folklife collectors (past and present), and would agree that most regions and genres are still almost criminally under-collected. My point was that a dimension of traditional meanings exists which is not only ignored by most collectors and theorists, but which is also in principle *impossible* to elicit from others. Parsons clarifies this point by bringing up Langer's term to label the dimension of which I was speaking: "knowledge *of.*"

Moreover, I did not try to claim that "knowledge *of*" a traditional instrument or expressive genre constitutes a technique which should be required of all good fieldworkers; as McNeil notes, almost all perspectives can be useful and "successful." But a phenomenological dimension of artifactual meaning is not communicated by other people; it comes only to those who consider phenomena (like the experience of instrumental objects) directly, and it may help the folklorist in unforeseeable ways when he does go into the field. Certainly performing can get in the collector's way if it is indiscriminately done in the presence of an informant or potential informant. But if a fieldworker can himself experience the phenomenal relationship to an object which is indispensable to some genre of performance, he may be able to use that "knowledge *of*" to explore and question other informants' "knowledge *of*" and "*about*" the performance.

As Parsons also points out, the problem of using phenomenologically derived insights remains. We need to translate our own experiences of traditional performance into "testable statements" which identify hitherto unnoticed features of experience. The feature that seems central to me is control experience. The artifacts which can be called "instruments" in any sense enforce a strong feeling of control, testing and altering the limits of control or feeling secure in the reenactment of venerable control techniques. I would suggest again that the experience of control is a basic (though not necessarily a universal) phenomenon, and that the pleasure we feel during control experiences is

independent of the expressive output. Perhaps it is the pleasure of attempted control that keeps the incompetent beginner satisfied with whatever results he can achieve.

In any case, the recognition of a dimension of phenomenal experience provides, as Parsons says, "no short cuts." It rather places even greater demands on all types of cultural scientists; folklorists can use such a recognition to help make the leap from their own imaginable but unspeakable experiences with tradition to ideas which can be clearly named and examined. In so doing, folklorists will not be abandoning a discipline of texts, but rather supporting it in a philosophically critical way.

Thomas A. Adler

"My Mother Had One of Those": The Experience of the Pie Safe

Elizabeth Mosby Adler

History and Definition

Of increasing importance to folklife researchers in recent years is the consideration of an artifact's functional change—how people have experienced objects in their surroundings and their performance of construction and use. In this essay, I explore aspects of such an artifactual analysis in the instance of the American "pie safe."

"Pie safe" is a generic term to describe a set of traditional forms of ventilated-case furniture. The ventilated panels of the safe may consist of screen, wood, punched tin, or cloth. The punched-tin safes have decorative panels with patterns that vary widely, yet exhibit a great degree of design consistency. The tins usually measure about nine to ten inches by twelve to thirteen inches, and are mounted on the doors, sides, or both, of the safe. The holes punched through the tin allow air to circulate inside the furniture and also are said to control insect and vermin entry.

Pie safes take a number of forms: there are plain safes (fig. 6-2a), safes with one or two drawers on the top or bottom (figs. 6-1a, 6-2a, 6-2c, 6-2d), and cupboards with one or two drawers in the center (fig. 6-2d). Furthermore, the primary characteristic of the safe—ventilation in the form of punched tin—is found on other types of furniture as well, such as corner cupboards or sideboards. Some safes were also designed to hang from the ceiling in a further attempt at discouraging mice.

Historically, craftsmen made piesafes by hand. The safes therefore show variations in construction techniques, materials used, and degree of workmanship achieved. In Indiana, for example, several signed pieces exist and craftsmen have been identified. William H. H. Johnson of Bellville, for instance,

b. Tin Panels on Cupboard Doors. Fairhaven, Ohio, Antique Fair, 1978. *(Elizabeth Mosby Adler)*

Figure 6-1. a. Safe with Manufactured Tins. Lawrenceburg, Kentucky, Estate Auction, 1979. *(Elizabeth Mosby Adler)*

Figure 6-2. Sample Safe Designs.

Fig. 6-2a

Fig. 6-2b

Fig. 6-2c

Fig. 6-2d

gives directions for making safes in a workbook entry in 1856.[1] The account books of William McBride of Bluffton list numerous safes along with other fancy and plain furniture, wagon hubs, and houses.[2] McBride, in the style of the folk craftsman, was not always paid in cash, but frequently in produce, lumber, labor, boarding, clothing, coverlets, or quilts. In 1877 and 1878 he made Katie Thomas a "large safe" for eight dollars and a "cloths rack" for one dollar. To this nine-dollar account, Thomas paid, in installments, a total of $6.45, with the difference made up in three dozen eggs and an unstated amount of apples.[3]

The woods used in safe construction vary, but walnut, butternut, tulip poplar, and oak are among the most common. A typical safe builder would likely purchase tins in a standard ten by fourteen inch form. Tins were sold by mail from large hardware stores like that of John Duer and Sons, a Baltimore firm which sold a box of 224 punched tin sheets for $5.40 in the early part of the twentieth century.[4] Although many safe tins, particularly the more elaborate pictorial ones, were probably punched by hand, most of the later ones like those of Duer, were mass produced. By 1883 James S. Hagerty of Baltimore patented an improvement in kitchen safe tins. He developed a method for stiffening the plate at the edges and stamping V-grooves in the pattern to keep the plates from buckling and denting.[5] The fact that there are a limited number of different styles of cabinets mixed with a relatively limited number of tin patterns indicates that a variety of stamped tins were available to local cabinetmakers, and is further illustrated by the similarity of tin patterns found in such far-flung spots as Texas, Utah, Indiana, and Missouri.

The function of the pie safe changed over time. Originally, safes were designed to store foods which needed to be kept cool and insect free but not refrigerated. One writer noted in 1870, "If ants be troublesome, set the legs in tin cups of water."[6] Another wrote in 1899, "The utensils which properly belong to the kitchen are kept in an old-fashioned kitchen safe rather than a closet opening out from the kitchen. A safe is more readily cleaned than a closet, and the perforated metal doors render the upper part of it an excellent place for storing cold food, which is not desirable to keep in the refrigerator. Then if, as may happen in any kitchen which is left to the care of the servants, vermin should take possession, the safe can be moved from the room, and trouble from this source avoided."[7] Thus the safes were not only used for storing foodstuffs, but also for utensils and dinnerware, particularly as food storage methods modernized.

The safe was usually kept in the kitchen or on the back porch of small houses and in the pantry or basement of larger houses. It was never found in the parlor or dining room; it was, like today's kitchen sink, primarily utilitarian. As refrigeration became more widely available and food storage methods changed, the pie safe was relegated to other domains and uses. The basement became a favorite repository where pie safes were used to store preserves and canned goods; sometimes the barn or the chicken coop became its new habitat. Not until

relatively recently did the pie safe again become a functioning piece of household furniture. Hence, despite the decline and disappearance of the artifact from its original niche, the form persisted and has again begun to flourish, though with new functions. Today the pie safe can be seen in any room of the house, used for a variety of purposes; it may be used to store linens, clothing, liquor, china, and other odds and ends. Rarely will a pie safe actually hold pies.

Experiential Categories

This long period of pie safe usage means that the form came to connote a variety of expressive experiences and meanings, which arise constantly and naturally from human interaction with all kinds of artifacts. Such meanings depend for their significance on the situational contexts of encounters with the artifact. In the case of the pie safe, a number of discrete experiential categories can be designated.

A primary experiential category for any artifact is perceived by its designer or builder, usually the same person in folk production, an individual who had to operate within the limitations of traditional design rules to create a recognizable and acceptable pie safe. The builders of pie safes have long been dead, but the rules governing their work can be found in manuscripts like Johnson's. Although McBride, for instance, differentiated between "safes," "large safes," "cupboard safes," and "walnut safes," we need to know exactly what he meant by "safe," and what made a good safe. Through an explication of the artifact's "grammar" we can begin to approach the builder's *competence* expressed as he performed the act of pie safe creation.

If the structure of the artifact can reveal competence, which is the ability of the craftsman to compose within the artifactural grammar, then the function of the artifact is revealed in *context*, or the ability of the artifact to relate to external factors. The combination of competence and context creates *performance*. The application of certain linguistic techniques allows the examination of a "performed artifact" solely in terms of form and function and not in terms of a later aesthetics or style. For example, an analysis of pie safes may be made in the form of a descriptive grammar which defines a number of optional and obligatory attributes contributing to "pie safeness," as well as establishing a norm for pie safes.

But the descriptive grammar fails to account for the passing of time. In fact, as shall be demonstrated, the function of the pie safe changes while the form remains stable. There is an obvious traditional competence at work here which allows the creation of only limited forms. The pie safe's grammar reveals the unvoiced aesthetic of the craftsman and generations of consumers. Such an aesthetic is particularly noticeable in tin locations and designs. For example, the tins do not appear on the drawers, and only rarely on both top and bottom

drawers. Like almost all Western folk art, the tins are characteristically bilaterally symmetrical and tripartite. The designs are repetitive, and where they extend for more than one panel, are mirror images or continuations of the same motif which conform to traditional notions of balance.

By the end of the nineteenth century, major furniture manufacturers began to produce tin-door pie safes. These manufacturers employed already established techniques for mass production and distribution. In addition, mail-order companies like Sears and Roebuck in Chicago, Martin Lammert in St. Louis, Belknap Hardware in Louisville, and Acme Kitchen Furniture in San Francisco sold safes in the early twentieth century.[8] They shipped safes in knocked-down form which could be easily assembled, or so the catalogues said, using only a screwdriver. The safes were explicitly described as kitchen furniture. For a time, the folk artifact and the commercially produced artifact existed side by side, both exhibiting similar types of wood and, often, identical patented tins. Simultaneously, however, the mass-produced pieces showed more formal stability and generally used less imaginative tin designs. In short, the safe became a less personal, but still highly recognizably form.

Consumers compose a second group who experience the pie safe. Many elderly people today remember that their mothers had pie safes, usually in the early twentieth century. Jack Allen, for example, of Paragon, Indiana, was born in Kentucky in 1910. He remembers his mother's oak pie safe, with a diamond pattern just like the pattern on the safe his wife keeps in the dining room. Jack told me, "About all the old-timers had pie safes and . . . 95 percent of them—not 95, 100 percent of them was handmade. Chances are their Dad or their Grandpa or somebody made the pie safe."[9] Jack presumes that they made the designs on the tin themselves with "something pointed." His mother kept "pies and cakes and her dishes . . . all gobbed up, all mixed up" in the safe. She kept the safe in the kitchen by the back door or close to the stove.

The pie safe, like other artifacts which we once had and disposed, offers an opportunity for reminiscing when it appears. Many people, but particularly many women, remember their mothers having one when they set up housekeeping, but somewhere along the way it was removed. And, like other old things which were once thought to have no value, the value of the pie safe, both monetary and sentimental, has increased. The common complaint now is, "Sure wish I had it now . . . do you know I had to go out and pay $100 to buy one!"

Laura Allen, who like Jack, is from Kentucky, was unfamiliar with pie safes until she lived in Indiana. The safe that she has now she bought 28 years ago from an old lady who had a second-hand store in Spencer, Indiana. Although it was greyish when Laura bought the safe, it got "painted up real pretty," white bordered in red, to match her kitchen.[10] Now, many coats later, the safe is blue and white to match Laura's dining room; it houses her dishes and crackers and other odds and ends. Laura first bought her pie safe to use as a piece of kitchen

furniture; over the years she has also used the safe in her bedroom, but only when she had adequate kitchen storage space.

Laura voices opinions similar to those of many other pie safe owners. She did not know much about safes, but she did like them, "because they're so old, I think, and then you can refinish then, make them look new, you know." Furthermore, Laura prefers pie safes to other types of old furniture because "It's old and you can use it ... like I say, you can use it for so many different things. A lot of things are so old, you just have to push it back and look at it. That's one reason I like it. If I didn't have to use it for dishes, I'd probably just fold up my bed linen, you know, and things like that—different things, anything I wanted to hide away, in other words. So that's the main thing, you can use it for anything, just sort of hide it away, you see, even refinished, it'd be nice for that. [It] could be used anywhere [in the house], I think. Now you could take the [safe], put glass in it if you wanted to, or you could refinish it. You could set that in your family room or your living room if you wanted to, or your dining room."[11]

Although most antique collectors would be horrified at the thought of replacing the tin with glass, as far as Laura is concerned, it would still be a pie safe, but would have the added ability to display her glassware collection. She is aware of the value of the safe to collectors, however, and therefore probably will not remove the tins. People frequently do alter the pie safes by stripping the paint from them and varnishing them over the "natural" wood. The many layers of paint on a piece of furniture can hint at its uses and the uses and aesthetics involved. Laura's safe, for example, had been painted grey, red and white, blue and white, brown, and a variety of other shades she could not remember. I have seen safes painted in colors ranging from fire-engine red to black, as well as natural wood colors or grains. Frequently, the owner will have gone to a great deal of work to remove the layers of paint, particularly on the troublesome tins, because, as one person who has five put it, "I just love them. They just make a lovely piece of furniture when they're refinished."[12]

Laura is a member of a group of users who first encounter pie safes at sales, auctions, or antique shops. Sometimes they are purchased because they are useful, but safes are also perceived as a sort of subcultural exotica, a folk item that will tie the owner to a lost past. Often, in fact, people will go beyond mere *users* to become pie safe collectors. One collector even told me, "Folk, folklore, that's one reason I like them, because it is something that the average person made, it wasn't an aristocratic type thing, although they did have them in their summer kitchens that the little other people maintained. But I collect them because I really think they're neat. I'm combing the area for them. I like these things, and to me, this is [the] folk art of Indiana."[13] In short, the pie safe presents a chance for the "common man" to purchase a genuine American "antique" with all the aura and mystique attached.

Because no matter what its age or manufacture it is considered a handcrafted antique, another group experiences the pie safe: the dealers who can be found in shops, flea markets, or antique shows. The dealers are an important link in the dissemination of pie safe information, because they are regarded as experts in the field. They rarely hesitate to give out information, often based on hearsay, in a manner that seems authoritative and conclusive. A few antique dealers will fabricate information, because they are out to make money in their business, and the older the piece, or the more unusual, the more money it will bring. Once when I saw a safe I would attribute to Sears and Roebuck manufacture, for example, the dealer said he did not know much about it but it was probably southern in origin since southern safes were thinner than the more northern varieties!

A common assertion made by antique dealers is that tins which are punched outward are older; there could be some truth to this statistically, but it is so far an unsubstantiated claim. Further compounding the general public's confusion about safes, most dealers will not admit to mass-produced safes, particularly when they are carrying them in their shops. And currently, because pie safes are considered an "in" antique, some dealers will pass off anything that has ventilated storage as a genuine pie safe. One woman recently told me that although some people called it a cheese safe, the four-legged screened piece she had was really a southeastern Pennsylvania pie safe. In her opinion, the straight, "cute little country Hepplewhite" legs added a marvelously high-class touch to an undistinguished artifact barely describable as "furniture."

Antique dealers and an antique-hungry population create an additional problem for the student of artifacts like pie safes because of their general lack of interest in the origin of the pieces. Unless the safe came out of an area already established as an important source, such as Bucks County, Pennsylvania, the dealer really does not care, or at least will not tell, if he does know. Furthermore, antique dealers travel from show to show and trade with other dealers as well as the general public. Thus artifacts are removed willy-nilly from their original nidus and taken to a more lucrative market. A friend of mine, for example, took truckloads of Indiana pie safes to Pennsylvania, where, because they were not as common, he could sell them at a larger profit. Sometimes a dealer will note that although he bought a safe in Indiana, he really believes it to be an Ohio piece. One dealer from upstate New York told me that a safe with patented tins was made in New York because that was where it was bought and because it was cherry, a wood native to New York. According to this reasoning, one might suppose that all cherry safes are of New York origin. The type of wood is a favorite basis for guessing at the origin of safes, but other factors must also be taken into consideration. Antique dealers acting as an economic and informational liason between consumers are a wealth of information, and misinformation.

These groups—dealers, first-time users, and collectors—often are not mutually exclusive. A dealer will be living with the same type of artifacts he is selling. An elderly dealer from Greenfield, Indiana, not only sells pie safes, but has two of her own. One is in her basement and formerly stored her preserves and home-canned produce; another is in her kitchen where she stores most canned goods and cereals. Other dealers are familiar with the artifact from their own youth. One man from northern Indiana told me how his mother's pie safe had to be kept on the back porch because there was not room in the kitchen for it and twelve children.

People who begin by buying one pie safe for home use sometimes become collectors, who often have three or more. One woman I talked to had seven pie safes, each different, and each functioned differently in the rooms of her home. And she claimed proudly that she was on the lookout for more. Other people serve as "pickers" for dealers; if they obtain a pie safe they like, they keep it; if not, they sell it to a dealer.

Men deal with pie safes almost exclusively as antiques; in functional terms, a constant reference is made to the woman, whether she is "my wife," "my mother," or most frequently, "she," as in "she stores glass in it." When asking Jack and Laura Allen about safes, for example, Jack said, "Talk to her, *she's* got one." The woman is the one who uses the safe, who cleans it, who strips it, who paints it to match her kitchen, and who ultimately makes the decision to buy or sell. Owners, users, and collectors, are almost invariably women who do the food processing and run the household.

The people who experience pie safes can reveal a great deal about the larger relationships between humans and traditional artifacts. Phenomenologically, an artifact is ahistorical; it presents itself without reference to history or intention. Actual encounters with pie safes, however, show the artifact and its ascribed functions to be closely intertwined. Most people who experienced pie safes in their original context do not remember them ever being used to store pies, although they did store baked foodstuffs, like homemade or store-bought bread. They know that the artifact is called a "pie safe," but cannot articulate why, except that someone somewhere must have used them to store pies. Today, an artifact with punched-tin panels may be called a pie safe.

The pie safe is a traditional object, a survival from an earlier period. They are popular today, at least partly because they are adaptable to new uses. They have the mystique, and concomitantly, the value of being old, being handmade, being something that our ancestors, or even more recently, our mothers and grandmothers, might have had. The aura of antiquity which now informs the concept of the pie safe is part of a process of revived traditionality by and for people who once abandoned tradition for progress. Whether it was mass-produced and marketed, or handmade locally, the safe is experienced as a piece of folk art or craft. It is accepted as a traditional artifact with all that "traditional"

connotes, although the pie safe shows clearly the interplay of folk tradition and the industrial revolution. It is commonly felt that no two safes are the same, and that they must therefore be the product of individual craftsmanship in both tin and cabinetwork. And because people perceive handwork, they associate the object with an earlier, bygone age; they recognize a concept of "antique." And because it is supposedly an antique—and individual—it is perfectly proper to take it out of the kitchen and put it in the living room where everyone can admire it. The pie safe, and artifacts like it, provide a means still within reach of most people who want to buy a piece of the past, of "Americana." Even the mass-produced pieces have a sense of individuality next to today's formica furniture. The pie safe has come around full circle from the kitchen through the barn to the living room. It is experienced as a newly discovered functional antique made by the folk of yesterday for today.

Notes for Chapter 6

1. William H. Johnson Manuscript Workbook, Bellville, Indiana (Indianapolis, Indiana State Library). See also Agnes McCulloch Hanna, "An Old Workbook on Cabinetmaking," *Indiana Magazine of History* 37 (1941): pp. 174–81, especially p. 177.

2. William McBride Account Books: Furniture and Undertaking Business of the McBride Family, 1837–1917 (Indianapolis, Indiana Historical Society).

3. Ibid.

4. John Duer and Sons, Inc., *Illustrated Catalogue* (Baltimore, n.d.), p. 252.

5. United States Patent Office, *Official Gazette* (Washington, D.C., 25 December 1883), p. 1246.

6. Catherine E. Beecher and Harriet Beecher Stowe, *The American Woman's Home* (New York: J.B. Ford, 1870), p. 376.

7. Louis H. Gibson, *Convenient Houses with Fifty Plans for the Housekeeper* (New York: Thomas Y. Crowell, 1889), p. 48.

8. The following catalogues listed pie safes for sale; the dates are not exclusive: *Martin Lammert Illustrated Catalogue* (St. Louis, 1 April 1878), p. 133; Belknap Hardware and Manufacturing Co., Inc., *Catalogue #86* (Louisville, 1932), p. 289; Sears and Roebuck Company, *Catalogue #118* (Chicago, 1908), p. 685; Acme Kitchen Furniture Company, 1910, cited in Linda Campbell Franklin, *From Hearth to Cookstove* (Florence, Alabama: House of Collectibles, 1976), p. 184.

9. Interview with Jack Allen, Paragon, Indiana, 30 September 1977.

10. Interview with Laura Allen, Paragon, Indiana, 30 September 1977.

11. Ibid.

12. Interview with Audrey Bruce, Bloomington, Indiana, 28 September 1977.

13. Interview with Sue Carter, Bloomington, Indiana, 28 September 1977.

Comments

Form, Function, and Region

Elizabeth Mosby Adler's analytical approach is undergirded by an examination of the persistence of the pie safe as a folk *form* over time, and its change of *function*. She adheres to the principles followed by Henry Glassie in defining material folk culture.[1] In stressing that "the function of the artifact pie safe changes while the form remains stable," Adler underscores the traditional nature of these objects. Noting that the form of the pie safe adheres to a basic series of variations (ventilated areas, wood construction, drawers, and so on), Adler traces the development of the form into a more popularized era. Although production of pie safes evolved into a mass-market distribution phase, the large-scale factory industries maintained the traditional form. The technological improvements introduced through several patented ideas and the acceptance of a mass distribution of the object did little to alter the persistence of the traditionally accepted folk form.

As Adler noted, pie safes did evolve in their function. Originally they were "designed to store food which needed to be kept cool and insect-free, but not refrigerated." In subsequent years they were used "for a variety of purposes; it may be used to store linens, clothing, liquor, china, and other odds and ends." Once built to occupy specific household locations (that is, pantry, kitchen, basement, porch), the passing of time and change of function also affected its household placement, and therefore its importance as an invaluable functional and decorative interior object. In grappling with the application of a descriptive grammar which relates the form and function, Adler points out that function as revealed in context must take into consideration the fact that the passage of time may affect the conditions of context, and hence the function of the object.

This initial study of the pie safe experience is a valuable inquiry into one type of regional material object. While theoretically well-founded, further investigation would be welcomed into both the components of the form and the function of the artifact. Especially valuable would be an examination of regional characteristics of this object and a consideration of variations or alternative forms used in various regions.

Consideration might also be given by the "experience/performance" analysts to the relationships of a particular form to other forms fulfilling similar functions. Such a formalistic study might be carried out in the same spirit as Robert F. Trent's *Hearts and Crowns: Folk Chairs of the Connecticut Coast from 1720 to 1840*.[2] His analysis of chairs was guided by the principle set forth by Henri Focillon, that "our goal in investigating folk art has been to show that objects can be set in series, not in discontinuity."[3] Following this direction, Trent painstakingly analyzed the components of the form of folk chairs from one region. By carefully measuring each object and computing the mathematical ratios of one part to another, he was able to establish that more than a visual and bilateral-symmetrical quality existed in the form. The equations denoted an operative production principle that guided the chairmaker and ultimately dictated the end product. Although many of the "new" material folk culture specialists shy away from formalistic analysis (probably because of its association with the supposedly elitist study of art history), such analysis of pie safes may uncover that the operative production principle existed for the folk craftsmen who built pie safes, since the components of the pie safe were generally constant.

An exploration of the dimensions of folk taxonomy might also prove illuminating. Were there other generic terms applied to a particular form and did those terms relate to regional variations or uses? For instance, do the terms milk safe, jelly cupboard, and pie safe denote a similar form, though used for perhaps slightly differing functions?

Finally, the use of informants in Adler's essay focused primarily on users of pie safes today. It would be advantageous to identify informants who were familiar with the previous or original functions of pie safes. A sample of recollections from this additional group of informants may in fact answer questions of differing taxonomy, divergent regional characteristics, and varying sequences of change in function and form.

C. Kurt Dewhurst and *Marsha MacDowell*

Notes

1. See Henry Glassie, *Pattern in the Material Folk Culture of the Eastern United States* (Philadelphia: University of Pennsylvania Press, 1968): idem, *Folk Housing in Middle Virginia* (Knoxville: University of Tennessee Press, 1975).

2. Robert F. Trent, *Hearts and Crowns: Folk Chairs of the Connecticut Coast from 1720 to 1840* (New Haven: New Haven Colony Historical Society, 1977).

3. Ibid., p. 17

Provenance Lost

Objects, like historical movements, are dependent on a cast of influential characters. Primary and secondary figures fill the pages of history. The artifact's history, as Elizabeth Mosby Adler points out, is affected by makers, owners, users, and markets. Artifact history has been more social than economic, and worth considering in the analysis of material culture is the influence of collectors and markets.

Collectors, that extreme breed of owners occupied with the need to gather numerous examples of an object-type, contribute in force to the researcher's nightmare—lost provenance. The trail of mistaken identity is too easily left uncorrected and misinformation becomes magnified by degrees as the object meanders from its source. Yet antique dealers and pickers contribute collections which provide evidence for analysis. For example, Holger Cahill, the architect of the monumental *Index of American Design* was a museum curator and sometime picker for dealers and collectors. At first gaining praise by decorative arts historians for his attention to the intellectual value of folk arts, Cahill was later cursed by ethnographers for his cavalier attention to aesthetics. The precedent of placing aesthetic consideration over historical and social context, especially by collectors, found favor early on and left subsequent ethnographic researchers in the lurch, much like pot hunters, with leftover samples plucked from disturbed soils.

Owners and intermediaries in the marketplace play alternately passive and active roles in writing and rewriting artifactural history. Contemporary marketing schemes abetted by gallery and museum exhibitions, artifact reproduction programs, and advertising and merchandising at every level have thrown the relationships among object, maker, and owner into previously unimagined realms. Ownership, in the traditional marketplace relationship being between maker and user, is dependent on use; ownership in a modern market is conspicuously dependent on fashion and consumption. As Adler shows, the same safe, over the years might satisfy changing needs in successive locations within a single household. Equally at home in the kitchen, basement, or back porch, the safe's adaptability has marked it as a survivor to the vagaries of changing needs and tastes.

A common piece of furniture, the safe shared popularity throughout America for many reasons. That the same object could enjoy life as a "kitchensafe" in New Orleans and much later as a hideaway for a television in Philadelphia hints at the confusion created by undocumented serial ownership over time. A source of new confusion accompanies the object's renaming by function. In France, the "Hi-Fi cabinet" may be one and the same with safe, chest, or cupboard. The pages of European interior design magazines are dedicated to marriages of old forms and new functions inconceivable at the time of their

fabrication.[1] If use were the solitary interest of the utilitarian object, the researcher should be content with the enumeration of applications. The safe's function as container is only partial history, history that unfolds with the recorded interpretation of each user.

The historical union of function and form in the safe is given order by a linguistic analysis of its design over time and space. The vocabulary of pierced tins, far from being "ahistorical," as Elizabeth Mosby Adler suggests, contains clues to time and place. Tins with multiple arches, symbolizing the state of Georgia, have been found since 1799 in the area surrounding Greene County, Georgia.[2] J. Roderick Moore of the Blue Ridge Institute, working in Wythe County, Virginia, "where every home seemed to have a pie safe," reports the depiction of courthouses, dates, initials, and portraits on examples dating from the mid-nineteenth century. That we know so much about safes in central Indiana and southwestern Virginia is a tribute to the contextual research carried on by folklorists. Following their social documentation, assuming that an area has not been "picked over" by antique hunters, it should be possible to geographically chart distribution patterns from manufacturing origins.

The work of the folklorist, as Elizabeth Mosby Adler shows, is distinguished not so much by the material that is studied as by the questions asked of the material. Commonly asked are what motivated the creation of objects and what sources were invoked by the techniques and forms used. Activities and artifacts deemed ordinary lie at the core of folkloristic inquiry. Oriented toward the actors in the drama of creation, folklorists gravitate toward social meaning and individual performance. This is why the collector and the marketplace who depend on removal of artifacts constitute a threat to folkloristic research. Rather than being threatened, folklorists can enhance their research by overcoming the purist bias toward handmade goods, accepting and appreciating the unalterable flow of modernity, and daring to label the new concoction as such.

Elaine Eff

Notes

1. "Hi-Fi et decoration," *Art and Decoration: La revue de ma maison,* No. 230 (October 1981), pp. 116–20.

2. *Neat Pieces: The Plain Style Furniture of 19th Century Georgia* (Atlanta: Atlanta Historical Society, 1984).

Reply: The Past and the Present of Pie Safes

Dewhurst and MacDowell point out the value of a regional study of safes; as I briefly mentioned, the form of the safe does not seem to indicate major geographical differences. But early tin patterns may be regional in character, and may serve to indicate areas which form the cultural hearth of the safe. The form of the safe is fairly standardized, although decorative moldings and leg profiles vary.

In answer to another comment by Dewhurst and MacDowell, regional substitutes did exist for the pie safe. Where the climate permitted, people harvested ice and therefore had cold storage in ice houses. Other forms mentioned by Dewhurst and MacDowell are obviously similar but do not seem to have fulfilled quite the same function as the pie safe. The milk safe, for example was used for storing pans of clabbering milk. The origin of the jelly cupboard, like that of the pie safe, is probably unknown, but apparently it was not designed to provide ventilation. Screening, punched wood, and cloth, in addition to tin, ventilated pie safes.

As the commentors point out, Robert Trent's fine study of Connecticut chairs provides a number of guidelines for examining furniture as well as other types of artifacts. The structure of the pie safe seems to be a function of the tin size, but although there is a standard tin size, the size of the safes vary. Pie safes have been altered, rebuilt, cut down, or added to; therefore, the measurements are not always an accurate reflection of the original form. Variation also exists in nomenclature; several terms describe the "safe" genus: pie safe, food safe, kitchen safe, safe, pie cupboard, or tin-door cupboard. The names are interchangeable where the pie safe exists as a traditional piece of furniture.

Elaine Eff poses good questions, particularly in regard to the effect of the marketplace on pie safes and material folk culture in general (log buildings are moved almost as easily as pie safes are). To be sure, without collectors there would be no study collections. Whether or not collectors are good or bad for antiques (or for the folklorists who study them), it is important to note that at least with pie safes, the provenance has long been unknown by the time the safe is recognized as an object of value. And collectors do contribute technical knowledge and oral tradition surrounding the artifacts. Without them, we would probably have only the artifacts.

Although the laws of supply and demand certainly affected an artifact's distribution, laissez-faire competition is not limited to our times. Through their history, safes were shipped where the market required. Where they were in great demand, they were built locally. Today, we may see "confusion" resulting from the many functions of artifacts like pie safes, but the form itself is so adaptable that these uses were probably anticipated by craftsmen of the past.

By saying that an artifact is phenomenologically ahistorical, I don't mean to say that we can't glean historical knowledge from visual clues. It is not wise to assume that Georgia safes with arches were built in 1799; more likely they were built *after* that date, maybe even in 1899 in honor of a state centennial. An artifact gives strong clues to its history—in the tins and in its form and construction. At the same time, however, artifacts are ahistorical in that their function (and hence, their history) is continuous through time, or is diachronic rather than synchronic. If one had an artifact like a pie safe but had no knowledge of its history or intended function, it would be historical—it can exist in space without reference to time. This notion is important since it allows the artifact to be studied without historical biases. In most instances, however, the artifact and its functions are commonly known; in short, it is recognized as a *pie safe.*

At this point, it is hard to say what the original function of the safe really was. No one is left from 1850 to interview, so researchers rely on the often incomplete record of written accounts and old photographs. Many people remember using them in what was probably an original function—for holding leftovers, grains, breads, dishes, silverware, and other kitchen detritus. Apparently they were not built *just* to hold pies—traces of drawers and braces on the backs of shelves to display plates are obvious reminders of that fact. Probably Laura Allen is using her safe exactly the way it was designed to be used at the turn of the century. In Indiana, at least, many rural dwellers did not have access to electric refrigerators until after World War II, and ice for ice boxes was not always available. The safe continued to be a functional part of the kitchen long after its need had disappeared in other parts of the country. Material culture researchers, as antiquarians, are interested in pie safes and their past, but as folklorists, are considering their present and what such artifacts can tell us about people.

Elizabeth Mosby Adler

Investigating the Tree-Stump Tombstone in Indiana

Warren E. Roberts

Folklore and Material Culture

A number of parallels exist between the study of folklore, that is, oral traditions, and the study of traditional material culture, or folklife research. For one thing, both rely heavily on collecting, or fieldwork. In folklore collecting we can see a development over the years in the attitude of the collector toward the informant. Early collectors such as Sir Walter Scott were hardly interested in the informant at all. To Sir Walter the ballad was an "antique," a chance survival from an earlier and nobler age. The person whom he heard sing the ballad was of no importance, for it was very much a matter of chance in his mind who sang and who did not.

By the beginning of the twentieth century, folklore collectors had begun to feel that the name and location of the informant should be included when the folklore item had been written down. True, the collector did not quite know why it should be done, for scholars rarely made any real use of this information. By 1979, however, the folklore collector assumed that the informant was a centrally important person. Much of the recent folklore scholarship stresses the individual rather than the folklore text.

It is, therefore, one of the great ironies of folklore scholarship that the huge archives of folklore so industriously assembled by past generations of folklorists are bypassed by most modern scholars. Archives contain reams of texts of various kinds, but they usually contain little information about the informants from whom they came. The paucity of contemporary published studies in folklore which make use of archival materials bears out this situation.

When we examine the study of material culture, we see that in many respects we are in the same stage in regard to collecting as folklorists had reached by about 1900. When an artifact is collected, the fieldworker is content often to

record the name of the person from whom it was obtained, and that is about all. In folk architectural studies, for example, the fieldworker, if he or she is conscientious, will record the name of the present owner of the house, but will not spend much time interviewing the owner. Many "windshield surveys" do not even go that far.

It would seem that the time has come for collectors to devote far more attention to the source of the artifact. It may well be that folklife researchers will choose not to study such information in the same way that folklorists study their informants, for the concept of "performance" barely applies to the owner of an artifact. If the goal of folklife research, however, is to study the traditional way of life of the preindustrial era, it should also be our goal to study the ways in which that way of life persists into the present and the influences of that way of life on modern life. In such a study we can hardly ignore the owner of the artifact.

Context and the Artist's Role

If the situation is bad in regard to traditional material culture in general and fieldwork, it is even worse for folk art, however we understand that much-debated term. Most folk art that has been collected in the past and has found its way into museums was made in the nineteenth century. Consequently, it has been impossible to interview the artists or their patrons. Hence we have the art without, for the most part, its cultural context.

I would suggest that it would be wise for those interested in folk art to turn their attention, if possible, to the study of *living* folk artists or those who have lived so recently that information about them can be obtained. It is, of course, clear that the results thus reached cannot automatically be transferred to earlier folk art. Nonetheless, some important information that will help us understand folk art will come to light.

As a case in point, let me cite the issue of the artist's position in relation to society. Is the artist and his work accepted by the people among whom he lives? Does the artist mirror the tastes and aspirations of his culture? Are the artist's creations regarded as part of everyday life? Answering yes to these questions identifies, for want of a better term, the model of the "Medieval artist," for it is widely believed that something like this set of criteria characterized the artist of the Middle Ages.

Or, on the other hand, is the artist set apart from society? Does the artist introduce new ideas, new symbols that appeal only to an educated, sensitive elite? And are the artist's creations considered to be somehow above and finer than the humdrum affairs of everyday life? If so, we realize the model I will label the "Romantic artist," for it characterizes much of the high-style art of the Romantic period, art which is still very much with us today.

In a provocative essay entitled "The Wood Carver," Roger L. Welsch wrote on the results of extensive fieldwork interviewing Norwegian-American wood-carvers or their descendants in the upper Midwest. As a result of this fieldwork, he came down squarely on the side of the "Romantic" model of the folk artist. His wood-carver is alienated from society; his carvings do not appeal to his neighbors and are often rejected by them. Only special people such as museum personnel and folklife researchers appreciate them. Welsch declares, for instance, "Thus the folk artist/carver is an outsider to begin with; he is isolated in more than physical ways," and "It is possible...that woodcarvers are also like high-style artists in that they are aliens within their own cultures."[1]

These insights into the role and position of the folk artist that Welsch gives us are valuable because they are based on extensive fieldwork. But would it be safe to generalize about all folk artists on the basis of his experience? Is the "Romantic" model the correct one for the folk artist? To arrive at an answer, look at another example, some stone-carvers instead of wood-carvers.

The Tree-Stump Tombstone

Bloomington, Indiana, lies near the northern edge of the area where Bedford limestone is quarrried, cut, and carved. The area is only about thirty miles long and a few miles wide, but it produced immense quantities of building stone, shipped far and wide. All of the limestone for the Empire State building, for example, was taken from a single quarry near Bloomington. The quarry was opened to supply the stone for that one job and has not been worked since. One might say that there it is possible to see the hole in the ground from which the Empire State Building came. The limestone industry was underway on a large scale about 1875 and flourished mightily until the 1930s when The Great Depression cut deeply into the demand for high quality building stone. Quarrying and stonecutting are still active today, but not on the scale of earlier years. Only a few carvers are still working.

When the industry was still flourishing, the local mills employed great numbers of stone-carvers to produce the carved work that adorned buildings. Day in and day out they worked at their "bankers," as the carvers called their workbenches. In so doing they developed incredible skills and they acquired an intimate knowledge of the qualities of the stone with which they worked. At the mill, of course, they followed the designs of others—architects and draftsmen. But on occasion, in their spare time or in between jobs, they could turn their skills and knowledge to making items basically of their own designs.

One of the most striking things they thus produced is the tree-stump tombstone. Mixed in local cemeteries among the simpler stones of an earlier era and the chaste, almost severe tombstones of contemporary times, one finds

jutting skywards these almost exuberant memorials which date from about 1890 to 1920. Are they folk art? Let us assume that they are, since they satisfy the criteria of traditionality and a predominant pleasure giving function over a utilitarian one.[2] Two things strike me when I see tree-stump tombstones. One is the incredible skill of the carver; the other, the union of the rich and complex—a symbolism that is not esoteric or purely personal to the artist, but a symbolism widely and immediately understood by the community for which they were made.

Consider the outstanding tree-stump tombstone carved by two brothers, Claude and Silvester Hoadley, for Marcus Smith (1815–1897) in the Gosport cemetery (fig. 7-1). Some of the symbolism is readily apparent, such as the broken-off tree trunk standing for the end of life and the branches coming from the trunk to show the number of children born to the couple. Erskine Hoadley, nephew of the carvers, commented on some of the other symbolism when interviewed in 1971.[3] "Marcus Smith was the most generous man anyone ever knew. That generosity was represented on the carving as one hand giving another a biscuit" (fig. 7-2). He said that they had always been amused in their family about the stone biscuit and how Silvester had thought up that way to "represent the generosity of that old boy."

On the wife's side at the bottom of the monument is carved a spinning wheel (fig. 7-3). Hoadley said, "No doubt it showed that she was a weaver and in the family they wove their own cloth." In a more general way it represents all the domestic skills that Malinda Smith was so well versed in. On the husband's side are an axe, a wedge, and a maul. "This," said Hoadley, "represented the clearing of the woods. It would mean he was a farmer and had to clear the land, as all the old timers did" (fig. 7-4). Also near the base is the replica of a hand reaching for the top book of a stack of books on a pedestal (fig. 7-5). "That was probably the Bible," Hoadley explained. "The idea was exactly that; the Bible was the top book of all."

I could continue with other symbolism found on this and other stones; the dove for peace, the lily for virtue, the Christmas fern, green the year round, for immortality. These examples suffice, I trust, however, to illustrate my point that everything about the monuments has some symbolic meaning that spoke to, and for, those for whom they were made.

What sort of men made these great examples of folk art? Were they "aliens to their culture"? Did they dwell apart from common men? Did they think their work to be art, fine and rare? Did they "walk down Picadilly with a poppy or a lily in their medieval hands"? Hardly. They were seemingly prosaic, matter-of-fact, hard-working men trying to make a decent living at a time when that was none too easy. Although the carvers themselves are dead, some of the comments by Erskine Hoadley, and by Mrs. Newman Bennett about her dead husband, reveal something about the carvers' attitudes.[4]

Figure 7-1. Tree-Stump Tombstone, Gosport. Indiana. A memorial
 to Marcus Smith (1815-97) and his Wife, Malinda. It
 was carved by two brothers, Claude and Silvester
 Hoadley.
 (Warren Roberts)

Figure 7-2. Detail of figure 7-1. One hand is passing a biscuit to the
 other, a symbol of the generosity of the Smiths.
 (Warren Roberts)

Figure 7-3.

Detail of figure 7-1. The spinning wheel symbolizes the domestic skills of Malinda Smith and that she lived in an era when these skills were vital. The thin rim and delicate spokes of a real spinning wheel would have been impractical to represent in the rather coarse-grained limestone. Hence the carvers have not attempted to make accurate reproductions of these parts of the spinning wheel.
(Warren Roberts)

Figure 7-4.

Axe, splitting wedge, and maul on a limestone Tombstone. The heavy Smith stone has sunk into the ground far enough so that the heads of the tools are covered. I show a nearby monument with the same tools which was undoubtedly carved by the Hoadley brothers. It is a memorial to Montgomery Taylor (1823-91) and his wife, Mary. Both Marcus Smith and Montgomery Taylor were farmers, but the tools show that they lived in an era when the land and making split-rail fences were common.
(Warren Roberts)

Figure 7-5.

Detail of figure 7-1. The top book is the Bible symbolizing the importance of religion and the Bible to the Smiths. *(Warren Roberts)*

When asked what the monuments were called, Mrs. Bennett replied, "I think you just called them 'tree stumps'—he'd come home and say, 'I sold a stump job today.'" Asked if carving was a creative talent, an art, Mrs. Bennett said, "I guess it is an art. I never thought about it that way. I was always surrounded by stone people.... When you are raised on it, you don't think about anyone else being interested in it." As we might expect, she stressed the skills needed rather than the creative talent of the carver. "A stonecutter knows where every tool he has is and where to use it. You'd be surprised what you can do with a piece of stone. When they start out, it looks like a big hunk of nothing." When asked if there was anything her husband emphasized about his work, she said, "He liked deep letters; said they lasted longer that way. He didn't think Jess [his brother] made them deep enough."

Further comments reveal the pragmatic attitudes of the carvers. Mr. Hoadley said of his uncles' carvings, for instance, "Claude roughed them out and Silvester put the finishing touches on them." Mrs. Bennett also said, "If Newman [her husband] sold a monument and it needed a sheep carved on top of it, Jess [his brother] usually did it. Newman could do it if Jess laid it out for him." As time went on Newman Bennett made smaller monuments. Mrs. Bennett reported, "People got so they wanted smaller ones. He said the larger ones got knocked over too easily."

Let me offer another stone-carving example for discussion. Located in the cemetery at Bedford is a monument, a footstone rather than a headstone, to Louis J. Baker who died 29 August 1917 at the age of twenty-three (fig. 7–6). A stonecarver at a local mill, he left his work in progress at the mill at the end of that fatal day, went home, and was killed by lightning. His fellow carvers made an exact replica of his workbench, or "banker." On the banker is the piece of architectural stone, unfinished, exactly as he left it. It is even said that this is the exact piece of stone he was working on, but such cannot be the case. Atop this stone appear his tools. The fidelity of the work is amazing; the wood grain of the banker is clearly shown as are the bent-over nails holding it together. There is no attempt to tidy things up or make it finer than it was. These stonecarvers, who normally executed the designs of others, could nevertheless produce a striking and poignant memorial of their own design and one that speaks far more movingly than some classical urn, or draperies, or some similar ornament.[5]

The stone-carvers who created these monuments fit the "Medieval" model I proposed. They and their creations were accepted by the people among whom they lived as part of daily life. They spoke to and for their neighbors in their work. Their symbolism was rich and varied, but it was understood and appreciated. In no way would they be called "aliens in their own culture."

Roger Welsch probably reached his conclusions because of a rather special set of circumstances. His wood-carvers have been perpetuating a Norwegian tradition at a time when most Norwegian-Americans were busy abandoning their Norwegian background and adopting the ways of the dominant Anglo-American society. To them art was a painting to hang a wall or a marble statue, for such was the attitude of most middle-class Americans. To the Norwegian-Americans an elaborately carved wooden box that would have delighted their Norwegian ancestors was only a curiosity and a waste of time. Society changed but the carvers remained, in their work, at least, much the same. As a result, the carvers were apart from society in many ways for a couple of generations at least.

Had Welsch been able to do fieldwork in Norway 150 years ago, he most likely would have found that wood-carvers were respected craftsmen, very much a part of society, producing decorative wares for appreciative patrons. Let me dare a prophecy about the near future. Thanks to changing attitudes toward their Norwegian backgrounds by Norwegian-Americans and owing to publications of museums and other attention, the wood-carvers will be esteemed again. Even today, the carvings done in the past are being eagerly sought out and cherished by many people.

What is the moral of all this? Roger Welsch finds wood-carvers who fit the "Romantic" model while I find that stonecarvers fit the "Medieval" model. The moral on one level is, that folk artists are a varied lot. Some fit one model, some another, and many probably fall somewhere in between. On another level,

Figure 7-6.

Monument for Louis J. Baker, Stone Carver.
Died August 29, 1917.
Green Hill Cemetery, Bedford, Indiana.
(Warren Roberts)

though, the moral is clear and unequivocal; it is fieldwork that will tell us most about folk art and about folk artists.

Notes for Chapter 7

1. Roger Welsch, "The Wood Carver," in Darrell D. Henning, Marion J. Nelson, and Roger L. Welsch, *Norwegian-American Wood Carving of the Upper Midwest* (Decorah, Iowa: The Norwegian-American Museum, 1978), pp. 22, 24.

2. See Henry Glassie, "Folk Art," in *Folklore and Folklife: An Introduction,* ed. Richard M. Dorson (Chicago: University of Chicago Press, 1972), pp. 253–80.

3. Interviewed in Gosport, Indiana, 22 November 1971.

4. Interviewed in Bloomington, Indiana, 29 November 1971.

5. For other similar examples, see Warren E. Roberts, "Tools on Tombstones: Some Indiana Examples," *Pioneer America* 10 (1978): pp. 106–11; Simon J. Bronner, "The Durlauf Family: Three Generations of Stonecarvers in Southern Indiana," *Pioneer America* 13 (1981): pp. 17–26.

Comments

Consideration of the Folk Artist

I concur with Warren Roberts's models, the Medieval and Romantic artists, but it is important to keep in mind his last paragraph, in which he emphasizes the important consideration that is forgotten in so many discussions—especially where there are dichotomies—that there is no discrete line between the two models.[1] The limited number of Norwegian carvers I visited and treated in my essay, "The Wood Carver," held remarkably similar attitudes toward their work and their position in the community, and they happen to be those of Warren Roberts's Romantic artist.[2] I have no doubt that the situation would have been different had I been collecting 150 years ago, as he suggests. Moreover, the orientation of the artist within the Medieval/Romantic continuum varies in accordance with many considerations. It could be that the wood-carver because he works (in this case) with primarily decorative items has less support in the community than the gravestone carver who creates an item with a very real function. Or that status depends upon the fact that the stone carver works on commission for a customer who comes asking to him while the wood-carver stands like a beggar, art in hand, waiting for a moment's favor of a buyer.

Perhaps my corpus was a whim of mortality. I suspect that it is almost certainly a bad sample that is selected by death. A carver I worked with dismissed my praise for his extraordinary work with the devastating words, "I'm one of the best only because I'm one of the last." Perhaps the Minnesota carvers were not cultural exiles because they were artist-survivors or artist-pioneers but rather they survived because they fled or were cast out of the cultural mainstream. There *is* a shift in the acceptance of the wood-carvers, as Roberts suggests, but the shift is lamentably (to my taste) away from traditional patterns and toward the more easily marketed popular culture kitsch.

Nor can we ignore the influence of the fieldworker on field reports. I am a hopeless, admitted, card-carrying Romantic and therefore tend to see the world in Romantic terms. My view of folklife is still as a humanistic study, not a social science; I still roll my eyes at the poetry of folksongs; less and less I measure

buildings and more and more I build them, live in them, and think about them, trying to gather impressions that seem to me at least as important as wall lengths. In short, the artists I wrote about may have turned out to fit Roberts's Romantic model as much because I am Romantic as because they actually fit the model.

Roberts's concluding paragraphs are the keys. What we need is more investigation, documentation, and consideration of the folk *artist*.[3] Not to see "the truth," for there are many truths, but to find some of the *other* truths. Whatever other fieldworkers find in their work with wood-carvers, or migrant carvers, or Norwegian carvers, or Minnesota Norwegian carvers, I do not believe that I will be brought to admit that my observations and conclusions in "The Wood Carver" were in any way wrong (nor do I think that Roberts is suggesting that). They were necessarily my perceptions and for the purpose of an essay I chose to deal with them as unabashedly subjective impressions. They will almost certainly therefore differ from the perceptions of others. The more such views we have to draw upon, the more provocative they are, the closer we will be able to come to the essence of art and folk art, again as Roberts has suggested in his essay. This consideration is only part of the maturation that folklife study has experienced over the past few decades, moving from a concentration on item to one of context, then process, then meaning.

Roger L. Welsch

Notes

1. On a number of occasions—all of them futile—I have tried to suggest that the definitional problems of folklore rest more with the processes of definition than with the nature of folklore. For those who are amused by contemplation of whether there is a sound when a tree falls and no one is within earshot, I recommend my "A Note on Definitions," *Journal of American Folklore* 81 (1968): pp. 262–64; "Beating a Live Horse: Yet Another Note on Definitions and Defining," in *Perspectives on American Folk Art,* ed. Ian M.G. Quimby and Scott T. Swank (New York: W.W. Norton, 1980), pp. 218–33.

2. Roger L. Welsch, "The Wood Carver," in *Norwegian-American Wood Carving of the Upper Midwest* (Decorah, Iowa: The Norwegian-American Museum, 1978), pp. 21–26.

3. The work of Michael Owen Jones is particularly notable in this regard; see his *The Hand Made Object and Its Maker* (Los Angeles and Berkeley: University of California Press, 1975). Donald Van Horn's *Carved in Wood: Folk Sculpture in the Arkansas Ozarks* (Arkansas College Folklore Archive Publications, 1979) is another important contribution to the understanding of the traditional carver, especially in regard to the tensions between traditional and popular culture motifs and techniques.

Folkloristics and Fieldwork

In addition to suggesting that the Indiana stone-carver fits the model of a so-called Medieval artist, Warren Roberts insists in his essay that doing fieldwork is the only adequate way to obtain information about folk art and artists. Doing fieldwork, of course, is considered by many to be an indispensable part of the training of folklorists and to be the principal source of information on which a discipline is based. The word "fieldwork" has come to denote inquiring into the nature of phenomena by studying them firsthand in the environments in which they naturally exist or occur.[1] As a means of obtaining information, fieldwork embraces not only interviewing, which Roberts stresses, but also observation and record making.

Many justifications have been given for doing fieldwork. The only intellectually defensible one is implicit in Roberts's essay—namely to obtain data not previously recorded by others, and in the process, to test a hypothesis that cannot otherwise be confirmed or denied to one's satisfaction. But this particular defense of fieldwork does not mean that other sources of information do not exist or cannot be employed, that records of observations made by others in the past are useless in the present, or that the only way to make a significant contribution to folklife studies today is to do fieldwork.

To some extent both art and artists, the topics of interest to Roberts, were indeed neglected by earlier observers. Even when they were documented, the motives for doing so and the nature of the records produced often left much to be desired. Both Franz Boas and Alfred C. Haddon, for example, collected objects in order to support their studies of other phenomena.[2] Given the paucity of funds available in the 1890s to do fieldwork, selling specimens of native art to museums proved to be a good way (and is still used) to defray travel expenses. Rarely did much information accompany the objects that were shipped home. Initially Boas was more interested in finding concrete illustrations of native-language stories than in studying the manufacture of objects, while Haddon perhaps was seeking proof of the theory of cultural evolution. Nevertheless, both fieldworkers were aware, or soon became aware, that knowing what an object was called and where it was made was not enough; reasons for its form had to be discerned. Both fieldworkers later published books that continue to influence students of art because of the authors' insights.

Importantly, however, Boas's *Primitive Art* (1927) and Haddon's *Evolution in Art as Illustrated by the Life-Histories of Designs* (1895) consist of hypotheses derived largely from the examination of objects rather than from a study of interview materials. Informants are not quoted, except on rare occasion when Boas includes statements of Pueblo potters recorded by his student Ruth Bunzel. In addition, as Boas discovered to his chagrin and despair, comments by interviewees might be misleading or incomplete.[3] Moreover, whether the data

base is composed of masks or remarks, the researcher's inferences are always determined by the analytical framework subscribed to, the kinds of questions posed, and the assumptions entertained for purposes of finding solutions to particular problems.[4]

Some of Roberts's comments on fieldwork and folklife research bear out that a researcher's inferences depend not so much on the nature of the data base as on other experiences and the assumptions generated or reinforced by them. Consider, for example, the meanings of a broken-off tree trunk, branches on the trunk, a dove, a lily, or other designs on gravestones. From past experience (whether perhaps having been told by others or having read the reports of earlier observers) Roberts assumes that these images on tombstones mean the end of life, the number of children in the family, peace, and virtue. But to whom? Presumably to everyone who makes or sees them, because Roberts assumes further for purposes of discussion that folk art is the art of and for a community by a member of that community. Assumptions of enduring, undifferentiated attitudes and values go hand in hand with the supposition of the integration of elements into an organized whole. If a system is assumed to be a functioning whole, then presumably it is in equilibrium, no single element is disharmonious, no one person throws a wrench into the works, so to speak. Thus, finally, we arrive at Roberts's other thesis allegedly deriving from his fieldwork regarding folk art, namely that the Indiana stone-carver fits the model of a Medieval artist who was not alienated from his culture and whose creations reinforced the attitudes of his neighbors.

Is this thesis right or wrong? The answer depends less on Roberts's observations and interview data and more on the validity of each assumption, including the notion that no medieval artists produced works understood by, and in perfect harmony with the values of their "community." That it is "widely believed" that this was so does not, of course, lead to the conclusion that it was in fact so. Because of his word choice, suggesting some doubt about the validity of this widely held notion, Roberts seems to be implying that the assumption is entertained only for the purposes of discussion. If the reader also holds this notion, and accepts the other assumptions as well, then an argument built on this is meritorious; fieldwork data provide reinforcement. But if one or another supposition is questioned, a shadow of doubt is cast on the conclusion that *the* Indiana stone-carver was an integral part of his society creating images that reflected community taste; observational data will be challenged on the grounds that fieldwork was not undertaken to test a hypothesis but only to reaffirm a presupposition.

Roberts proposes a third thesis seemingly independent of all or most of these assumptions. It is that "folk artists are a varied lot"; some of them might be alienated and others integrated, while yet others fall between these extremes. The correctness of this thesis seems to rest not on the foundation of assumptions

identified above, nor does it require fieldwork to test; rather, it stands or falls on the strength of a mixture of logic and what one knows experientially about human beings (having the distinct advantage of being human oneself). To believe or to doubt this thesis of Roberts's compels a reconsideration of some of the words, terms, and concepts often employed in folklife studies and in Roberts's essay.[5]

What do the words "folklore," "folklife," and "folk art" mean, after all? Unfortunately, within the "community" of scholars calling themselves folklorists there is no consensus; these words have different meanings for different people. Nor is there agreement as to the goals of folkloristics (or to what Roberts identifies as folklife research). Unlike some others, Roberts distinguishes between folklore and folklife, although he implies that "tradition" is the crucial component of both. The goal of folklife research according to Roberts is to study "the way of life of the preindustrial era ... [and the] ways in which it persists into the present." That is to say, the folklife researcher examines "survivals" from the past. This goal is not necessarily shared by all folklorists, some of whom would bristle at the thought that they are antiquarians. But it might not even be subscribed to by Roberts who articulates it. Roberts criticizes earlier collectors who conceived of some form of folklore as "an 'antique,' a chance survival from an earlier and nobler age," which logically is also a critique of the conception of folklife and the goal of folklife research posited by Roberts later. When speaking of art, Roberts mentions "incredible skill" and the "rich and complex symbolism involved," implying that these are distinguishing qualities. Some readers, however, probably would observe that "incredible skill" is a value judgment subject to much dispute; and further if everyone understands the image then the designs which are allegedly symbolic are neither so "rich" nor so "complex" as Roberts states. And everyone does understand the images, according to Roberts, who explains that what is to be labeled "folk" is that which is "widely and immediately understood by the community." At this point the reader might begin to doubt the validity of Roberts's third thesis that artists are a varied lot. Given Roberts's emphasis on the persistence of survivals, on stasis and homogeneity, and on integration and sociocultural equilibrium, how can there be variation?[6]

But day to day experience dictates the verity of Roberts's pronouncement. Individuals differ in attitude, temperament, capability, and behavior. There is a diversity of human expression and there are differences in identity. As Roberts suggests, however, important similarities abound. One of the similarities is that being human urges us to try to perfect form in some aspects of our lives and to appreciate the achievement of formal excellence by others. That perfection of form is fundamental to human experience can be inferred from the productions and performances of people as described and analyzed by those who have concerned themselves with not only the monumental and novel, but also the commonplace and familiar. This includes the present essay by Roberts.

Obviously I disagree with Roberts's first two theses and their implications. While making observations of phenomena in the situations in which they naturally exist or occur might aid one in solving research problems, this is not necessarily so. Doing fieldwork does not ensure establishing facts, gaining insights, or correctly interpreting human behavior. And whether helpful or not, fieldwork is neither mandatory for researchers nor is it the only or best source of information and means of testing hypotheses. In addition, in my view the goal of folkloristics (which I prefer to folklife research) is to study the continuities and consistencies in behavior, manifested primarily in first hand interaction, through personal observation or by means of records composed by others in order to understand better and appreciate more fully what people make and do and how they think. To accomplish this goal, the continuities and consistencies in the behavior of anyone anywhere at any time can be examined.[7]

It is apparent also that I agree with Roberts's third thesis that human beings, all of whom have a feeling for form apparent both in what they create and how they respond to it, are a varied lot. I have reached a conclusion similar to Roberts's, but seemingly along a rather different path from what he has proposed that we follow.

Michael Owen Jones

Notes

1. Robert A. Georges and Michael Owen Jones, *People Studying People: The Human Element in Fieldwork* (Berkeley: University of California Press, 1980), p. 1.

2. Ronald P. Rohner, ed., *The Ethnography of Franz Boas: Letters and Diaries of Franz Boas Written on the Northwest Coast from 1886-1931* (Chicago: University of Chicago Press, 1969); A. Hingston Quiggin, *Haddon the Head Hunter: A Short Sketch of the Life of A.C. Haddon* (Cambridge: The University Press, 1942).

3. Rohner, p. 61. For some other remarks about problems with informants, see also pp. 24-25, 53, 55, 158, 163, 165-66. For other examples and a discussion of deception and apparent "uncooperativeness," see Georges and Jones's fifth chapter, "Reflection and Introspection."

4. Examples are given in Michael Owen Jones, "In Progress: Fieldwork—Theory and Self," *Folklore and Mythology Studies* 1 (1977): pp. 1-23. See also Jones, "The Study of Folk Art Study: Reflections or Images," in *Folklore Today: A Festschrift for Richard M. Dorson,* ed. Linda Dégh, Henry Glassie, and Felix Oinas (Bloomington: Indiana University Research Center for Language and Semiotic Studies, 1976), pp. 291-303; Simon J. Bronner, "Reflections on Field Research in the Folklife Sciences," *New York Folklore* 6 (1980): pp. 151-60.

5. See Michael Owen Jones, *The Hand Made Object and Its Maker* (Berkeley: University of California Press, 1975).

6. See Michael Owen Jones's review of *American Folklife* in *Western Folklore* 36 (1977): pp. 259-65.

7. As for example, some of the behavior examined by Michael Owen Jones in "L.A. Add-ons and Re-dos: Renovation in Folk Art Study and Architectural Design," in *Perspectives on American Folk Art,* ed. Ian M.G. Quimby and Scott T. Swank (New York: W.W. Norton, 1980), pp. 325-64, and by Simon Bronner in the last chapter of this book.

Reply: Folklife Research and Folkloristics

Actually, Roger Welsch and I are in basic agreement. Welsch did his fieldwork and I did mine; our results may differ somewhat but our approaches are similar. Michael Owen Jones, on the other hand, criticizes basic concepts of folklife research, as it has come to be known.

Consider Jones's thesis that a community must be totally homogeneous before one can generalize about it. He states, for instance, that if one medieval artist differs from the others, any generalization about medieval artists is invalid. If carried to its extreme, the argument would imply that no generalizations can be made about group or community of any size. Yet based on predominant trends generalizations are possible, indeed necessary.

The two major questions that Jones raises concern the character of folklife research and the importance of fieldwork to that research. Folklife research is properly the study of the old traditional way of life of Western Europe and of the peoples of North America of European ancestry with emphasis on the material manifestations of that way of life—the persistence of that way of life into contemporary times and its influences on modern life.

I have adopted this description for several reasons. First, it adequately portrays what people who call themselves folklife researchers have been doing and are doing in Scandinavia, Great Britain, and the United States. Should anyone question the validity of this assertion, let them look through the pages of the Swedish journal *Folk-Liv,* the British journal *Folk Life,* and the American journal *Pennsylvania Folklife.* Most of their articles will be found to treat subjects that are included in my description.

Second, this description represents a holistic approach and avoids trying to isolate items of culture from their context as happens when one tries to study "anyone anywhere at any time." I feel strongly that if one picks out a few items such as artifacts from a strange culture, one can hardly understand them or deal with them successfully. It is hard enough to understand all the ramifications of items from our own culture, but with the help of fieldwork one at least has a chance.

Third, I feel that fieldwork is basic to folklife research. I also assert that it will not be productive in a culture to which the fieldworker is a stranger and where a language is spoken which the fieldworker cannot understand or can only imperfectly understand. The American folklife researcher therefore should work in Western Europe and in North America. If folklife research is to be undertaken in Pakistan, let us say, it should be undertaken by Pakistani scholars who understand the languages spoken and who are familiar with the traditional culture. I would hope that folklife researchers in different parts of the world would keep in touch with one another, of course, to discuss research methods and to share their research findings.

Fourth, all scholarly disciplines that deal with human beings and with human society should be merged so that all sorts of artificial barriers which hinder research could be swept away. I am, however, realistic enough to realize that the merger will probably never come about. Hence I feel that anthropologists, sociologists, and students of popular culture should study the societies they wish to and leave the traditional society of the preindustrial era, especially as it persists into contemporary times, to the folklife researcher. I realize with some regret that anthropologists study European "peasant" society while some sociologists study American rural society, but this sort of overlapping is unavoidable.

A division among scholarly disciplines on the basis of what cultures they study makes far more sense than any other arrangement. Indeed, if one is to follow the holistic approach to culture, what other alternative is there? What sense does it make to have two people studying all aspects of a certain society with one claiming to be an anthropologist while the other claims to be a folklorist? The alternative, of course, is for the folklorists to claim that they study only a few aspects of a culture while ignoring the rest. This is why Michael Owen Jones can claim that he and other folklorists are examining "the continuities and consistencies in the behavior of anyone anywhere at any time." I continue to hold, nonetheless, that this sweeping notion is untenable at worst, and too ambiguous at best.

Even when folkloristics is done in cities, for example, it has usually dealt with material from preindustrial, rural societies that for one reason or another has persisted in the cities.[1] Consistently, folklorists apply a folklife research conception because it is basic to the intellectual heritage of the discipline.

For me, the most distressing aspect of Jones's perspective is his equation of folklife research with "folkloristics." Given that folkloristics tries to examine the behavior of anyone anywhere at any time, it ultimately must revert to removing items from their cultural contexts. That is one of the main reasons I abandoned folkloristics twenty years ago and have since devoted my attention to folklife research. The techniques of folkloristics may indeed be suitable for the problems Jones poses, but it is misleading to associate folklife researchers with "antiquarians" who study "survivals."

The basic question here is whether folklife research and folkloristics are identical. I submit they are not. Folklife research tries to deal with all aspects of traditional society. I admit that its practitioners have concentrated on the artifacts of that society. But folkloristics tries to deal with only a few elements, mainly tales and songs, and ignores the rest. Folklife research concentrates on one society. Some of its research goals have been and should continue to include discovering how homogeneous that society was. Folkloristics, however, includes the study of all human societies, and behaviors that transcend cultures.

In short, the task of folklife research should be to understand as much as possible about traditional society and what has happened to it. The goals and scope of folklife research are thus realistic and valuable. The goal of folkloristics may be the examination of fundamental human behavior in all places at all times, but I question the manageability of its scope.

On the issue of fieldwork in folklife research, Jones undercuts the importance of fieldwork and asserts that the only intellectually defensible justification for it is to collect data, and, at the same time, to test a hypothesis. It is obvious, however, that fieldwork is the main source of information upon which both folklife research and folkloristics are based. Whether or not one does fieldwork oneself, one constantly uses the material collected by other fieldworkers. Fieldwork can involve interviewing, but folklife researchers also compile records by measuring, photographing, and collecting artifacts.

Although we may actually not be that far apart on the importance of fieldwork, I cannot agree with Jones's insistence that fieldwork must always involve testing a hypothesis. Fieldwork of a general exploratory nature is vital. Henry Glassie's *Passing the Time* (1982) is an example of a successful ethnography that was not restricted by a hypothesis. In addition, when I set out some years ago to investigate local cemeteries, I had no idea I would find great numbers of tree-stump tombstones. In fact, at the time nothing was written on the subject to help me. What kind of hypothesis could I have set out to test when I did not know tree-stump tombstones existed? Indeed, Jones's study of a Kentucky chairmaker was inspired by fieldwork that did not test a hypothesis.[2]

Folkloristics is not a panacea for the difficulties of folk artifact study. Although folklife research may not be the cure-all either, it boasts valid and valuable insights into culture, society, and humanity. It is a method still appropriate, indeed crucial, to present and future research in the discipline.

Warren E. Roberts

Notes

1. For a discussion of urban material culture research disputing Roberts's claim, see Simon J. Bronner's "Researching Material Folk Culture in the Modern American City" in this volume.—Ed.

2. Michael Owen Jones, "Chairmaking in Appalachia: A Study in Style and Creative Imagination in American Folk Art" (Ph.d. dissertation, Indiana University, 1970); idem, *The Hand Made Object and Its Maker* (Berkeley and Los Angeles: University of California Press, 1975). See also Henry Glassie, *Passing the Time in Ballymenone: Culture and History of an Ulster Community* (Philadelphia: University of Pennsylvania, 1982).

Time and Performance: Folk Houses in Delaware

Bernard L. Herman

The broad intent of this essay is to begin transcending the confines of genre-oriented studies in a quest for the fundamental human unities which render the analysis of material culture part of community life and work.[1] Less ambitiously, however, I will dwell here on a single problem which involves the close analysis of a single pair of objects in an effort to breach the common ground of individually and collectively shared aspects of tradition, creativity, and expression through time.

Theoretical Models of Material Culture

The dimension of time is just one of several contextual frames which may be considered in the ethnographic study of material culture; but it is also one of the most problematic and least understood. Structural analysis offers a tool for comprehending the workings of time and material expression, but in the disciplinary rift between synchronic and diachronic perspectives the full force of time as an analytic dimension is lost through historians' recurrent penchant to perceive the real world as an ordered series of events or to collapse time to a cluster of cognitive issues that are artificially eternal.[2] Object-oriented ethnographers' basic method usually works from artifacts to comprehend patterns and, in turn, to interpret in cultural, historical, linguistic, or other analytic terms just what those patterns mean beyond the establishment of their material presence.

To accomplish those ends a number of theoretical models have been advanced which allow us to evaluate the nongenre-bound relationships of things. One such significant model, "performance," recognizes that all areas of expressive culture possess some sort of constitutive grammar: that material

culture like speech works from certain rules of composition and that these rules are subject to change through the necessarily individual, variational articulation of collectively or individually delineated concepts.[3] Such grammars are developed around semantic codes which dictate a correct articulation or expression. The grammar then comes to be modified through its expressive manifestations, or performances of material forms. The semantic codes of material culture allow for the interplay of tradition and individual elaboration within the directing dictates of specific cognitive grammars.[4] The grammar of correct forms allows for conceptual options, each culturally appropriate at certain times, and each allowing for variation through the available options of performance.

Types of Temporal Relationships

Turning to the dimension of time in material culture, items may be assessed as possessing at least three sets of temporal relationships: initial performance, subsequent performance, and mnemonic-cognitive presence.

Initial performance denotes the first complete or whole material statements of a given concept and, accordingly, its full set of relations to the context in which it was generated. When the artifact is "articulated," it becomes a physical synthesis of an entire range of conceptual options and contextual limitations which result in the empirical compromise of replication and variation. In the act of creation the craftsman and client work within a process which produces a satisfactory resolution to a given problem. Should the conclusion be unsatisfactory, then the client-craftsman contract has been violated, and the resolution is either an outright rejection of the object or the reworking of the artifact to bring it into accordance with the expectations implicit in the initial generative grammar.[5] On occasion something which fails in acceptability may be categorized as aberrant or idiosyncratic. In this way the community may make a conceptual slot for an expressive item perceived as radically out of line with the norm, but nonetheless minimally acceptable on those terms.

Material culture is unique in the sense that once the artifact had been executed it physically passed through time. This quality provides the potential for the physical modification of the object in accordance with ensuing conceptual options. The most common expression of this *subsequent performance* is through the processes of addition, subtraction, improvement, elaboration, and repair. Through any one of these methods of change the initial statement via subsequent interpretations may come to be dramatically different from its original expressive values. At this point the analytic problem is introduced of how to interpret the object, that is, at what point in its history should attention be given to and what inferences made from the object. The seriated bias which previous historical studies have stressed is rendered superficial in examining an artifact that has passed through generations of changes reflective of the hands

and minds of many individuals who have manipulated complex and varied ideas in an effort to bring the item into accordance with perceptions of utility or the values of the period.

The *mnemonic-cognitive presence* and power of the artifact through time is more easily recognizable, yet more difficult to evaluate in terms of its impact on the grammar from which it was generated and made material. Once the artifact has been made, it endures through subsequent changes and expressive overlays as a statement of both a competence in the articulation and execution of ideas and as a memory looking back to physical and conceptual antecedents, and forward as an antecedent in its own right.[6] The presence of deep structures, mental templates, or constitutive images has been repeatedly noted, but the notion of the reinforcement of those images through actual objects has not been as well developed.[7]

Perception is rooted in empirical experience, and perception thus provides the core of abstraction for a grammar of working ideas. In this sense the object functions as a bearer of articulated competence and manifest memory; but it is in the mind of the builder, client, and audience that those perceptions are ordered into a cluster of available options left open to interpretation through performance. Accordingly, there is an inherited mechanism for the rejection of particular options. Rejection does not occur as an act of outright and irrevocable deliberation; rather it takes place as a phasing out process whereby established options are gradually superseded by other possibilities. In such a grammar, nothing may be deemed as backward, but rather as fulfilling specific expressive needs in contexts where alternative options have generally proven to be more viable—options which have assumed a dominant position in what might be designated as the mainstream. Thus the character of tradition achieves the configuration of conceptual images conveyed through material forms.

Architectural Illustrations of Temporal Relationships

The quality and function of the three temporal relationships may be best plotted through actual objects. Although any artifact genre would equally illustrate the nongenre-based utility of these ideas in the interpretation of the generation, modification, and impact of materializing thought through tangible things, consider examples taken from my study of Delaware vernacular architecture. The two exemplary houses I will discuss share eighteenth-century origins and raise issues of time and creativity. Discussed together they map a unity of thought and cultural process. To provide a tighter contextual frame for analysis, I examined primary source materials including tax assessments, land records, wills, and inventories and I plotted the relative significance of the buildings in relationship to one another and the surrounding historical landscape.

Located in St. Georges Hundred in central New Castle County, Delaware, the James McDonough House and the Christopher Vandergrift House originated in the mid-eighteenth century. The McDonough House was built as a brick, two-story, one-room plan dwelling with rough exterior dimensions of twenty by twenty-four feet (figs. 8-1, 8-2).[8] The principal facades were laid in Flemish bond and accented by a full-length pent running along the first-floor level and a balanced, three-bay, center door fenestration, while the gable end was laid in common bond and pierced only by a bulkhead entrance to the cellar. On the interior, the first and second floor rooms were finished with fully paneled hearth walls; the first floor was ornamented with raised-panel aprons beneath the windows. When the house was assessed for taxes in 1816 it was one of only thirty brick dwellings in St. Georges Hundred.[9]

The Christopher Vandergrift House (fig. 8-3) was begun in the third quarter of the eighteenth century as a one-room plan, one-story plus loft dwelling of straight mill-sawn plank construction. Sawn plank as a construction technique has been found in the last five years of research to be a major building technology employed in the later eighteenth and early nineteenth centuries throughout the Chesapeake Bay country and adjacent Piedmont regions. Falling into two primary construction types, sawn-plank walling may be either notched at the corners, usually with full or half-dovetail joints, or tenoned into corner posts in a manner not unlike *pièce sur pièce* log construction. To date, areas with this building method have been surveyed and recorded in Queen Anne County, Maryland, and Southampton County, Virginia, with scattered examples located in Delaware and the Virginia Piedmont.[10]

The Vandergrift House (fig. 8-4) has sawn planks with an average twelve-inch face and four-inch thickness, notched together at the corners with full dovetail joints and the interstices between the planks caulked with oakum—a tarred fiber used by shipbuilders for seaming the hulls of wooden vessels. With little evidence of weathering on the exterior surfaces of the plank walling, it is likely that the house was originally sheathed with some sort of clapboard or weatherboard siding as was the case with many log structures in neighboring areas of Pennsylvania and Maryland. The first-floor room of the Vandergrift House (fig. 8-5) was furnished with a large interior gable-end chimney. A fireplace opening was capped by a hewn-beam lintel beveled upwards on the interior side of the hearth.[11] Overhead, the ceiling joists were left exposed with champfered edges ending in simply flared terminals. The one-story structure was capped with a steeply pitched gable roof with the eaves projecting roughly six inches beyond the face of the gable-end walls. The whole building rested on an English bond foundation over a full cellar. Again, according to the 1816 tax evaluations for the Hundred, the Vandergrift House was one of thirty structures classed as being of log construction and one of a total of 107 structures described as being built of some sort of wood or timber fabric.[12]

Figure 8-1.　McDonough House, McDonough, Delware.
Begun Second Quarter of the Eighteenth Century and Enlarged
and Altered Repeatedly During the Nineteenth Century.
(Bernard Herman)

Figure 8-2. 1750 Plat of "The Trap" Depicting the McDonough
House at the Time of its Purchase by James McDonough.
(Bernard Herman)

In 1816 the two one-room plan structures would have been considered well above the average dwelling in terms of the quality of construction and ornamentation. Probate inventories further substantiate this likelihood with extensive listings of expensive personal goods. Patrick McDonough's estate, recorded in 1804, included three dwelling houses, kitchen, barn, stable, and crib.[13] His inventory, dated 10 November 1803, appraises the value of a number of items such as six yellow Windsor chairs, "three pictures in the Brick Room," silver service, wool wheels, farming equipment, a supply of unused beehives in the smokehouse and assorted livestock.[14] The whole of McDonough's estate, excluding land holdings, was evaluated at $1,903.14.

Christopher Vandergrift, whose inventory was taken on 19 March 1818, owned maps, a walnut desk, a "large Blue Chest & Glass," carpet in both the parlor and the "Common Room," a stockpile of milled lumber and eight slaves, including three adult males and five children ranging in age from three to fifteen. Vandergrift's estate was appraised at $3,497.30, but if the $1,390 in slaves is subtracted, the whole of his estate is worth $2,107.30 or nearly equal in value to McDonough's property.[15] The comparative worth of the two properties, however, is obscured because Christopher Vandergrift's father predeceased his son by only a year and many of the possessions listed on the elder's inventory reappear in the second accounting.[16] From the evidence in the 1816 tax assessments there is no doubt that father and son were maintaining separate households with Christopher Sr. residing in a "good wooden dwelling" and his

Figure 8-3. Vandergrift House, Biddle's Corner, Delaware. Begun Third Quarter of the Eighteenth Century and Enlarged Seven Times Prior to 1900.
(*Bernard Herman*)

Figure 8-4. Plank Walling Chinked with Oakum in the Original Block.
Vandergrift House, Biddle's Corner, Delaware.
(*Bernard Herman*)

Figure 8-5. First Floor Interior of the Original Block Showing Brick Piers Defining the First Hearth and Plaster Board Covering Formerly Exposed, Chamfered and Whitewashed Ceiling Joists. Vandergrift House, Biddle's Corner, Delaware. (Bernard Herman)

son living in a log house sited just across a mile of intervening fields.[17] Patrick McDonough's descendants and heirs are similarly shown inhabiting the brick structure noted in the inventory of thirteen years before.[18]

These documents would *seem* to provide little information, outside the groundwork for the construction of a folk taxonomy for personal goods, toward our understanding of the dwellings under discussion. Such is not the case, however, for the probate inventories and tax assessments furnish an invaluable sense of persona at a crucial moment in the architectural development of St. Georges Hundred. By 1835, a dramatic reshaping of the vernacular landscape was in progress and symbolized by the opening of the Chesapeake and Delaware Canal in 1829.[19] In previous generations, with only a handful of notable exceptions, rising affluence was expressed in terms of land, plate, and slaves; but in the years following, conspicuous consumption could be seen in a general rebuilding period lasting until the 1870s (fig. 8-6). There are indications that the McDonough House and Vandergrift House prior to 1835 had started to expand beyond their one-room plan origins. Both sets of inventories suggest the presence of more than a single first-floor room, but what is of particular note is the formal qualities the additions assumed.[20] At some point in the first quarter of the nineteenth century the two dwellings had each received a major addition which restructured the layout of the original houses.

A central deficiency in the quest for specific generative grammars in material culture studies is the ardent preoccupation with objects as singular statements created at a particular moment in time rather than as a plural phenomenon modified by a series of creative acts across broad spans of time. It is in *subsequent performance*, though, that the power of changing notions of design is most keenly felt. In architecture especially, the spatial, stylistic, or constructural idiom which describes the *initial performance* may be subjected to seemingly radical change, thus transforming the original expression into something almost unrecognizably different. The norm, however, is to accomplish the physical requirements of subsequent performances with as little discomfort or expense as possible. Subsequent performance, then, becomes a marker of individuals' perceptions of themselves in their community under the stress of changing fashions and human needs. Qualitatively, subsequent performance can aggressively alter an initial expression and yet maintain certain continuous images of self.

Both the McDonough House and the Vandergrift House plot the pattern of these successive impressions through the multiple additions and alterations they received from the early to mid-nineteenth century. The inventories of the early nineteenth century owners show a degree of affluence and landed stability denied to the bulk of the population, while the houses themselves fall into a formal class built by members of all economic strata. That the one-room plan dwellings of modest dimensions were an acceptable Anglo-American domestic space

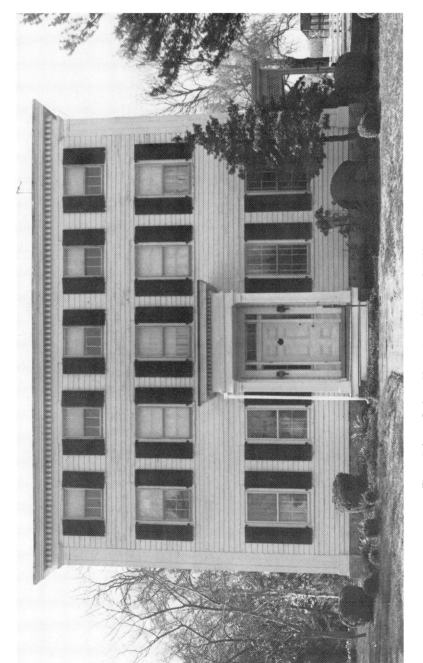

Figure 8-6. Cochran House, Located West of Middletown, St. Georges Hundred, New Castle County, Delaware. *(Bernard Herman)*

regardless of economic class lines may be inferred from these two buildings, their neighbors, and the houses of Maryland's western shore tenant population of the third quarter of the eighteenth century.[21] In all instances the standard house was approximately sixteen by twenty feet and rarely greater than a story and a half in elevation except in the instance of brick structures which were often erected to a height of two stories with an attic. When elements of style and the quality of construction are taken into account, a significant difference between the structures of a single formal type becomes evident; those dwellings originally more substantial and fashionable are the same ones receiving overlays of *subsequent performances*. Such dwellings survive to the present day as something more than subsurface archaeological remains.

When the McDonough and Vandergrift houses received their first major additions, the Georgian standard of a center hall, double pile, bilaterally symmetrical, tripartite house had been current in the area for nearly a century. In addition, all of the so-called Georgian subtypes—side hall plans; one-room deep, center hall plans; and four-room plans—were relied on with increasing frequency throughout the rebuilding period from approximately 1835 to 1870, for new houses, and for the enlargement of older structures. Through the manipulation of an additive grammar the McDonough and Vandergrift houses were expanded beyond their one-room plan origins into more or less Georgian forms.

For the Vandergrift dwelling (fig. 8-7) this change may be witnessed as phases two and three of seven successive *subsequent performances*. The eighteenth-century, one-story dwelling received its first major addition—a side hall plan, one-room deep, two-story frame, gable-end wing sometime prior to 1834—which resulted in a center hall plan of uneven elevation. An Orphan's Court survey undertaken in 1834 sketches the house at this stage in its development with two primary entrances: one into the new centrally located passage, and the other into the original block or what was designated in the 1818 inventory as the common room (fig. 8-8).[22] The house had thus been formally brought into line with the prevailing Georgian standard common among the houses of the more affluent members of the folk community; but the irregular fenestration and sharply differing roof lines scarcely conveyed the builders' design intentions as reflected in the ground floor plan. To remedy this feature, the Vandergrift House, which had now passed into the hands of the Biddle family,[23] received a framed vertical addition requiring the demolition of the original plank-house loft, the reuse of the original rafters in the construction of the new roof, and the raising of the corner-braced walls to the height of the new plate. The completed product now displayed a continuous roof line and five-bay fenestration at the second-story level in addition to the already established center passage plan.

Figure 8-7. First Floor Plan.
Vandergrift House, Biddle's Corner, Delaware.
(Charles Bergengren, Historic American Buildings Survey)

Figure 8-8. 1834 Sketch of the Vandergrift House at the Time of its Sale to Eli Biddle.
(Bernard Herman)

The McDonough House underwent a similar, albeit less complicated set of additions (fig. 8-9). In *subsequent performance* the plan was extended into a center passage arrangement by means of a two-story, braced-frame, gable-end wing. The original roof line was raised approximately one foot at the ridge, the pents removed, and the center doorway of the brick core infilled and relocated in the new center passage. At the same time the first floor interior trim was removed and replaced with more stylish early nineteenth-century architectural elements. Building scars suggest the former existence of a fully paneled, first floor fireplace wall containing a flanking storage closet or cupboard. A stair closet is also suggested; it opened up into the second-floor chamber where two-thirds of a paneled end wall remains intact including an overmantel with a central cupboard finished with two eight-light doors hung on "H" hinges and furnished on the interior with butterfly shelves (fig. 8-10). The mantel succeeding the eighteenth-century, first-floor paneling provides at least two valuable insights into the interpretation of the conceptual workings of subsequent performance. First, a strong sense of the function of style in folk arts exists, and second, there is a commentary on the factor of utility in design.

Stylistic motifs are typically understood as seriated phenomena around which periods of ornamentation may be temporally mapped. Style, however, also functions as a highly focused presentation of self.[24] Fashion, in terms of motifs, assumes an extremely fluid character, sometimes assuming dramatically

Figure 8-9.　First Floor Plan.
McDonough House, McDonough, Delaware.
(Bernard Herman)

Figure 8-10. Second Floor Interior of the Original House Showing
Fireplace Architrave, Chimney Cupboard and Surrounding Panel.
McDonough House, McDonough, Delaware.
(Bernard Herman)

different contours over the lapse of just a few years.[25] The purpose of style, though, is continuous in its intentions toward delivering a vital public impression of self on a number of levels. The Vandergrift and McDonough houses could have been enlarged through a number of formally acceptable means including the use of ells or one-room plan, gable-end appendages; but in both instances the occupants or owners of these dwellings chose to bring their houses into alignment with the prevailing formal standard of the Georgian house. In the McDonough House the change is so complete that the original entry into the brick house is enclosed (fig. 8-11) and the room is completely redefined from the common room status noted in the Vandergrift inventory.[26] Thus the McDonough House in subsequent performance is more than a bigger dwelling—it is a new dwelling with physically segregated spaces which map an altered image of what this particular house should be and it conveys that image to the outside world. The function of the changes wrought in this instance indicates more than simple utility; the changes are caught up in projections of status through style articulated in applied ornament and form.

Alterations in material culture with references to utility and without concern for fashion do occur in artifactual genres besides architecture. The remnants of Delaware's sail-powered fleet, for example, were converted with inboard engines by 1930, while the forward masts were left intact as truncated uprights which supported loading booms. A split oak basket (fig. 8-12) in south central North Carolina has one bottom corner worn out, but rather than being discarded, was repaired with scraps of a child's shoe. Similarly, furniture may be modified through overlays of new trim and paint or, as illustrated by John Kirk, a particular banister back armchair was transformed into a nineteenth-century, upholstered wing chair.[27]

Houses, in particular, are monuments to the living, and in the multiple layers of subsequent performance they display continuous and yet disparate attitudes to utility, community, style, and self. This characteristic is true for the contents of the houses as well. American social historians frequently survey inventories and wills for evidence of status goods such as plate or especially fine pieces of furniture in an effort to better understand the place of particular individuals in the pattern of a larger community context. In the record of the sale of Christopher Vandergrift's estate in 1818 among the most valuable objects was a pair of pictures of Admiral Perry and Commodore Thomas McDonough.[28] Commodore McDonough, well known as the "Hero of Lake Champlain" in the War of 1812, was born and raised in St. Georges Hundred.[29] Although related to the McDonoughs discussed here and probably a visitor to their house many times, whether or not the Commodore ever resided within its walls or participated in its changes remains questionable. Of significance, though, is that those associated with the local hero must have achieved considerable status within the collective eyes of their not so well connected neighbors. When Sara

Figure 8-11. McDonough House, East Elevation of the Original
Dwelling. As Originally Built, the House Possessed
Three Bays across Each Floor. The Central Door Leading
into the House was Bricked in During Renovations
Carried out in the 1800s. The Door was Located under
the Central Window on the Second Floor.
(Bernard Herman)

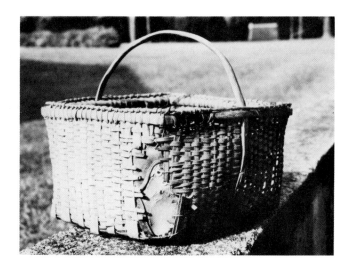

Figure 8-12. Split Oak Basket with Repair.
Mecklenburg County, North Carolina.
(Bernard Herman)

McDonough died in 1827 her estate also included a portrait of Thomas McDonough which celebrated her nephew's victory in the recent conflict with Britain.[30] The portrait commemorates things past, but its acceptance and importance in the eyes of the living is not to be denied, for just as the house with all its stylish additions and alterations shapes community impressions, the pictorial representation of family luminaries provides the same vital contextual framing of self.

The final series of *subsequent performance* overlays involved the addition of multiple wings with some attention to late nineteenth-century stylistic trends. In the period after 1840 the McDonough House and Vandergrift House received a series of service appendages. Additional sleeping chambers and parlors were added on to the gable ends and rear elevations. Kitchens were now brought into the house and wed to the overall plan, and servants were no longer housed apart but brought into segregated spaces established within the main body of the dwellings. The Vandergrift House received an irregular Victorian cross-gable addition and a bow-front window cut into the north wall of the plank core, and both dwellings were made more fashionable with the construction of sitting porches enhanced with factory-produced, turned, and champfered posts and scalloped and scrolled trim. As complicated and diverse as all these changes may appear to our sensibilities, they never fell outside the cognitive pale of the surrounding architectural environment. The Vandergrifts, McDonoughs, and later families who owned and occupied the same dwellings, were never the first

to introduce innovations but they were always in the tasteful vanguard of those who incorporated those ideas into their own experience, once practicality and acceptability had been proven and established.

Here, then, is the *mnemonic-cognitive presence* of the folk artifact. The McDonough and Vandergrift houses through time exhibit varying degrees of fashion and responses to shifting styles. Every artifact, in fact, is evidence of single and multiple competency successively and sucessfully executed in multi-layered, archaeologically distinguishable, strata of performance. The object is a document made meaningful through contextual relationships. The object also records through the passage of time the vitality and frailty of individual human needs and aspirations. The house, the basket, and the chair are memory and knowledge made and made again. It is at this juncture that time may be collapsed into an interpretive synchronic frame, for in the long run the temporally definable and the timeless must be brought into dynamic accord.

Notes for Chapter 8

1. See Robert Redfield, *The Little Community and Peasant Society and Culture* (Chicago: University of Chicago Press, 1962), p. 14.

2. Michael Lane, "Introduction," in *Introduction to Structuralism,* ed. Michael Lane (New York: Basic Books, 1970), pp. 11–39.

3. Henry Glassie, *Folk Housing in Middle Virginia* (Knoxville: University of Tennessee Press, 1975), pp. 19–40.

4. Dell Upton, "The Descent of Forms and Architectural Codes" (paper read at the American Studies Association meeting, Boston, 1977); see also his "Toward a Performance Theory of Vernacular Architecture: Early Tidewater Virginia as a Case Study," *Folklore Forum* 12 (1979): pp. 173–98.

5. Louis J. Chiaramonte, *Craftsman-Client Contracts: Interpersonal Relations in a Newfoundland Fishing Community* (St. Johns, Newfoundland: Institute of Social and Economic Research, Memorial University, 1970), pp. 47–62.

6. Bernard L. Herman and David G. Orr, "Pear Valley *Et Al.*: An Excursion into the Analysis of Southern Vernacular Architecture," *Southern Folklore Quarterly* 39 (1975): pp. 312-14; Yvonne J. Milspaw, "Reshaping Tradition: Changes to Pennsylvania German Folk Houses," *Pioneer America* 15 (1983): pp. 67-84.

7. Gaston Bachelard, *The Poetics of Space* (New York: Orion Press, 1964), p. xv; James Deetz, *Invitation to Archaeology* (New York: Natural History Press, 1967), pp. 83–96; Robert F. Trent, *Hearts and Crowns: Folk Chairs of the Connecticut Coast, 1720-1840* (New Haven: New Haven Colony Historical Society, 1977); Glassie, pp. 19–21.

8. Survey of James McDonough's property, "The Trap," New Castle Country Surveys, M2: No. 55 (August 1750).

9. "St. Georges Hundred Assessment List," *New Castle County Tax Assessment Records, 1816-1817* (Hall of Records, Division of Historical and Cultural Affairs; Dover, Delaware), p. 71.

10. The sawn-plank building tradition of Queen Anne County, Maryland, was first recognized and brought to my attention through the work of Orlando Ridout, Maryland Historical Trust.

11. The fireplace, originally present in the Vandergrift House, was removed during the course of nineteenth-century alterations. A parallel arrangement remains *in situ* in the Young House (1868) located in neighboring Red Lion Hundred.

12. *New Castle County Tax Assessment Records, 1816-1817,* pp. 116–17.

13. "St. Georges Hundred Assessment List," *New Castle County Tax Assessment Records, 1804* (Hall of Records, Division of Historical and Cultural Affairs; Dover, Delaware).

14. "Inventory for Patrick McDonough, November 1803," *New Castle County Inventories* (Hall of Records, Division of Historical and Cultural Affairs; Dover, Delaware).

15. "Inventory for Christopher Vandergrift, March 1818," *New Castle County Inventories.*

16. "Inventory for Christopher Vandergrift, Sr., March 1817," *New Castle County Inventories.*

17. *New Castle County Tax Assessment Records, 1816-1817,* pp. 116–17.

18. Ibid., p. 71.

19. Carol E. Hoffecker, *Delaware: A Bicentennial History* (New York: W.W. Norton, 1977), pp. 39–48.

20. As products of the rebuilding of St. Georges Hundred, 1835–1870, the McDonough and Vandegrift houses responded to the prevailing Georgian formal tastes of the period.

21. Gregory A. Stiverson, *Poverty in a Land of Plenty: Tenancy in Eighteenth-Century Maryland* (Baltimore: Johns Hopkins University Press, 1977), pp. 56–84.

22. "Inventory for Christopher Vandergrift."

23. *New Castle County Orphans Court Records* (Hall of Records, Division of Historical and Cultural Affairs; Dover, Delaware), Book O, pp. 178–79.

24. Erving Goffman, *The Presentation of Self in Everyday Life* (Garden City, New York: Doubleday, 1959).

25. Meyer Shapiro, "Style," in *Anthropology Today,* ed. A.L. Kroeber (Chicago: University of Chicago Press, 1953), pp. 287–312.

26. "Inventory for Christopher Vandergrift."

27. John T. Kirk, *The Impecunious Collector's Guide to American Antiques* (New York: Knopf, 1975), p. 114.

28. "Sale of the Personal Property of Christopher Vandergrift, March 1818," *New Castle County Inventories.*

29. Harold Donaldson Eberlein and Cortlandt V.D. Hubbard, *Historic Houses and Buildings of Delaware* (New York: Dover Publications, 1962), pp. 137–40.

30. "Inventory for Mrs. Sara McDonough, March 1827," *New Castle County Inventories.*

Comments

Time as an Analytical Concept in Material Culture

Bernard Herman's essay addresses issues which have concerned me during the years I spent studying folk architecture in a Utah valley and working with the Utah State Historical Society's preservation section. Let me begin by applauding Herman's contextualist effort; our cultural-geographic past has rarely stimulated such active historical involvement. The artifact is never quite so "mute" as we might first think. Primary sources like plat records, probate inventories, and census reports—relatively neutral documents—contain important information about the situation in which the object occurred. Even an owner's name is important for it opens up another set of records—obituary notices, diaries, and oral interviews—which can humanize the material object and figure prominently in answering ultimate questions concerning the expression of individual and cultural identity. Such supporting material also gives the researcher a better handle on dating procedure.

Technological signs, if properly controlled, still continue to be useful chronological guides. A simple record of property ownership can often, however, substantiate what we see in nails and molding; exact dating is probably impossible, but the attempt is worth the time and trouble if we want to build effective models of change. Here in the West we are working with a time-depth—fifty to sixty years of a vigorous folk tradition—which makes dating more of an issue, but other sections of the country should also be concerned about the reliability of collected data. Herman's work sets an important example in elevating context to an estimable position, but it makes its most pointed statement in the area of subsequent performance. My Utah work with this problem moves me to add several comments.

In bringing up time as an analytical concept, Herman is responding to a widely held fear that structuralism locks the artifact into a rigid set of rules which ignores the dynamic nature of performance; Herman cautions that material things are often plural phenomena rather than singular statements. The analyst is thus caught on the uneven ground between the diachronic recognition of

change and the synchronic need to know well what it is that changes. The realization, as Herman points out, that material culture like speech works from rules of composition and, further, that these rules are subject to change leaves us in much the same predicament. Inevitably, decision of priority must be made. Henry Glassie solved the dilemma by ordering his analytical moves, using synchrony "as a step toward diachrony."[1] Herman's solution rests with the delineation of performance levels, each becoming essentially layered synchronic steps held together by the artifacts' mnemonic-cognitive ability to exist through time as both tradition and innovation. In either case, temporal qualities form part of an artifactual whole which is material fact.

In the field, initial and subsequent performance cannot be isolated for independent scrutiny. The analyst's task must therefore be to record the complete statement in order to extract performance strata. Walking around the house, measuring its walls, and poking in the attic, we can see successive overlays of construction. From this fieldwork we abstract a geometric repertory—the structure which binds objects and the modification of those objects into a rational system, a "constitutive grammar." Such a process is necessarily synchronic; we order what we see before attempting explanation. The artifactual competence generates things which have form, occupy space, and exist in time. Each complete initial performance and each subsequent performance, once recorded, can be dated, and by introducing time we reinstate chronology and illuminate change (or its lack). The transformations witnessed in the McDonough and Vandergrift houses are understandable only in terms of a larger analytical frame, as part of Herman's study of Delaware vernacular architecture.

Herman outlines a series of conceptual moves taken by the occupants of the McDonough and Vandergrift houses to make overtly "new" articulations of expressive form. The alterations are more than utilitarian, they strive to bring the house into accord with changing style. The additions aspire to a predictable model—predictable because Herman knows the "semantic codes" operating within the architectural competence. Without synchronic study, changes in performances might be discovered but the thinking behind such design modifications would remain obscure. The taxonomy of local house types includes (among others) the single room "hall plan" house of the late eighteenth century and the Georgian "double pile, center hall" symmetrical house of the mid-nineteenth century. The tale of subsequent performance laid out here results from a dialogue between these two ideas—one conservative and the other innovative. The competence contains rules for both designs, yet by the 1850s builders were increasingly opting for the Georgian style in new buildings. Older buildings were remodeled similarly, yet with varying degrees of success. The dialectic created in the initial to subsequent performance sequence often required internal compromises in the conceptual grammar, a point in need of more development.

Figure 8-13.

Floor Plan, Orville Sutherland Cox House. Manti, Sanpete County, Utah, 1978. *(Tom Carter)*

For the purpose of discussion, let me offer an example from Utah. The Orville Sutherland Cox home (figs. 8-13, 8-14a, 8-14b), a two-story limestone house with an asymmetrical six-bay facade, is located in Manti, Sanpete County, Utah. Cox's diary tells us that the house was constructed in 1858. The house, according to local court records, was purchased by Jezreel Shoemaker in the mid-1860s when Cox left Manti to serve a mission for the Church of Jesus Christ of Latter-day Saints. Following Shoemaker's death in 1879, Edward Parry bought the home. Parry was a stonemason and was "called" to Manti to supervise the masonry on the Mormon Temple, which was to be erected in that town. I recorded the Cox house in November 1978 as part of a larger study of Sanpete County folk housing.

The base structure of the original house was a double-pen (in Glassie's terms: XX) arrangement which sported a symmetrical six-bay, double-door facade (fig. 8-14a). Probably around 1880, soon after Edward Parry acquired the house, a center hall and staircase (the original boxed staircase ran along the back wall of the south front room) was inserted; this act required the restructuring of the principal facade into its present, rather off-balance configuration (fig. 8-14b). Although evidence of alteration was apparent in the blocked front doors and the late nineteenth-century framing on the hall, the remodeling was also expressed in the recognizably ungrammatical nature of the addition. The local folk competence contains rules for both the double-pen (XX) and the center-hall (XY₃X) house types. Study in the area reveals that the center-hall idea, while

Figure 8-14. Sequence of Facade Alteration on the Orville Cox House.
(Lee Benion)

a. 1858.

b. 1880.

obviously an option here from the time of first settlement in 1849, was employed only sparingly until the 1880s when most larger homes (usually built of brick) contained center passageways. At that time, several houses (like the Cox house) underwent center hall alterations. Thus data indicates that the center-hall option was used increasingly after 1880 for both new houses and for remodeling old ones. During subsequent performance a conflict in the rule system occurs which cannot be totally resolved.

Combining the rules for center hall houses (XY_3X) and double pen (XX) houses is conceptually easy: a six-foot-wide hall (Y_3) is placed between two square rooms ($16'1'' \times 16'4''$ and $17'10'' \times 16'4''$—the discrepancy is the center stone partition). In real terms, the move is impossible without knocking down stone walls. For hall and parlor houses (XY), the insertion of the passageway (fig. 8-15) proved relatively compatible with the original design concept and produced an altered home which maintained an internal-external balance. Superimposing the rules for the center hall on the double pen plan disrupted the competence and created an ungrammatical house which was incomplete on the inside (Y_2Y_2X—the hall being deducted from one of the rooms) and asymmetrical on the facade. In the mind that commissioned the work, the remodeled house complied with the rules to the extent that the house remained successful. If problems existed in the final solution, they were outweighed by the luxury of the new hall and staircase. Our only outward clue to the compromise effected in the designing capability is apparent on the facade.

Herman's Delaware houses display a similar confusion between *initial* and *subsequent performance*. The Vandergrift house was a five-opening-over-six facade on its first major addition, and the McDonough house appears as a six-over-five statement. In each case, the workmen knew the rules, and from the available options chose the best solutions. In actual performance, problems were encountered. Each house continues to be the articulation of the new idea, but not always a completely good one. The student of material culture must also know the rules before struggling with the concept of time. Once the constitutive grammar is established, overlays of performance are easily recognized.

Tom Carter

Notes

1. Henry Glassie, *Folk Housing in Middle Virginia: A Structural Study of Historic Artifacts* (Knoxville: University of Tennessee Press, 1975). The symbols used in my comments (XX, XY_3X, XY, Y_2Y_3X) are based on the taxonomy he uses.

Figure 8-15.

Robert Johnston House.
This Stone Two-Story Hall and Parlor House
was Constructed ca. 1865. The Hall Addition,
Three-Inch Vertical Beaded Boards, Appears
to Date from the Late 1880s.
Manti, Utah, 1979.
(Tom Carter)

The Preconditions for a Performance Theory of Architecture

Herman's argument is an appealing one, and on first and even second reading commands assent. Subsequent consideration suggests several elisions which are common to most of us who study artifacts. It seems to me that no convincing performance theory for material culture can be constructed unless we probe some of these gaps.

Working from a linguistic analogy, we have come to believe that, as Dell Hymes has claimed for language, "underlying the diversity...within communities and in the conduct of individuals are systematic relations, relations that, just as social and grammatical structure, can be the objects of qualitative inquiry."[1] Specifically, we believe that the range of social meanings and the range of choices in the construction and ornamentation of buildings are related, and that the makers and users adjust their actions in the latter in some orderly response to the former. A performance theory proposes to describe and ultimately to explain this relationship.

Two things are required for the construction of such a theory. One is to specify the community context in which the performance occurs, that is, to identify the social situations to which the building is a response. The other is to specify the exact content of the performance, the individual elements which are manipulated in response to social nuance. The performance theorist can then proceed to correlate the social situations to the artifactual response and arrive at

some conclusions about behavior. Without this sort of specifity, however, our theories can never go beyond speculation and impressionistic generalizations, nor can they ever be tested.

Such an undertaking requires intense examination of highly localized examples, as Herman has done. Further, as he shows, some comparative strategy is needed. That is, the study of an *individual's* responses cannot lead us very far. Hence he has chosen to explore two groups of individuals' actions, as revealed in a series of alterations to a pair of buildings. He has allowed an unanalyzed complex of traits that we like to call the "Georgian model" to stand for a statement of specific attributes of the Delaware houses that he treats. He assumes the existence of a Georgian standard of the appearance and morphology of buildings, a pervasive aesthetic introduced into Anglo-American traditional building during the eighteenth century.[2] The value of this insight, which is great, has been obscured by a tendency to overstress its unitary and universal aspects, and to blur the distinction between the model as a grammatical structure which reflects the cultural competence and specific examples of it produced in local performance.

When that happens, we forget to connect specific manifestations of the model to specific levels of social organization. Do they reflect responses to living in the locality, the nation, the culture, or some combination thereof? This general failure is present in Herman's argument, where the disembodied "current" Georgian standard is used to explain subsequent additions to the original single-room structures. But one wants to know the exact contents and relevance of the standard for nineteenth-century Delawareans.

As with language and literary symbolism, the symbolism of objects is often richly complex. The referents of a given expression—a paneled wall, a symmetrical five-part facade, a plan type—lie at several levels of social identification and intent, communicating through mutual reinforcement and nuance, or alternately through mutual contradiction. As an example of the former, the fact that a paneled wall is in a relatively current style, like that at the McDonough House, suggests something about the self-location of the owners within the context of Anglo-American culture, yet the particular form of paneled wall, in the context of the multiple, often eccentric variations discoverable in any extensive local survey, may have some less metropolitan significance. Levels of meaning here are apparent through the elaboration of mutually reinforcing attributes; they are lost when one accounts for the form merely on the basis of "awareness of style." Conversely, as Edward Chappell has shown for Shenandoah Valley Germanic houses, there can also be a contradiction in the reference— between an Anglo-American exterior, for instance, and a traditional Continental plan.[3] Here the contrast is meaningful, for the builder or user has responded to different aspects of his local and national context in differing ways.

Even features apparently extralocal in their references—the very Georgian model plan so widely distributed throughout eighteenth and nineteenth century Anglo-American building is an example—can be shown, through close local study, to have been adopted more for local reasons than for compositional ones. In eighteenth-century Virginia, the double pile and central passage elements of the Georgian model were taken up as one of several possible solutions to local problems of house planning which arose out of the peculiar socioeconomic structure that was created in the colony in the seventeenth century. The Georgian features were adopted partly because they resembled similar, but less satisfactory solutions used in Virginia in the late seventeenth century, and newer forms were often used analogously to the older ones. Straightforward application of the model was rare, and solutions entirely different from it were as common as those which employed central passages and double pile plans. The Georgian elements were part of a spectrum of architectural solutions to a program which was distinctly local. Though those plans which had Georgian elements undoubtedly had extralocal references, the local reference was the governing one.[4]

A performance theory of architecture, then, must specify carefully what the elements of the performance are and at which level or levels of social organization—family, neighborhood, county, region, and so on—the artifact is significant, and relate those elements to specific situations.[5] After locating the performance at a social level, the individual situations which provoke alterations in it must be identified. Students of folk architecture in their search for formal grammars and unifying architectural traditions have tended to forget that even rural societies are not monolithic ones. Sharp differences of class and economic standing (not the same things, as Herman implies) and values differentiate members of all communities. Recent studies of eighteenth and early nineteenth-century England and America have demonstrated the depth of these divisions and the consequent limitations of the social and cultural consensus upon which the notion of a Georgian model of architecture depends. Those ideas of symmetry, order, and hierarchy in society and politics, ideas which are customarily ascribed to the Georgian mindset were, as historians have shown, matters of constant dispute.[6]

If, as we all believe, artifacts like language are ways of commenting on those divisions, a workable performance theory of architecture involves close attention to these conflicts within the local milieu. The suggestion of simple social aspiration, implied in Herman's reference to the picture of Commodore McDonough, does not go far enough. Rather, the socioeconomic fabric must be described and the builders located within the whole cloth of ethnography. This cannot be done merely by examining the estate values of the individuals whose houses are discussed. The examination of objects as keys to values must go beyond the probate inventories of individuals, although the comparison of the McDonough and Vandergrift houses to other aspects of the families' material culture is a useful beginning.

Although the areas of inquiry suggested here go beyond the bounds of what is usually considered folklife, they point to the basic questions that a performance theorist must ask. Part of the problem is that the enterprise is so new that much elementary work needs to be done. A close study like Herman's is a step in the right direction, but without the careful analysis of specifics by performance theorists, the theoretically "new" result becomes merely the "old" observation.

Dell Upton

Notes

1. Dell Hymes, "Models of the Interaction of Language and Social Life," in *Directions in Sociolinguistics: The Ethnography of Communication,* ed. John J. Gumperz and Dell Hymes (New York: Holt, Rinehart and Winston, 1972), p. 38.

2. The concept was first formulated by Henry Glassie and presented in his *Pattern in the Material Folk Culture of the Eastern United States* (Philadelphia: University of Pennsylvania Press, 1969), especially pp. 48–59, 64–67. It was elaborated upon in his subsequent works, notably in his "Eighteenth-Century Cultural Process in Delaware Valley Folk Building," *Winterthur Portfolio,* 7 (1972): pp. 35–39; and in *Folk Housing in Middle Virginia* (Knoxville: University of Tennessee Press, 1975).

3. Edward A. Chappell, "Cultural Change in the Shenandoah Valley: Northern Augusta County Houses Before 1861" (Master's thesis, University of Virginia, 1977), pp. 52–76; see also Glassie, "Eighteenth-Century Cultural Process," pp. 41–43.

4. See Dell Upton, "Early Vernacular Architecture in Southeastern Virginia" (Ph.D. dissertation, Brown University, 1979), chapters 5, 6.

5. Hymes, pp. 43, 55.

6. See E.P. Thompson, "The Crime of Anonymity," in *Albion's Fatal Tree: Crime and Society in Eighteenth-Century England* (New York: Pantheon, 1975), pp. 304–8. The entire volume examines the conflict of values in rural and urban society, as does Raymond Williams's *The Country and the City* (New York: Oxford University Press, 1973). The theme is extended to America in Jesse Lemisch, "Beseiged in His Bunker," *Radical History Review* 4 (1977): pp. 74–77, and in most of the New England community studies, notably John Demos, *A Little Commonwealth: Family Life in Plymouth Colony* (New York: Oxford University Press, 1970).

Reply: Observation and Analysis

When I began my essay my intention was to map out an analytical frame in which the object's relationship to time and performance could be assessed. Issues of form, style, construction, and context were taken into account, but in this particular instance they were not the center of attention. I did not plan to suggest the tacit acceptance of yet another conceptual model, but to initiate some debate over the relevance of time in regard to material expression.

Upton especially clarifies analytical alternatives for dealing with vernacular architecture; one must certainly specify the community contexts and the social situations of performance to avoid the sterile wasteland of object-oriented studies undertaken without concern for the particular minds and hands that brought them into existence. Students of material culture inevitably find themselves walking a tightrope between individual and collective expression and tradition.

In St. Georges Hundred I recorded in detail over one hundred dwellings built and altered between 1700 and 1900. The Vandergrift and McDonough houses were chosen for this essay not as socially representative, but as two examples of artifacts that had witnessed radical change over a span of one hunded and fifty years. The most significant changes occurred in the early to mid-nineteenth century—a period when, for several economic, commercial, and social reasons, the area underwent a dramatic architectural redefinition. In terms of the built environment, observation tells us how and when these changes were felt; the two buildings presented here are part of the much larger pattern in which the Georgian house form and all of its associated variants became a dominant visual factor. Thus, as far as the examples of my essay are concerned, they are representative of one normative pattern of change among the more affluent members of nineteenth-century St. Georges Hundred society. But only archaeology and more intensive documentary research will inform us as to their relationship to a larger architectural landscape. In sum, where Upton's criticisms hold the most validity for my work, and, it is hoped, for the efforts of others wrestling with similar bodies of material, is in the need for a broader holistic approach to lend coherent meaning to observation.

Tom Carter's analysis of my work in St. Georges Hundred is closer to the intention of the central theme in the essay. Citing his own work in Utah and drawing on Glassie's rules for architectural competence in middle Virginia, Carter immediately grasps the problem of establishing a dialogue between the synchronic and diachronic qualities of material culture. What lies at the heart of Upton and Carter's, and my, observations, is the desire to strengthen analytical models designed to evaluate the mediational possibilities and realities between thought and material form found in performance. Carter notes the subtleties of the situation when he describes the "internal compromise" required in the movement from initial performance through the overlays of subsequent performances. Drawing on the example of the Cox house in Sanpete County, Utah, Carter finds, as I have found in Delaware, that there are numerous appropriate options which might be chosen by the client and craftsman as they move towards the resolution of pragmatic considerations with reference to prevailing conceptual ideals. Thus stepping from observation to analysis, the performance perspective with the added consideration of time-depth offers some, if not all, answers to questions raised by the artifactual world.

Bernard Herman

(Portland, Maine, *Mark Weidhaas, Courtesy of Humanities Division, Penn State-Capitol Campus*)

Part IV: Dialogues on Folklife and the Museum/Historical Agency

A paradox in the history of American ideas lies in the coexistent apotheoses of newness (the New Frontier, New Wave, New Deal) and oldness (the Old West, Good Ol' Days, Old Glory). Indeed, the history museum materially represents this paradox: a "new" setting of importance for old or familiar objects. We can even say of the museum: old wine in new cellars. People have flocked to museums to witness new exhibits which preserve, glorify, and elucidate a material slice of our past. Today, the American folklorist's interest in museology is considered a "new" movement, although exhibitions of objects collected by American folklorists date back to the beginnings of folklore as a discipline. Stewart Culin wrote on "folklore museums" as early as 1890 and he created major exhibitions of folk artifacts, many drawn from American Folklore Society members. By 1890 "The Boston Association" of the American Folklore Society was established with the Director of the Peabody Museum as President. The United States National Museum employed leaders of the American Folklore Society such as Otis Mason and Thomas Wilson. Frederick Starr at the American Museum of Natural History organized exhibits of folk masks and had a catalogue published (1899) under the imprint of the Folklore Society in England. American folk museums began to spring up in the late nineteenth century inspired by European models.

Museums today have diversified: there are children's museums, outdoor museums, house museums, university museums, and maritime museums. Folklife can be part of the scope of all these institutions. Not only has the concern of folklife study with traditional, past-oriented items and activities of everyday life surfaced in contemporary museum programs, but also the ethnographic, present-oriented, and behavioral research of modern folklife study is beginning to reach into the work of historical and cultural agencies and community organizations. With an increasing number of professionals having cross-cutting interests in folklife, material culture, and museology, the dialogues that follow on the relations of folklife and the museum and historical agency take on a special importance for the development of an integrated philosophy of cultural research and presentation.

The dialogue provoked by Ormond Loomis addresses a particularly sensitive issue in the presentation of folklife at museums. Who should demonstrate old crafts in the new setting of the museum, and how should they be presented? Loomis calls into question fundamental assumptions about museum goals as a research, educational, entertainment, and preservational institution. From their present vantage points in museum administration and their backgrounds in folk culture study, Darwin Kelsey and John Braunlein speak frankly on Loomis's stand on the issue.

With Patricia Hall's essay we turn our attention to folklife at the local and community organizational level. Hall reviews the relations of local history and folklife and previews the positive roles of folklife and folklorists in the future of local historical agencies. Roderick Roberts counters by pointing out the grave consequences of the union between folklorists and the "genteel" institutions of historical agencies and museums. We are thus forced to reflect, "What road should folklorists take to retain their integrity and maintain their craft?

The final dialogue concerns the state of urban material culture research. I simultaneously criticize the "sterile, static, and ordered" format of museum presentations of the decidedly complex and dynamic urban scene and the rural or Old World transplant emphasis of previous folkloristic literature on cities. I propound a type of behavioristic perspective which can illuminate the customs and thoughts underlying urban life and I discuss the portents of a behavioristic reorientation in folklife research and museology. Inta Carpenter and Robert Teske critically evaluate my suggestions in the light of their own experiences with urban ethnic research.

In recent years, an awareness of a responsibility on the part of history museums and folklife centers to their surrounding communities has challenged the notion of these institutions as shelters for collections and *recollections* of the exotic world or the removed past. Folklife research and museology are increasingly coming to grips with the interpretation of the present with the typical as frames of reference for their programs. Upon reflection, several oppositions emerge between museology and folklife research: preoccupation with the historic past in the museum/historical agency and the immediacy of the ethnographic present in folklife fieldwork, formalistic object orientation of the museum and the contextual *de rigeur* of folklife, and the academic power base of folklife and the "public sector" nest of the museum. Folklife centers and museums seem to share, however, the Socratic credo that *recollection* is a needed process of recovering and understanding that which is in danger of being forgotten through time or inattention. Yet the unified concept of the folk museum as it is known in Europe has made scant headway in America. Rather, we now have the situation of folklorists working in history museums or museum professionals doing folklife research. Like Janus, readers may sense that they stand before a doorway to a future perspective with faces looking in opposite

directions. But also as a patron of beginnings and endings, Janus may signify the old giving way to the new just as the new depends on the old when we reassess the place of folklife and museums in relation to each other.

Further Reading

For background and supplemental reading on the folklife and museum relationship, consult the titles in Ormond Loomis's bibliography, *Sources on Folk Museums and Living Historical Farms* (Bloomington, Indiana: Folklore Forum Bibliographic and Special Series, No. 16, 1977). For a historical perspective on the folk museum movement, see Howard Wight Marshall, "Folklife and the Rise of American Folk Museums," *Journal of American Folklore* 90 (1977): pp. 391-413; Thomas J. Schlereth, "Material Culture Studies in America 1876-1976: A Historical Perspective," in *Material Culture Studies in America* (Nashville: American Association for State and Local History, 1982); Don Yoder, "The Folklife Studies Movement," *Pennsylvania Folklife* 13 (July 1963) no. 3, pp. 43-56; Beatrix Rumford, "Uncommon Art of the Common People: A Review of Trends in the Collecting and Exhibiting of American Folk Art," in *Perspectives on American Folk Art,* ed. Ian M.G. Quimby and Scott T. Swank (New York: W.W. Norton, 1980), pp. 13-53; Jay Anderson, "Living History: Simulating Everyday Life in Living Museums," *American Quarterly* 34 (1982): pp. 290-306, and his *Time Machines* (Nashville: American Association for State and Local History, 1984).

Conceptual discussions of the folklife-museum relationship can be found in Howard Wight Marshall, "Material Culture and the Museum," *Association for Living History Farms and Agricultural Museums Annual* 3 (1977): pp. 35-38; Warren E. Roberts, "Folk Architecture in Context: The Folk Museum," *Pioneer America Society Proceedings* 1 (1973): pp. 34-50; Robert Baron, "Folklife and the American Museum," *Museum News* 59 (March/April 1981), pp. 46-50, 58-64; Maria Znamierowska-Prüfferowa, "Ethnomuseology and Its Problems," *Ethnologia Europaea* 4 (1970):pp. 203-6; Ormond Loomis, "Folklife Museums," *Association for Living History Farms and Agricultural Museums Annual* 3 (1977): pp. 7-10; J. Geraint Jenkins, "Folklife Studies and the Museum," *Museums Journal* 61 (1961): pp. 3-7; J. Geraint Jenkins, "The Use of Artifacts and Folk Art in the Folk Museum," in *Folklore and Folklife: An Introduction,* ed. Richard M. Dorson (Chicago: University of Chicago Press, 1972), pp. 497-516; Jay Anderson, "Immaterial Material Culture: The Implications of Experimental Research for Folklife Museums," *Keystone Folklore* 21 (1976-1977): pp. 1-13; Wolfgang Brückner and Bernward Deneke, eds., *Volkskunde im Museum* (Würzburg: Bayerische Blätter für Volkskunde, 1976).

Individual museums dealing with folklife are discussed in Holger Rasmussen, ed., *Dansk Folkemuseum and Frilandsmuseet: History and*

Activities (Copenhagen: Nationalmuseet, 1966); Iorwerth C. Peate, "The Welsh Folk Museum," *Journal of the Folklore Institute* 2 (1965): pp. 314–16; Douglass A. Allan, "Folk Museums at Home and Abroad," *Proceedings of the Scottish Anthropological and Folklore Society* 5 (1956): pp. 91–121; Arnold Lühning, "Feilichtmuseum in den USA," *Beiträge zur deutschen Volks and Altertumskunde* 4 (1959): pp. 67–79; Richard W.E. Perrin, *Outdoor Museums* (Milwaukee: Milwaukee Public Museum Publications in Museology, No. 4, 1975); George R. Clay, "The Lightbulb Angel, A Definition of the Folk Museum at Cooperstown," *Curator* 3 (1960): pp. 43–65; Mats Rehnberg, *The Nordiska Museet and Skansen: An Introduction to the History and Activities of a Famous Swedish Museum* (Stockholm: Nordiska Museet, 1957); Shyamchand Mukherjee, *Folklore Museum* (Calcutta: Indian Publications, 1969); International Council of Museums, *Organization of Open-Air Museums— Principles and Methods* (Bucharest, 1966); Louis C. Jones, *The Farmers' Museum* (Cooperstown: New York State Historical Association, 1948).

Discussions of folklife and the local historical agency are found in Louis C. Jones, "Folk Culture and the Historical Society," *Minnesota History* 31 (1950): pp. 11–17; Louis C. Jones, "The Folklorist Looks at Historians," *Dutchess County Historical Society Yearbook* 23 (1943): pp. 30–33: Austin Fife, "Folklore and Local History," *Utah Historical Quarterly* 31 (1963): pp. 315–23; Alexander Fenton, "Material Culture as an Aid to Local History Studies in Scotland," *Journal of the Folklore Institute* 2 (1965): pp. 326-29; Richard M. Dorson, *American Folklore and the Historian* (Chicago: University of Chicago Press, 1971), pp. 145–56; Charles Pythian-Adams, *Local History and Folklore: A New Framework* (London: Bedford Square Press, 1975); Barbara Allen and William Lynwood Montell, *From Memory to History: Using Oral Sources in Local Historical Research* (Nashville, Tennessee: American Association for State and Local History, 1981).

Simon J. Bronner

Folk Artisans Under Glass: Practical and Ethical Considerations for the Museum

Ormond Loomis

Museum demonstrations serve an important educational purpose: in re-creating processes which by virtue of history, geography, or society are otherwise inaccessible, they let the public see the dynamic between material, tool, skill, and culture. The action gives focus to interpretive discussion, and the immediacy of the events provides an aid to understanding, as well as being a source of entertainment. If frequency indicates success, demonstrations must be a most instructive approach, for they can be found at both open-air and more conventional indoor museums throughout the country (fig. 9-1).

Unfortunately, serious differences exist between the folk arts and crafts as practiced in the field and the way they appear in the museum. A farmer making brooms in a shed behind his house may use the same kind of straw and winder that an interpreter in a museum uses, but one craftsperson possesses vitality derived from his interaction with a natural context whereas the other has had that vitality wrung out by the conditioning effect of his refined setting. To produce demonstrations, museums inevitably change folk traditions. By putting an artisan under glass, they create, for the sake of educational clarity and institutional convenience, distortions of the cultures they tap.

From my work as a folklife researcher, it occurs to me that much of the tempering done to render folk material suitable for museum presentation is undesirable and possibly unnecessary. On numerous occasions when working to produce background for exhibits, I have been urged to generate information which can be easily adapted to demonstrations: period songs fitting the talents of guides, distinctive objects capable of being manufactured within the ten-minute attention span of high school-level audiences, and curious facts that will produce neat labels. At the same time, I have met interpreters who, feeling constrained by the format of their demonstrations, wanted information which I was not

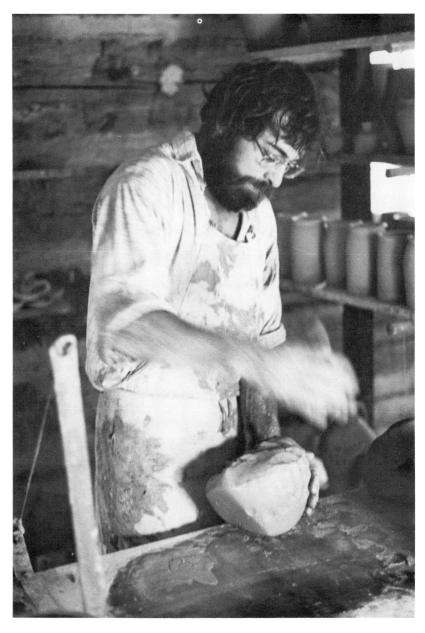

Figure 9-1. Blacksmith "Interpreter" at Conner Prairie Settlement.
Noblesville, Indiana, 1975.
(Simon Bronner)

commissioned to get, and informants who, knowing that the data I gathered were intended for exhibit use, requested that I limit my notes to prevent the misrepresentation of material they treasured. These experiences lead me to wonder whether museums must overstructure, homogenize, and bowdlerize traditions to the extent that presentations based on them bore those who present them and embarrass those who share them.

A major source of the interpretive dilemma lies in a number of conventions employed in the business of demonstration, conventions which detract from accurate representation. Most concern contextual detail, and by themselves amount to small concessions for the supposed educational benefit they provide. In combination, however, they produce a surreal atmosphere for interpretation. A more critical group of practices regards the choice and training of interpreters. Considering the skewing tendencies inherent in the usual demonstration context, even those with strong backgrounds in a regional tradition need continued associations with the roots of their craft to be most effective. But museums rarely hire tradition-oriented artisans as interpreters, and seldom provide them or any other interpreters with adequate exposure to the shaping influences of an integrated local tradition.

Conventional Museum Demonstrations

One set of frustrating conventions can be classified under the heading of *the well-ordered stage.* Such a stage is evident where the demonstration area—shop, kitchen, or backyard—has been arranged so that the maximum audience can watch the interpreter without causing a disturbance. Typically, it also contains an overabundance of individually appropriate artifacts which suggest an unreal material influence, a vestigial practice, perhaps, from the days of the encyclopedic collection and exhibition. More than once, I have heard museum staff explain how a pantry or a smithy held the inventories from two or three complete donations. Further, these arenas usually locate particularly attractive or distinctive artifacts in spots where they will be noticed.

A frequent manifestation of the "attractive artifact" convention occurs in *the exploded layout;* here, examples of several steps in an extended process are arranged, however subtly, in a sequence and can be seen at once. At a restored mill containing two sets of burr stones, for example, the interpreter remarked that there probably never was such a mill, but that the museum had them in its collection; so the museum installed them for the public to see one in use and the other was broken down for sharpening.

The folk artisan who works in an orderly area is rare. Most function best amid apparent clutter which has an order that grows out of creative, not educational, activity. In a genuine craft shop, no barriers keep visitors out of the artisan's way; caution and courtesy do. At the same time, the most fascinating

tools are frequently tucked out of sight, and the best examples of the worker's art have been traded away. The only illustrations of intermediate phases of work available for examination are likely to be random pieces of projects at hand.

Museum demonstrations carefully avoid the confusion of presenting disjointed phases of work. To keep visitors from getting a fragmentary impression of the varied skills an artisan possesses, they limit presentations to small units of production.[1] Potters throw basic pots; smiths forge simple welds. Weavers spin single strands of yarn. While this brief product convention gives the public a unified scene of a craftsperson at work, it masks the complexity of a craft tradition. The abstracting of vignettes from a past repertoire of skills falls into the general category of *modified manufacture for the museum market.*

Another convention in the same category is that of making crafts for museum sales. It seems doubtful that generations ago entire countries ever consumed as many pewter spoons or as much lye soap and corn meal as are produced and sold at some individual restorations today. Museum shops generate desirable income, and to keep them stocked with popular items, interpreters modify tradition. Candle makers use electric kettles and cabinetmakers use power planers, thereby speeding and standardizing their work. The brief products of capsulized demonstrations often provide an ideal supply of impulse items. Insidious changes occur when staff produce goods for the tourist trade. A basketmaker at a southern re-creation learned his trade making cotton baskets, but today when he is not supplying orders for wastebaskets and laundry baskets, he makes small berry baskets since these objects can be priced within the budget of most souvenir hunters.

Beyond the museum, folk artisans respond to the needs and aesthetics of a more immediate community which regulates quality and invests symbols with meaning. When a mountain chairmaker in Kentucky leaves the arms, seats, legs, and rockers of his chairs with a crude finish, it is because his neighbors plan to use them on their front porches where exposure ruins a fine finish, not because a transient clientele desires a rustic appearance. A broommaker in Indiana once explained that he took the trouble to add a fifth row of stitches to his brooms because the women to whom he peddled them refused to accept less. Such controls do not affect the museum interpreter who has pressures instead from supervisors and shop managers to abbreviate processes. When a folk artisan working within a natural context performs a brief, repetitive operation, the labor is seen as part of a total effort in which the social worth of the artifact produced merits the tedium it requires. As individual steps in a creative process follow one after another, the artisan gains the satisfaction of completing a major project and, ultimately, of seeing a valued product given further satisfaction to its consumer. Thus a woodcarver in Minnesota carves an intricate rosette on a distaff because he knows it will please a neighbor as she spins flax to weave into a tablecloth for her granddaughter.

Conventions which relate to the interpreter's discussion of a craft contain other potential hazards. Professional literature cautions against dull narratives,[2] but the constraints of demonstration can predispose even the best actors and storytellers to fail. The desire to fill interpretation with cultural and historical facts, listed or not, often produces "the didactic monologue." "The working lecture" results when an accomplished interpreter couples craft processes with commentary. In time, movement around the well-ordered stage becomes calculated and blocked and measured gestures develop. The sum of these elements is an overly polished act, *the routine,* evident from the weaver who never makes a mistake as she throws her shuttle, to the cabinetmaker who never misplaces his rule although both supply nonstop, almost nonthinking chatter.

Craftspeople who are visited outside museums seldom work when guests are present: they stop to talk. To explain their arts, they describe works in progress and tools at hand, and may illustrate by quietly performing the next step in a current project. But an overview of a trade or detail on specific techniques must be asked for, and such queries often precipitate minor confusion as informants weigh their answers or search for tools. Smooth demonstrations hardly characterize folk craft processes.

Escaping Convention

A few interpreters escape the influence of the well-ordered stage, modified manufacture for the museum market, and the routine; but it appears there is a prejudice in museum administration which selects and conditions, independently of these factors, to shape the domesticated interpreter. Hiring and training can eliminate or enhance the aura of traditionality which surrounds a demonstration. As in most businesses, museum personnel practices favor those who will adapt to the institution. If we are to portray tradition accurately, however, ought not these practices favor those who feel more committed to a tradition than to an institution? William Alderson and Shirley Low suggest seeking people "whose education and background are appropriate to the interpretive assignment at hand," but in addition, such people need the freedom to reflect that education and background.[3]

In the interpretation of broommaking, for instance, a college student or senior citizen can be hired and taught the essentials of the craft. They may learn the significance of the trade within the hypothetical museum community, but these interpreters will not be able to comment sympathetically on the education a folk broommaker receives. If an experienced broommaker from a factory was hired and taught the background of a museum village, unless from a similar community, he could not comment sympathetically about the links between the manufacture and the housewives who will not buy brooms without five rows of stitches binding the straws. Only the folk broommaker possesses the necessary

background for extensively accurate interpretation and can respond in character to any inquiry. But when taught that proper interpretation should contain historical background, observations on community aesthetics, and clear diction, a tradition-oriented artisan may eschew his or her heritage to give an acceptable, though ersatz, presentation.

The thatchers, coopers, millers, and smiths who want museum work are exceptional. Most informants with skills which have potential for museum demonstration never seriously consider the possibility of such employment because of their satisfaction with their established lives. A few who entertain the idea reject it because of the restricting, adulterating, carnival atmosphere they perceive in museums. When musing about the possibility of work at what he calls a "living history farm," a farmer who plows with draft horses began discussing the value of solitude in his marginally profitable enterprises. Another craftsman explained that he perceived himself as a shy person and would not be able to relate to groups of people.

Repeated examples substantiate the impression that museum demonstrations inhibit the expression of valid folk experience. At a re-creation of a mid-nineteenth-century southern town, an interpreter told me who built the house in which she was stationed, how it was built, and how it illustrated the fashions of an earlier age. Only after several minutes of relating such information did she mention that she had lived in the house before it was restored at the museum. Then with prodding, she awkwardly described, frequently qualifying and apologizing for the nonhistorical nature of the facts, a few of her personal memories of the building. At another open-air site, an interpreter wound cotton twine in the manner he learned years ago for making reins. When asked why the rope he was working on differed from a pair of reins hanging behind him on the shop wall, he explained that the new ones were sold as jump ropes so they could be lighter in weight than the old reins, and that he introduced colored strands in the jump ropes to improve their sales at the museum gift shop. A young blacksmith who went to work at a midwestern museum village did so on the condition that he would not have to make "horseshoe nail rings," but in exchange adopted the character of a nineteenth-century frontier smith, and in so doing was prevented from telling anecdotes about how he learned the trade from older, contemporary craftsmen.

A miller at a restored grist mill provided a refreshing contrast to these examples. The miller had worked in the building long before it was moved to its present museum site. In his interpretation he entertained his visitors with tales of accidents at the mill, stories which he had heard from people who used the mill before he took over its operation. Through the stories the museum audience had an opportunity to glimpse the miller as both a producer of meal and a bearer of local history.

Whatever abberations the business of demonstration seems to require, we have an obligation to give the public as accurate a portrayal as possible of regional cultures. In the long run, accuracy serves our educational goals, and more importantly, honors the people whose traditions are on exhibit. For this reason, we need to reevaluate accustomed approaches to demonstration with a recognition of the shaping influence of the museum setting. Granted, the practicalities of working within a museum require concessions; but those who create demonstrations are likely to discover greater flexibility in presenting information than has yet been used, Such a reevaluation can begin by acknowledging the effects of putting the folk artisan under glass.

Notes for Chapter 9

1. For another perspective on limiting demonstrations to well defined units of production, see Peter W. Cook, "The Craft of Demonstration," *Museum News* 51 (November 1974), pp. 11–15, 63.

2. See William T. Alderson and Shirley Payne Low, *Interpretation of Historic Sites* (Nashville: American Association for State and Local History, 1976), pp. 36–38; Freeman Tilden, *Interpreting Our Heritage* (Chapel Hill: The University of North Carolina Press, 1957), pp. 26–31.

3. Alderson and Low, *Historic Sites,* p. 106.

Comments

The Equation of Re-creation with Accuracy

Ormond Loomis has argued that museum demonstrations present an inaccurate interpretation of folk technology through the use of conventions that distort traditional processes. Loomis equates a *successful re-creation* with an *accurate demonstration,* and argues that the techniques employed by museum educators do not re-create and are therefore inaccurate. While many of his complaints with museum conventions are justified, the real problem I find with his argument is his equation of re-creation with accuracy.

If museums attempted to re-create history, they would indeed strip demonstrations of "valid folk experience" and present processes inaccurately. To re-create a part of history—in fact to "re-create" anything—would require the reproduction of its context. For example, to reproduce an early nineteenth-century door hinge, a museum would have to re-create the step by step operation of its manufacture and the sociological, psychological, and philosophical factors that contributed to the production, form, and use of door hinges in the nineteenth century. Process is not limited to physical manifestation.

No one can "re-create" history in this strict sense, but this use of the term seems to be the basis for Loomis's argument. The people, places, and events of the past cannot be relocated in the combination of elements that defined their existence. To even approach this ideal, museums would have to construct a historical community and then prohibit visitors from intruding into their "successful" re-creation. In effect, they would have to put folk artisans under glass. Museum professionals are working to solve the problems inherent in demonstrations. The central issue here should be whether historically and folkloristically appropriate demonstrations are consistent with the purpose of the institution and not with the re-creation of "valid folk experience." Certainly, we must demand that museums present accurate demonstration of folk technology, but "accuracy" is not defined by the "re-creation" of folk culture. If, for example, the Brooklyn Museum sponsored a workshop on the techniques of eighteenth-century cabinetmaking, it would be entirely appropriate and not

inaccurate for the craftsmen conducting that workshop to employ deliberately several educational conventions such as the "well-ordered stage," "the exploded layout," and the "didactic monologue." It would be inappropriate and inaccurate, however, for the demonstrators to use power tools and plywood.

To his credit, Loomis has challenged museum workers to recognize inappropriate or obfuscating conventions and to employ creatively approaches that reveal more of the cultural context than is evident in many historical simulations. Alteration in the form and construction of traditional craft products for the purpose of easy sales in museum shops is a deplorable practice that most museum workers would find offensive. It is therefore imperative for workers to identify appropriate products, and to devise solutions to the problems of production and sales. The interpretation of a schoolhouse need not be limited to the time of its construction but could be expanded to include narratives and reminiscences from recent memory. In addition to presenting conventional explanations of quilting, a museum instructor could also be available to work with persons involved in various stages of quilting and would be able to transmit information in a less formal, often more traditional, manner of presentation. These suggestions are the types of approaches for which Loomis is arguing; they represent to me the real lesson and benefit of his essay.

John H. Braunlein

The Perspective of the Museum

Ormond Loomis concentrates on a specific problem in the presentation of material folk culture: the relationship of "traditional" or "folk" crafts and museum demonstrations. Although it is a valuable exercise to examine museum craft demonstrations from the perspective of those values and biases usually associated with the academic discipline of folklife research, it is equally instructive to examine them from the perspective of the stated purposes and objectives of presenter institutions. Loomis's discussion assumes that the purpose of most museums where crafts are demonstrated is, or should be, the preservation of a folk tradition; or, to put it more accurately, the modern remnant of an old tradition. Few museums which regularly demonstrate crafts have any such intention. Most such museums attempt to show *historic* trades fifty, one hundred, or three hundred years old, not their modern remnants. The good ones pay careful attention to the accuracy of the tools, processes, and contexts in which such work was performed. The poor ones introduce anachronistic tools, modern processes, and ignore accurate contexts; hence they demonstrate neither a historic craft nor its modern descendant. The point here is that most modern folk survivals differ in many particulars from their antecedents—precisely how will only be known by rigorous archival research.

Moreover, a rigorous look at the historical record for degrees of specialization and levels of production will usually verify *not* that modern museums are producing more pewter spoons, lye soap, and cornmeal than was consumed in this or that country by the ancients. On the contrary, it will show that production efforts at most museums are small scale and inefficient compared to the historic instances they purport to show.

While most museum "villages" or other re-created historic environments could use more precision in self-definition, the coherence and consistency they already possess would be effectively destroyed if every trade, household activity, or child's game demonstrated was presented in terms of the individual demonstrator's personal experience. Since most presenter institutions do not deal with *historic* cultures, what they really need is the sort of staff training which allow "folk" demonstrators to avoid the necessity of "making up" their own versions of the past when that past is actually remote from their personal experience. And those of us who have done any fieldwork among folk artisans, in their own surroundings, know that few indeed know a great deal about the history and evolution of their craft. That usually comes with being an academic of one stripe or another.

I also part with Loomis on the issue of context and audience. A folk artisan's shop never was intended to perform the same function for the same kind of audience that most museum artisans' shops are set up for. Most folk artisans' shops would be wholly inadequate to meet the needs of a large museum audience, assuming they found out about it, wanted to visit, and were allowed to do so. The nature of audience needs, expectations, and interactions in these two contexts are fundamentally different.

Although the discipline of folklife research has much to offer museum and agencies, to make much of an impact its advocates and practitioners will need to apply their insights and methods to the self-perceived needs of presenter institutions.

Darwin P. Kelsey

Reply: The Matter of Museums' Goals

The business of interpretation needs periodic reexamination if museums are to make the best use of their potential for education. Judging from the comments, the response to my essay was thoughtful and varied; these replies are encouraging. They point out, in one way or another, that every museum must tailor its programs, specifically its demonstrations, according to its goals. Indeed, among those goals may be the research and preservation of folk tradition; museums should therefore be concerned with, and sensitive to, the bearers of such tradition. That requires assuming some folkloristic values and perspectives.

I acknowledge that not every museum will want to take a heavily folkloristic approach any more than every one will want to emphasize a historic period. But as a museum grows, its goals may change; and as the museum profession grows, our skill with interpretation improves. Perhaps as a result of the discussion begun here, each museum will find the form of demonstration which suits it best.

Ormond Loomis

A Case for Folklife and the Local Historical Society

Patricia A. Hall

Many university-based history departments and large state or federal historical agencies place great emphasis on history from a national or "monumental" perspective. There exist, however, numerous institutions with a commitment to the documentation of local or community history. The local historical agency— usually small in size and modest in budget—can take the form of a local historical society, a regional museum, a library or archives, a local history commission, or a combination of these. Such institutions document the history of a community and tend to have a *local* perspective; that is, they are as oriented to personal, cultural, and social history, as they are to formal political history.

The workforce in local historical agencies usually has historians and individuals serving in capacities such as curator, administrator, education specialist, researcher, archivist, librarian, interpreter, editor, and exhibit specialist. Some may be trained, paid professionals; in many instances they are volunteers. A 1978 salary survey conducted by the American Association for State and Local History (AASLH) solicited information from the 4,442 historical agencies listed in their 1978 *Directory of Historical Agencies in the United States and Canada*. A total of 1,050 questionnaires were returned to the AASLH. Approximately 700 of these responses were from historical agencies designating themselves a "local," as opposed to "state," "regional," or "national."[1] Considering that fully two-thirds of the responses to the AASLH comprised organizations dedicated to local concerns, we should reexamine the relationship of folklife research—a discipline usually associated with the local level—and historical presentation.

In this essay I present some observations concerning the large number of *local* historical societies in the United States and what their chief concerns appear to be, and the folklife discipline's possible relationship to some of these

concerns. It also contains what I believe to be theoretical implications for the folklife and local history connection. In the light of background literature on the problem, I address issues of local history that may be relevant to folklife studies and areas of research and presentation in which folklife specialists can make their greatest contributions to a local historical society.

Background

The reluctance of many historians to acknowledge folklife as a viable and necessary component of a complete historical record has been stated and analyzed by such scholars as Richard M. Dorson, Robert Lowie, David Pendergast, Clement Meighan, Neil V. Rosenberg, Simon J. Bronner and Louis C. Jones.[2] Historians who do choose to incorporate folklore into a historical record, or who adopt a folkloristic method over a strictly historical one, often find themselves in the defensive posture of justifying folklife's validity to fellow historians.

I suggest some explanations for history's resistance to folklife. Any given item of folklife usually represents two general processes: continuity and change. Although the documentation of both continuity and change is a primary task of formal historians, they must be able to separate the two processes as they are reflected in source material, to arrive at a historiographic goal: namely, a historically and factually correct interpretation. The origins, transmission patterns, and variant possibilities of folklife being what they are, it is often difficult to distinguish between continuity and change as reflected in any given item of folklife. This circumstance renders folkloric data questionable source material for a historian who is after strictly verifiable facts. With folkloric source material, the researcher can arrive at folk *truth,* but not necessarily historic *fact.*

Since narrative folklore and folk crafts may come from the past, but are related or rendered in the present, they always contain a measure of the teller's or maker's attitudes and beliefs, as well as those of the community in which the texts or skills are found (fig. 10-1). Folklife is, then, the *past* edited by the *present;* the average oral narrative, for example, has more in common with an interpretive history text than it does with the documents on which that history text is based. For the historian folklife can have too much of the present or indefinite past in it to ever be above suspicion as a strict, factual historical resource.

Another problem for many historians emerges from the use of terminology. The word folk implies to some such qualities as inferior, peasant, nonliterate, unacademic, untruthful, or quaint—the opposite of what many mean by the word historical. Thus many historians seem to avoid the use of the word folk, instead preferring terms like ethnic, customary, traditional, everyday, common, grassroots, and oral, and they shy away from folkloristic methods to describe folk materials and processes.

Figure 10-1. Demonstration of Making Apple Butter in South Central Pennsylvania. Ca., Early Twentieth Century. *(Dauphin County Historical Society, Pennsylvania)*

Such problems with the relationship of folklife and history arise at the local historical level. But since local and community history emphasizes individuals, families, and ethnic groups, local history is not as highly dependent on source material necessarily being printed or written. Therefore, the problems are somewhat less pronounced. In fact, there are several key areas of local historical concern for which the folk item *is* sought as the suitable data, and a folkloristic method is considered the appropriate method.

Louis C. Jones was one of the pioneers in bringing the study of folklife within the realm of local history studies. His article, "Folk Culture and the Historical Society," appeared in 1950 and underscored the importance of documenting the common working person through preservation of folk cultures. He made a timely plea for "folk" museums (like Cooperstown's Farmers' Museum) in which everyday artifacts and lifestyles would be presented and interpreted.[3] In a later essay, "Three Eyes on the Past," Jones suggested a "triangulation" for local studies—an ideal research team consisting of folklorist, local historian, and museologist.[4]

Since Jones's pleas, Howard W. Marshall, Edward L. Hawes, and Candace T. Matelic have published studies related to American and European "folklife" museums.[5] They examined the highly developed regional folklife museum concept in Europe and looked to its implications for agricultural museums and living history farms such as the Farmers' Museum, Old Sturbridge Village, Clayville Rural Life Center, Iowa Living History Farms, and Conner Prairie Pioneer Settlement.

Some European scholars such as Charles Pythian-Adams have also grappled with the folklife-local history connection. Pythian-Adams's research focused largely on custom and belief, and the problems of using survivals as data for interpretation. In his volume, *Local History and Folklore: A New Framework,* he suggested that a historical context, particularly at the community level, provides an appropriate context for the interpretation of folklore. Conversely, he maintained, the interpretation of folklore can lead, in many instances, to a more historically accurate documentation of a community.[6]

Other writers have identified the essential components and orientations of local historical activities and interpretations, a requisite step to adopting a folklife method. In *Families and Communities: A New View of American History,* historian David Russo contended that humans live simultaneously in a hierarchy of communities, be they politically, socially, economically, culturally, or intellectually defined, ranging from the neighborhood to the nation. Russo's view is based on the notion that until the beginning of the twentieth century, American living patterns were largely organized at the local level, in which the town, not the nation, was the main referent. Russo thus viewed American history as the progressive "nationalization" of life originally organized at the local level.[7]

Dorothy Weyer Creigh, author of *A Primer for Local Historical Societies,* speaks to more "nuts and bolts" issues of local historical research. She typifies the local history field as being "short on money, long on enthusiasm, imagination, and ingenuity ... geographically remote from professional help and advice ... relying on volunteer labor and spending much time raising money through various means."[8] Creigh characterized the local historical society as contributing harmony and cohesiveness to the community as it presents local history. Her chapter topics name some of the local historical society's priorities and worries: restoration, museums, financing, publishing, libraries, tours, oral history, site marking, use of volunteers, preservation, and publicity.

Concerns in the Local History Field

It is possible to designate several areas of current, primary concern today in the local history field, areas in which the folklorist can make significant contributions. Three such areas are local museum work (material culture), oral history programs, and historic preservation efforts. Included in all three areas is an agenda for documenting and interpreting the cultural, ethnic, and social components of a multifaceted community.

Most local museums are oriented toward a tangible form of historical data: the artifact—material evidence which requires collection, identification, registration, interpretation, and presentation if it is to serve its purpose in imparting historical information. At the local level, museum artifacts tend to be tied closely to the sociocultural history of groups and individuals native or connected to the community. Folklife's obvious link to museum work would be in the area of material culture studies; at the local level, this study would be on the material culture of the "everyday," "common" people (fig. 10-2). Especially important contributions which can be made by folklorists in museum-artifact work range from the collection and identification of artifacts—that is, seeking out and selecting artifacts which may conceivably be overlooked by a historian—to the interpretation and presentation of artifacts. That means designating and describing an object's relationship to its source, and deciding upon an appropriate exhibit context.

In a folklife museum, a folklorist may not have trouble collecting and interpreting with a folklife approach. But in an average local museum, the lone folklorist could well be surrounded by coworkers who may not appreciate folklife's importance or relevance to the local historical record. Take, for example, a point made recently by a young history museum director I encountered. His reluctance to hire a folklorist as part of the museum staff was based on his view that folklife specialists seem more interested in the entire culture surrounding the artifact, than in the artifact itself. Some, he maintained, instead of just collecting and interpreting the artifact want to collect and

Figure 10-2. In the Historical Storage Area of The Michigan State
University Museum, Director Kurt Dewhurst Records
Carol Cheney's Stories of Working with the Flint, Michigan,
Puppeteer David Lano.
(*Folk Arts Division, The Michigan State University Museum*)

interpret the entire culture! Yet most modern folklorists see the investigation of cultural contexts of artifacts as the prime appeal of museum affiliations. Changes, of course, are occurring as museums reexamine their role in historical education; many are recognizing the interpretive potential of artifacts' sociocultural connections. Such a move generally embraces folklorists; in addition, the increasing number of folklorists on local museum staffs improves the visibility and prestige of folklife approaches. In the short run, however, folklorists and other cultural scientists must be aware that a comprehensive cultural approach is often seen by average artifact-oriented local museums as a questionable luxury.

In what ways, one might ask, can a folklorist be of assistance to a local historical society which is *not* a museum, or has no artifact collection? One obvious way is through fieldwork, and more specifically, oral history interviews. The book and film versions of *Roots* and the Foxfire movement have enlivened in the public an interest in the documentation of the past through oral interviews. This awakened interest appears especially in the activities of local historical societies, many of which have active oral history programs. But in talking of the folklorist's potential contribution to an oral history program, we must immediately differentiate between oral interviews conducted folkloristically and oral interviews conducted historically. The differences relate back to the truth versus fact and present versus past dichotomies mentioned earlier. Historical oral interviews are designed to tell us something authoritative and documentable about the past. Folkloristic oral interviews tell us more about present interpretations of the past, and something about the narrator.

The diverse varieties of oral interviews are important to the local or community historical society since interviews address the concerns of societies with: (1) filling factual gaps in the historical record; (2) documenting folk customs and folklife patterns; (3) focusing on the narrator and narrators; and (4) studying the historical material deemed important enough to be related by narrators. Folklorists, with their knowledge of the migratory nature of traditional material and their understanding of the importance of cultural context, should be crucial figures in the recognition and interpretation of what is implied in the broader use of the term oral history. They can seek and recognize narrators who can impart the essence of a community's belief and recollection patterns; they can help to interpret the more factual oral histories, checking their historicity against a knowledge of the oral and migratory behavior of folklife. And, the folklorist can justify including oral history and folklife in the complete community historical record.

Another major concern of the local historical society is historic preservation. A popular contemporary activity in the state and local history field, historic preservation has important implications for folklife research, for historic preservation's main emphasis—the identification, restoration, and

interpretation of historic sites and structures—relates to folklife researcher's efforts to identify and preserve America's vernacular architecture and material culture. But historic preservation has an even stronger relationship to folklife than simply shared architectural concerns. In the same way that folklorists must deal with *past and present,* as reflected in folklore, so too does a historic preservationist contend with and interpret the *past and present* implications of a given structure's history.

Some of the most energetic historic preservation activity can be found at the community or neighborhood level. Usually coordinated through a local society or agency, the center of activity can be preservation, restoration, and in some cases, the adaptive reuse of buildings or entire neighborhoods. A folklorist, with a contextual awareness and expertise in such areas can be vital to a historic preservation program, especially at the identification and interpretation stage. The definition of the term historic preservation has been expanded in recent years by preservation specialists to mean not only site and structure preservation, but also the broad concept of *heritage preservation*—the consideration of artifacts, landscapes, and festivals which are significant to a community's sense of heritage. This concept moves historic preservation even closer to the common perspectives of folklife research.

Enter the Folklorist

Folklife studies encountered a new wave of acceptability in the minds of the public during the 1970s. In the wake of the American Bicentennial and civil rights movement came concerns for *heritage* and *ethnicity.* Such concerns are reflected in the operations at the national level of the American Folklife Center in the Library of Congress, the Smithsonian Institution's Office of Folklife Programs, and the Folk Arts Programs of the National Endowment for the Arts. At the state level, the number of state folklife programs with salaried state folklorists steadily grows; at the regional level, folklife centers such as the Center for Southern Folklore in Tennessee, the Center for the Study of North Country Folklife in New York, and the Ozark Folk Center in Arkansas are expanding their roles in the cultural life of their regions. With this spate of folklife activity at the national, state, and regional levels, should there be any problems generating folklife activity at the community level, specifically through a local historical society? Do local historical societies hire, or even need folklorists?

Some answers may come from the AASLH salary survey mentioned earlier. Of the 700 local historical societies responding to the survey, only three indicated the presence of a "folklorist" or "folklife specialist" on their staffs. But because the salary survey questionnaire did not specifically ask, "Do you have a folklorist on staff," and because individuals with folklife training may have job titles other than folklorist, such results are inconclusive. Still, the figures suggest that most

community and local historical societies may not yet have made the local history and folklife connection. Community history, with its folklife components, may not be a field in which the folklorist can currently find a comfortable (and salaried) niche. Why?

A primary problem is funding. How many local historical societies have the financial resources to hire a professional folklorist, much less any paid interdisciplinary specialist? Local and community societies rely to a great extent on part-time and volunteer labor. Rarely do their budgets exceed forty to fifty thousand dollars. Without funds, how can a society based in a community be a likely employment possibility for a folklorist? One solution may be for folklorists to use community-based agencies in the same ways they are now using state-based historical societies—soliciting grant funding for community and regional folklorist positions or for specific folklife projects to be conducted with a local historical society.

A second problem may be one discussed earlier: formal history's resistance to the term *folk*, and the related notion that folklife has nothing to do with "real" history. By understanding the concerns of the local historical society, however, a sensitive folklife specialist should be able to solve the potential problem. Through continued exposure to state and regional folklife centers and the positive relationship folklife has to history, a community historical society might well be willing to accept the contributions of a folklorist.

And then there is the problem regarding museum artifacts; or more accurately, the discomfort many museums feel when faced with a comprehensive cultural approach to material things. To be sure, folklorists' greatest strength remain in their broad training as students of culture. But, when working in a field like local history, designated as something other than folklife, folklorists must take care to draw on and emphasize the *components* of their interdisciplinary training. A local historical society may not have much patience with a folklorist who fails to demonstrate some knowledge of history, historical method, and in a museum context—curatorial techniques. Folklorists bring with them distinctive methods and orientations, but it would most likely pay to demonstrate other training as well. Then, the "unenlightened" museum director might be less likely to criticize the folklorist for views that are less curatorial than they are culturally interpretive.

Problems are also voiced by folklorists; they often seem reticent to "get mixed up with a bunch of amateur historians," or reluctant to accept a position without the title folklorist. Yet trained folklorists could be the ones to add a touch of welcome professionalism to a small historical society, and job titles aside, might easily find themselves in leadership positions. I contend that an all important reason for cooperation between folklorists and local historical agencies is the fact that these agencies exist *now*. They often possess governmental and community support, and can function as a channel for funding

of folklife and oral history projects. If the barriers that seem to now separate the two subjects cannot be overcome at the local level, then we must ultimately duplicate local historical societies with parallel local folklife institutions. This process would be administratively redundant, expensive, and time consuming.

Despite problems with the local historical society and folklife specialist connection, it nonetheless should be evident that folklorists have significant contributions to make to the workings of local historical agencies. Taking care to accumulate a few marketable skills (not always found in the university), diplomatically approaching and communicating with the local society, and taking advantage of possible funding sources, folklorists can place themselves in a rewarding local context. The local historical society, with its unique relationship to material culture and folklife, along with its commitment to document community life is thus an opportune avenue for the trained student of folklife to pursue.

Notes for Chapter 10

1. Patricia A. Hall, comp., "Salaries in Historical Agencies: An Updated Report, 1978," *History News* (December 1978), suppl.

2. See Richard M. Dorson, *American Folklore and the Historian* (Chicago: University of Chicago Press, 1971); idem, *Folklore and Fakelore* (Cambridge: Harvard University Press, 1976); Robert Lowie, "Oral Tradition and History," *Journal of American Folklore* 30 (1917): pp. 161–67; David M. Pendergast and Clement W. Meighan, "Folk Traditions as Historical Facts," *Journal of American Folklore* 72 (1959): pp. 128–33; Neil V. Rosenberg, ed., *Folklore and Oral History* (St. Johns: Memorial University of Newfoundland, 1978); Louis C. Jones, "Folk Culture and the Historical Society," *Minnesota History* 31 (1950): pp. 11–17; idem, "Three Eyes on the Past: A New Triangulation for Local Studies," *New York Folklore Quarterly* 12 (1956): pp. 3–13; Simon J. Bronner, ed., "Historical Methodology in Folkloristics," *Western Folklore* 41 (1982): pp. 28-61.

3. Jones, "Folk Culture and the Historical Society," pp. 11–17.

4. Jones, "Three Eyes on the Past," pp. 3–13.

5. See Howard Wight Marshall, "Folklife and the Rise of American Folk Museums," *Journal of American Folklore* 90 (1977): pp. 391-413; Edward L. Hawes, "Museum Interpretation of Folk/Popular Interactions" (Paper read at the American Folklore Society meeting, Detroit, 1977); Candace T. Matelic, *Handbook for Interpreters* (Des Moines: Iowa Living History Farms, 1978).

6. Charles Pythian-Adams, *Local History and Folklore: A New Framework* (London: Bedford Square Press, 1975).

7. David J. Russo, *Families and Communities: A New View of American History* (Nashville: The American Association for State and Local History, 1974); see also Kathleen Neils Conzen, "Community Studies, Urban History, and American Local History," in *The Past Before Us,* ed. Michael Kammen (Ithaca: Cornell University Press, 1980), pp. 270–91.

8. Dorothy Weyer Creigh, *A Primer for Local Historical Societies* (Nashville: The American Association for State and Local History, 1976).

Comments

Since its inception in modern times, the discipline of folklore has been in the hands of the genteel. Clergymen, savants, bibliophiles, and aristocrats, intrigued by the possibility that their unlettered neighbors might possess material of surprising charm and interest, ventured into convenient fields or mined the work of earlier toilers in search of such items. When they found these gems in abundance, they adopted the colonial model of their colleagues in anthropology, rooting out each morsel of interest, apparently deaf to any mandrake shriek, and bearing it, stripped clean of context, back to the home ground of elite culture for evaluation by its standards and for appreciation by its aesthetic. In anthropology this attitude led to the concept of "survivals in culture" and "the savage mind"; in folklore it dictated the valuing of the curious, the quaint, the exotic.

Given this high culture background, it is not surprising that the discipline found its bases and formed its alliances with bourgeois institutions. It was only natural that scholars should seek university support, and that when interest in artifacts arose, these scholars should seek out the agency with the fullest experience in handling them, the museum. But with that support and expertise came the world view imposed by those alliances, and workers in the field were forced into a desperate struggle for respectability. Their attempts to legitimize their interest in folk materials led to the unquestioning adoption of the values and aesthetics of those existing institutions and the consequent winnowing of fieldworkers' harvest with an eye to those criteria. This striving for acceptance effectively squelched any meaningful attempts at discovering the functions of collected items or the regard in which they were held in the societies in which they were found.

Thus the distingué lent the 305 English and Scottish ballads by the imprimatur of Francis James Child. This seal of approval, granted because of their importance to the history of English poetry, has clung to them into the present, often working to the detriment of non-Child items in the traditional repertoire, even though these latter items may be much more relevant to life in

the community. Similarly, laborers in the field of folk art have unerringly chosen works which reflect the aesthetic standards of formal Western art with little regard for the opinions of the communities from which those works are drawn. Such caste-bound judgments are bound to work to the detriment of tradition-oriented cultures and to leave us appallingly ignorant of the values and impulses which direct their activities. Even in those rare instances in which investigators had their origins in the community under investigation, acceptance of their work was only forthcoming when they adopted the critical standards of the higher culture.

I point the finger of guilt at no individual, for this is the manner in which we were trained. Formal institutions have offered the only viable bases from which those interested in traditional cultures could operate, and with these auspices have come evaluative standards. My respect for Patricia Hall as a scholar is considerable, yet when she tells us that it is impossible to arrive at historic *fact* through folklore, the notion is implicit that it can be or has been achieved by historians who limit themselves to more generally accepted documentary research. This agreed-upon fable has cultural sanction, of course, but it requires an obstinate naiveté for a scholar, or for that matter, any thinking human being to subscribe to it. If one is put off by the plebian candor of Henry Ford's "History is bunk," he may be sufficiently soothed by the respectability of Plutarch's "So very difficult a matter is it to trace and find out the truth of anything by history," Sir Robert Walpole's "Anything but history, for history must be false," Nietzsche's "History is nothing more than the belief in the senses, the belief in falsehood," or Thomas Moore's "How oft we sigh/When histories charm to think that histories lie!" to appreciate the errancy of this attribution of accuracy to conventional historical research. The past is irretrievable, through any method, and the best we can hope for is some approximation of what some segment of it was like. There are many instances in which Hall's historic fact is better preserved in traditional accounts than it is in the documentary record. This is especially true in cases in which the recording mechanisms of the society were in the control of groups which had a vested interest in presenting a particular version of what happened.[1] The agreed-upon fable then is a consensus that reflects the desires of groups of power and influence in the community; therefore, the treasured historic *fact* is no more reliable and probably less important than the despised folkloric *truth*.

The argument that Hall and others (like Louis C. Jones whom she cites) make has a single basic fault: the belief that folklife can realize a profound future through alliances with museums and local historical societies. That these agencies exist makes them an alluring prospect for the folklorist, but unlike the university with its commitment to academic freedom, the price that these institutions exact for their aegis is much too great. No serious scholar dedicated to the study of tradition-oriented cultures can afford the imposition of high-

culture values on his data. No dedicated folklorist can tolerate the treatment of traditional items of culture as curious exotica. No sincere humanist can continue to abet the neglect of the aspirations, the beliefs, and the standards of taste of the mass of mankind.

The road *not* thus far taken will be a rough one. The university can provide the Archimedean rest point, but the movement must be essentially an upward one if it is to accomplish the task of divesting the discipline of cultural constrictions. Fortunately, much of the groundwork has already been laid. The awakening consciousness of ethnic and regional groups across the land has provided a potentially viable base for the serious study of the subcultures in which these groups participate. Many of these groups already support organizations which might be encouraged to sponsor serious research into group traditions. The task will prove difficult, for one of the first lessons taught to the aspirant is that he must be prepared to abandon stigmatizing items of traditional baggage and replace them with certain staples that mark the individual of cultivation.

Many of the organizations supported by traditional groups are stampeding to avail themselves of this blind bargain in a desperate attempt to legitimize themselves in the eyes of the elite, and these segments of the population must be educated to the value of the traditions they possess and the need to document and preserve them. They must also be alerted to the disproportionate share of government funds that supports high culture and be mobilized to demand and to claim their rightful portion of public monies for use in the preservation of traditional values and the advancement of traditional arts.

The twelve bittersweet years that I spent at the Cooperstown Graduate Programs in American Folk Culture and History Museum Studies as a sort of "resident barbarian" will always be precious to me for those that I came to know, for those that I came to love, and for the lessons I learned. For any teacher the opportunity to guide students with complete freedom is a rare one, and when attained, should be properly valued and fiercely defended. For a teacher of folklife, this is doubly true, for there is no discipline in the academic gamut with more potential for insight into humanity than his and the teaching opportunities in his field are few. But here on the banks of the Glimmerglass a truth was driven home to me: the institutions of formal culture have little tolerance for the folklorist who takes his study seriously. So long as he reports his findings as curiosities, the lifestyles of his informants as defective to the degree that they deviate from the formal one, and judges his material by high culture standards, he poses no threat and is even mildly encouraged in his endeavors. But once he begins to search for the significance of traditional expressive behaviors in the cultures which support them, to work toward the articulation of traditional aesthetics, and to consider traditional lifestyles as viable alternatives to our demonstrably defective scientific-technologically based one, he constitutes a menace not to be endured.

I, for one, am not willing to trade Hank Williams for Igor Stravinsky, dogtrot cabins for Georgian mansions, or coffee can geraniums, whitewashed tire planters, and pink flamingos for the Hudson River School. I am a product of a tradition-oriented culture, and I refuse to betray that heritage or others like it. If formal institutions force me to that betrayal, then I must look elsewhere for sustenance, and the principal hope for the equitable treatment of traditional groups lies within those very groups. I tend to think in terms of Irish history (all those damned wakes I was dragged to as a kid, I guess), and to my mind, the salvation of the discipline of folklife lies with Sinn Fein, "Ourselves Alone."

Roderick J. Roberts

Notes

1. For an excellent example in print, see Américo Paredes, *With His Pistol in His Hand: A Border Ballad and Its Hero* (Austin: University of Texas Press, 1958). For a discussion of the historicity of historical legends, see my *The Powers Boys: The Uses of an Historical Legend* (Bloomington, Indiana: Folklore Publications Group, 1980) and my "Legends and Local History," *New York Folklore Quarterly* 26 (1970): pp. 83–90.

Folklorists in Historical Societies

Patricia Hall addresses the differences between the disciplines of academic history and folklife studies, the potential for alliance between folklorists and local historians, and three specific areas—museums, oral history, and historic preservation—in which folklorists can provide special insights. She concludes with suggestions for generating folklife studies at the local level. In my experience, Hall's specific suggestions to folklorists who want to work in local historical societies are perfectly correct. There is, however, at least as much split between local historical agencies and academic historians as there is between folklife studies and academic history. The interpretive weaknesses of local historical agencies are caused by an inability to use methods available to them, and not out of any conflict between academic disciplines.

Local historical agencies could use, and some are now using, the tools of many disciplines in their search and interpretation: oral history, local history, folklife studies, genealogy, family history, anthropology, archaeology, and sociology. While it is true that most historical agencies are not currently undertaking significant folklife research, it is not because of a bias against the discipline; the agencies are not undertaking significant historical research either. The society with a budget of $40,000 in Hall's example is, probably, gathering data and making it available to the public; and that is all its resources will bear.

I feel sure that local historical agencies will hire folklorists. Application of Hall's suggested approaches should enhance that probability. She recommends

that: (1) folklife specialists be willing to seek their own funding using local agencies as bases of operations; (2) they should be prepared to persuade local historical agencies that folklife study is a discipline relevant to their purposes; and (3) folklorists should be able to demonstrate their broader usefulness to historical agencies. Indeed, if folklorists want to work in a local museum primarily as a folklorist, rather than as an administrator, registrar, or archivist, they will have to underwrite salary and all the other project expenses; that is the current state of affairs. The local agency will have to believe that the folklorist's project is truly cooperative and that it will enhance the agency's credibility in the local community.

If, however, folklorists are willing to stretch their technical skills and interpretive understanding, they may well find positions in local historical societies; but their titles will be educator, curator, or director. One reflection of this trend is found in the March 1979 edition of the *Cooperstown Graduate Association Directory*. Traditionally, this organization has represented the simultaneous split between, and union of, folklife and the history museum, for folk culture majors and history museum majors took separate core courses yet jointly participated in electives. The *Directory* identified 64 graduates of the folk culture program. Of these 64, 27 (over 40 percent) hold museum or historical agency positions without the title of folklorist. Only nine—four of them students in other advanced graduate folklore programs—were working expressly as folklorists. These 27 people are having a quiet but important impact on the way their agencies interpret material culture, oral history, historic structures, and the other raw materials of community history.

In my role as director of an organization that serves historical agencies, I can see the results of the folklife-local history interchange everyday in central and upstate New York. As more technical skills and interpretive methods are available to local historical research, our understanding of communities and their continuous flow from the past into the present becomes even more significant.

Alice Hemenway

Reply: Further Thoughts

Alice Hemenway's comments enlarge upon my own plea for the incorporation of folklife into the activities of local historical societies. She suggests that local historical agencies could benefit not only from the inclusion of folklife study, but also from the acknowledgment and adoption of other disciplines' tools and techniques. I agree, and would hasten to add that the sooner community historical agencies recognize the advantages of adopting, when appropriate, multidisciplinary approaches, the sooner they are likely to accept folklife as one of those disciplines.

Hemenway also eloquently substantiates my point regarding folklorists' willingness to live with a title other than that of "folklorist." Her unique perspective as director of the New York-based Regional Conference of Historical Agencies provides her with statistics which support her argument and supplement my own tentative findings in the 1978 AASLH Salary Survey. Of course we should remember that the type of folklorist included in the *Cooperstown Graduate Association Directory* was generally better equipped for the tasks of local historical agency work than other academic folklore programs. It remains to be calculated whether folklorists trained elsewhere integrate themselves into the community and local history agency complex as much.

Roderick Roberts makes several salient, often-overlooked points regarding institutional attitudes toward individuals possessing folklife training. I concur with Roberts's overall view that within many cultural institutions folklife is viewed with an antiquarian eye as being quaint, substandard deviations from a "high culture" norm. Yet one cannot lump together all cultural institutions in this judgment, least of all museums and historical societies. Unlike both the majority of conventional art museums and more formal national and state-based historical societies and museums, the local and community historical agency by virtue of its usual size, scope, and constituency is in a unique position to use folklife data and techniques. Many of them already use such approaches, though they may not be using proper folkloristic nomenclature to describe these activities.

Although I understand Roberts's general distrust of the high-culture attitude, I sense that he is somewhat dependent on the existence of high culture against which he can contrast his image of the resident barbarian with his understandable affection for things traditional. Roberts's points on the irretrievability of a complete past record are well taken and require all of us to take a closer look at the perceived distinctions beteen historic fact and folkloric truth. Rather than express these concepts as givens, I present them now as terms describing how historians and folklorists have tended to view their data.

Patricia A. Hall

Researching Material Folk Culture in the Modern American City

Simon J. Bronner

In recent years a growing number of American folklorists have demonstrated a concern with traditions in modern urban, suburban, and industrial settings. Their studies have forced a reevaluation of preexisting assumptions about folkloric behavior—conclusions drawn from a previous scholarship that emphasized a past, rural orientation. As a result of the modern research of urban folklife, new questions arose. What is distinctive about urban traditions? What happens to old folklife in modern urban settings? How does new folklife arise in the urban environment? Do urban people possess a particular worldview? What is the significance of notions of "folk," "tradition," "community," and "culture" in modern cities? Data collected to this date have been primarily verbal, yet artifactual evidence promises additional, significant means of answering the questions being considered. In this essay, I outline current trends in urban folklife research, and suggest methods of augmenting that research with a behavioristic perspective on material culture.

Research Assumptions about Urban Folklife

Major statements on urban folklife research, Américo Paredes and Ellen Stekert's *The Urban Experience and Folk Tradition* (1971) and Richard M. Dorson's *Folklore in the Modern World* (1978), reveal recent American research assumptions about folklife in cities.[1] Although dated, the works had the significance of influencing the succeeeding generation's thinking. They were the sourcebooks for urban study by American folklife students. Worth noting are characteristics of methods in the books. First, the task of defining what is meant by urban is rarely addressed. Often, researchers choose a politically defined city, or assume that a state of "modernization" implies urbanization. One might

question, if industrial settings are necessarily urban, as has been assumed, even if not located in "cities" and not constituting a "modern" work system. When I was doing research in Greenville, Mississippi, identified politically as a "city," I asked about contests in insults known as "dozens playing." An informant told me, "Down here a lot of people play the dozens. You don't have that in the *cities*, you mind your own business in cities." In Harrisburg, Pennsylvania, city planners promoted the image of a bustling, "modern" metropolitan unit, although distinct working class neighborhoods operated under traditional patterns of reciprocal exchanges and kinship settlement. In short, a system of localism rather than cosmopolitanism more accurately described the social structure of the area.[2] Analysts of these regions are susceptible to using political (rather than cognitive and social) definitions based on Western bourgeois standards.

Second, urban folklife researchers tend not to stress emergent traditions *particular* to cities but instead emphasize Old World or rural folkloric transplants in new settings. One reason for this trend is that folklorists rely on their training which has up until now inculcated a recognition of verbal genres usually found in older, rural environments. To his credit, Richard Dorson did include "artifacts of tradition" in his study of Gary, Indiana, but the objects he found significant were either "transported" or "imported" from the Old World.[3] To be sure, modern folklorists have a natural aversion to the conception of survivals or relics in their studies, but they still seem unable to avoid overstating the importance of old remains.

Third, urban researchers acknowledge the complex and awesome task of collecting in what is by its nature an immense and intricate environment—the city. The challenge of such research drew considerable attention in a volume of papers edited by Inta Gale Carpenter, *Folklorists in the City: The Urban Field Experience*.[4] A common theme pervading the essays is the enormous amount of collecting needed by other means than the familiar hit or miss method of the sole folklorist foraying out into the field. Carpenter stated that folklorists in cities may be "equally bewildered by the growing number of potential contacts their notebooks contain or the accelerating pace of folkloric events in which they participate."[5] Team research and systematic collection of a small area are two possible solutions to this methodological dilemma. A need still exists for evaluating the methods of urban collecting which may depart from previous procedures. Indeed, Linda Dégh predicted that the goal of theorizing probably could not be achieved until much more collection in cities occurred.[6]

The Need for Artifact Research and Preservation

Dorson, Stekert, and Paredes recognized the three patterns I outlined and foresaw new research to advance the current state of folklife scholarship in cities. Still, they failed to realize fully the possible contribution of artifactual research to

that study. Indeed, the city can be effectively characterized by its material environment; therefore its physical and spatial elements need to be examined for insights into the expressive behavior of individuals who participate in the urban environment. Indeed, when Don Yoder published his object-oriented survey of American folklife scholarship in his *American Folklife*, he noted the previous accomplishments of German scholars to arrive at a conception of modern urban folklife, and rightfully called for similar research in America.[7] The exemplary reports he cited by Walter Havernick and Gerhard Heilfurth, however, suggested questionable emphases on historical studies of objects and an incorporation into folk culture study of an equilibrium model based on the assumption of a static group.[8] Havernick and Heilfurth thus minimized the understanding of the living individual's dynamic, volitive role in shaping his traditions and manipulating his environment. To their credit, however, they presented a strong argument for considering material aspects of urban culture in investigations of folklife in cities.

Museums have assumed the most active role of portraying urban life through objects. Tammis Kane Groft's *The Folk Spirit of Albany*, a catalogue for an exhibit at the Albany Institute of History and Art, attempted to interpret how inhabitants of this major urban center in upstate New York "viewed themselves and their surroundings" through various forms of folk art.[9] In Martin Friedman's introduction to *Naives and Visionaries*, a book accompanying an exhibition by the Walker Art Center of Minneapolis, he noted the expansion of folk art study to include objects found in urban ethnic centers.[10] As evidence of urban material folk culture, contributors discussed environmental artists working in cities such as Los Angeles and Washington, D.C.[11] Nonetheless, although museums have advanced the presentation of urban folklife, they have attracted the deserved criticism of the trained student of folklife.[12]

Because museums tend to isolate objects they arbitrarily deem significant, a sterile, static, ordered, and subjective view of urban life emerges. Thus an understanding of the complexities and dynamics of interactional processes in the city and the expressive behaviors of individuals who make and use objects is absent. Also missing is the relation of material traditions to verbal and social behaviors. An example of a static conception appears in museologist Philip Spiess's paper, "The City as Historical Artifact," which argued that the style and structure of urban artifacts such as schools and fences made the city distinctive as a culture.[13] By inventorying these objects he lifted them from the life of the individuals who created and used them—a common, and disturbing museological perspective. In his model urban artifacts become more dusty objects on the shelf instead of part of a folklife conception that attempts to relate objects to the life of the people.

A partial explanation for museums' isolation of objects from the environment lies in an exhibit's natural removal from its context. Visitors to a

museum usually expect a glimpse of other cultures through exotic objects rather than anticipating a view of their own culture through typical, everyday artifacts. A successful experiment, however, by the Farmers' Museum of Cooperstown, New York, to establish a "mini-museum" in East Utica, New York, in order to represent the life of the Latin community there suggests the fruitful results gained from interpreting the dynamics of a community in its own setting.[14] Using a local community center as headquarters, folklorists trained Puerto Rican teenagers to conduct fieldwork in their own neighborhoods (fig. 11-1). The teenagers collected artifacts and oral data, often from their own families, and erected an exhibit in the community center. In a special presentation, members of the community shared experiences they associated with the collected artifacts. In addition, community members participated in music, dance, and narrative events which were typically found in the local environment. Witnessing this presentation gave insiders an appreciation of the cultural aspects of urban life through the individuals that composed the community. The divisions between demonstrator, researcher, visitor, and interpreter were deliberately and pleasingly blurred.

Preservation of Community Life

Some historic preservationists have also argued for preserving the life, in addition to the structures, of an area. Steve Tabor, president of Californians for Preservation Action, for instance, told the 1979 California Historic Preservation Conference that saving old facades and buildings must be coupled with preserving the nature of urban living.[15] An example of this new view in action occurred when the old Church of the Holy Trinity in Brooklyn Heights, New York, was in danger of being destroyed. Several preservationists conservatively called for saving the church's stained glass, but officials of the New York Landmarks Conservancy countered by claiming that more than the stained glass and the building needed to be restored: "What is at stake is an essential part of the street and of the community."[16] Interpreting objects like stained glass, in other words, apart from the life of the community, assumed that objects can remain symbolic even when stripped clean of their contexts, yet experience teaches us that the life of the object is in its use and perception; and the life of the community is represented by potent objects and activities that evoke responses in everyday encounters with natural surroundings.

In their studies folklorists have shared with museum professionals and historic preservationists a concern for the genres of material culture. Folklorists have published articles on gardens in Louisville, Greek religious artifacts in Philadelphia, ethnic instruments in Gary, painted screens in Baltimore, and stone carvings in Washington, D.C.[17] Often, this generic approach resembles Fred Kniffen's outline of the cultural geographer's method which includes the

Figure 11-1. Museum Researcher Training Teens to
 Document Folk Life of Their Community.
 East Utica, New York, 1975.
 (Simon Bronner)

visual "counting of objects."[18] What emerges from this approach is an attempt to understand the urban environment by subjectively observing external appearances in the hope of achieving a holistic conception of culture. But this approach's practitioners often lose sight of the processes and behaviors that generated those appearances, and most disturbing, they may pass over consideration of the individuals who conceive, perceive, and use objects. And after all, if the life of an object is in its use, then urban life acquires significance as a result of the individuals who live with their material surroundings.

The Behavioristic Method

Although it is true that traditional material genres in cities need to be identified, an alternative method consists of an internal, microanalytical, behavioristic study, often based on hypotheses generated, at least in part, from being or living "urban." External examination of artifacts is not an end of research in this approach, but a means of understanding specific individual behavior, defined by folklorist Michael Owen Jones as "those activities and expressive structures manifested principally in situations of first hand interaction."[19] Each individual embodies a unique complex of skills, beliefs, values, and motivations that defy categorization into broad cultural or regional divisions. Rather than conformity, then, variation is emphasized; instead of presupposing tradition, motivation is stressed. One individual thus reflects one complex of behavior which is examined for clues to mental concepts that generate "culture." A city does not equal one culture, however, but an "organization of diversity"[20] represented by symbols of forces that link individuals and drive them apart. Through intensive investigations of singular makers or users of objects, clues are sought to understand personality, creativity, communication, interaction, and aesthetic operating in the city. Researchers who use this approach are thus not so concerned with moot historical-geographical questions of origin as they are with explaining the diversity of human processes, identities, and expressions.[21] They want to interpret the modern context instead of reconstructing the past.

The problematic notions of region and community may be investigated, for example, by concentrating on one informant to determine his perceptions of his physical surroundings. How does he order his environment? What are his material points of reference? What are his social relationships? What material traditions such as food preparation, furnishing, and dressing does he relate to personal, familial, urban, regional, or national factors? Answers to these questions should result in a cognitive map of an individual's environment which will shed light on internal categories of self, community, and region in contradistinction to an analyst's application of a priori assumptions. When John Vlach prepared his report on Philip Simmons, an Afro-American blacksmith in Charleston, South Carolina, he included a discussion of the physical and spatial

characteristics of the Simmon's shop, his attitude toward his craft and community, and his adaptation to the modern context.[22] Vlach thus offered a revealing analysis of the complexities of tradition in the modern city from a native perspective. By pursuing such behavioristic questions further, conclusions on the distinctiveness of urban life can be based on a solid foundation of specific ethnographic evidence, which addresses the influence of the built environment on, and from, human ways of acting and thinking.

The ubiquitous sight on urban sidewalks of trash cans does not normally fit into the conception of material folk culture. Nonetheless, through an examination of behavior, they can exhibit cognitive concepts of perception, creativity, and aesthetics.[23] In Bloomington, Indiana, in a neighborhood where I once lived, a resident resented the disruption that bad weather and trashmen brought of his neat, linear order of cans and trash. Drawing on his familiarity with construction techniques, he built a rectangular bin of concrete and wood to house the cans in a row on the sidewalk (figs. 11-2 and 11-3). He added an addition on the side to hold newspapers; a stick attached to a hinge kept the papers from blowing away. At this point one might consider his functional and aesthetic response merely idiosyncratic. In a behavioristic perspective, however, the analyst looks to the patterns of motivation and intention enacted according to traditional behavioral models, models which indicate sociopsychological and physiocultural characteristics. Significantly, down the street another resident built a similar, yet distinctive structure (figs. 11-4, 11-5, 11-6). He positioned steel columns filled with concrete to balance the structure; he thus reacted to a functional problem of an urban environment by employing behavioral models in his social experience, yet maintained his personal identity. In this manipulation of rectilinear forms in front of their personal spaces, these men assumed and revealed social and personal notions of the proper appearance, role, and surroundings of a fact of urban life—their visible and vulnerable trash. A material "tradition" is thus evolving based on needs and demands which sparked an impulse to create an addition to the urban landscape. Similarly, the streets of Harrisburg are lined with home-made basketball hoops, varying block by block, while "official" playgrounds commonly lie idle (fig. 11-7). Through first-hand investigation of such behaviors and products of those behaviors—and the thoughts and social organizations they manifest—the analyst can evaluate the motivations for and means of communicative, interactional, and creative processes that generate and reflect an immediate material culture.

Role of the Museum in Urban Material Culture

Museums can participate in expanding urban scholarship by taking advantage of the opportunities for first-hand documentation of processes and contexts, opportunities that will enhance their educational functions in their local

Figure 11-2. Front view of First Trash Can Structure.
Bloomington, Indiana, December 1980.
(Simon Bronner)

Figure 11-3. Rear View of First Trash Can Structure.
December 1980.
(Simon Bronner)

Figure 11-4. Front View of Second Trash Can Structure.
 Bloomington, Indiana, December 1980.
 (Simon Bronner)

Figure 11-5. Rear View of Second Trash Can Structure.
 December 1980.
 (Simon Bronner)

Figure 11-6. Ed Runyon Working on his Structure.
Bloomington, Indiana, May 1981.
(Simon Bronner)

communities. The representation of folklife in folk-oriented museums thus does not become manifested in captions for objects, but in insights into the individual lives that artifacts signify. The trained folklorist, however, is essential for this endeavor because of his sensitivity to careful methods of documentation and fieldwork. The folklorist can also provide a comprehensive analysis of urban life by interpreting all aspects of a local culture: verbal, gestural, social, and material—and their interrelationships. An attempt to combine the skills of exhibiting and field researching has already been made in formats such as the Smithsonian Institution's Festival of American Folklife, although critics have warned against the possible misleading public images of folklife resulting from such presentations.[24]

In moving away from a sterile, static, ordered notion of material culture, several conceptualizations should be developed in contrast to past assumptions. Technological change would be viewed as a positive force, thus forcing consideration of continuities between older, traditional technologies and modern processes.[25] Second, a view of urban diversity rather than homogeneity would emerge from examinations of the complexities of individuals. Perhaps also, an evaluation of what defines the community, neighborhood, city, or region could be posited.[26] Third, we can grasp and highlight the behavioral and cognitive aspects of people's lives. Thus we may enter realms of the urban scene which reveal the active, complex nature of living. Take, for example, urban ritualizing of foodways, patterning of dress, manipulation of forms on the job.[27] By

Figure 11-7. Basketball Courts on the Streets of Harrisburg, Pennsylvania.
1984.
(Simon Bronner)

Figure 11-7.

incorporating the modern urban field into the folkloristic purview, the American folklorist's goal of achieving a comprehensive analysis of American folklife can be justifiably realized. And with an eye to the efforts of other disciplines working within the urban field, we can distinctively contribute to integrated perspectives on urban behavior—behavior so crucial to comprehending contemporary life.[28]

There is no question that interpreting urban traditions is difficult, especially considering the paucity of previous research in the field and the pastoral bias in American life and letters.[29] Still, a significant contribution can be made to folklife scholarship by expanding the efforts to study the modern urban environment. Of course, ethnologically minded folklorists appreciate a sense of history in their investigations of the present, but the study of material aspects of American folk culture has been too fixed in distant epochs, an orientation which may lead critics to question the field's relevance to contemporary life. American material folk culture is not restricted to the distant past; it changes to meet the personal needs and demands created by modern urban living. New areas for research necessitate rethinking the assumptions made in previous studies, and require fresh analytical approaches.

Notes for Chapter 11

1. Américo Paredes and Ellen J. Stekert, eds., *The Urban Experience and Folk Tradition* (Austin: University of Texas Press, 1971); Richard M. Dorson, ed., *Folklore in the Modern World* (The Hague: Mouton, 1978). For relevant comments on European urban research, see Hermann Bausinger, *Volkskultur in der technischen Welt* (Stuttgart: W. Kohlhammer, 1961); Sigurd Erixon, "An Introduction to Folklife Research or Nordic Ethnology," *Folk-Liv* 14 (1950): pp. 5–15; Abner Cohen, ed., *Urban Ethnicity* (London: Tavistock, 1974).

2. Quote was collected from Paul Fennessey, 23 June 1976. For Harrisburg, see Simon J. Bronner, "The House on Penn Street: A *Praxis* of Creativity and Conflict" (Washington Meeting on Folk Art, Library of Congress, 1983).

3. Richard M. Dorson, "Is There a Folk in the City?," in *The Urban Experience and Folk Tradition*, ed. Paredes and Stekert, p. 46.

4. *Folklore Forum* 11 (1978): pp. 195–290.

5. Inta Gale Carpenter, "Introspective Accounts of the Field Experience: A Bibliographic Essay," *Folklore Forum* 11 (1978): p. 211.

6. Richard M. Dorson reports her comments in his introduction to *Folklore in the Modern World*, p. 5. A rich body of urban folklore collecting exists already, however, in nineteenth-century antiquarian literature such as John F. Watson's *Annals of Philadelphia* (1830) and *Annals of New York* (1846).

7. Don Yoder, "Folklife Studies in American Scholarship," in *American Folklife*, ed. Don Yoder (Austin: University of Texas Press, 1976), pp. 9–10.

8. Walter Havernick, "The Hamburg School of Folklore Research," *Journal of the Folklore Institute* 5 (1968): pp. 113–23; Gerhard Heilfurth, "The Institut für mitteleuropäische Volksforschung at the University of Marburg," *Journal of the Folklore Institute* 5 (1968): pp. 134–41. For further discussion of "the equilibrium model," see the essay by Michael Owen Jones in this volume.

9. Tammis Kane Groft, *The Folk Spirit of Albany* (Albany: Albany Institute of History and Art, 1978), p. vii.

10. Walker Art Center, *Naives and Visionaries* (New York: E.P. Dutton, 1974), p. 7.

11. Lynda Roscoe, "James Hampton's Throne" and Calvin Trillin, "Simon Rodia: Watts Towers," in *Naives and Visionaries* (New York: E.P. Dutton, 1974), pp. 13–19 and pp. 21–31, respectively.

12. Howard W. Marshall, "Material Culture and the Museum," *Association for Living Historical Farms and Agricultural Museums Annual* 3 (1977): pp. 35–38; idem, "Folklife and the Rise of American Folk Museums," *Journal of American Folklore* 90 (1977): pp. 391–413, especially pp. 410–11; Simon J. Bronner, "Recent Folk Art Publications: A Review Essay," *Mid-South Folklore* 6 (1978): pp. 27–30, especially pp. 28–29; Robert Baron, "Folklife and the American Museum," *Museum News* 59 (March/April 1981), pp. 46–50, 58–64; John Vlach "American Folk Art: Questions and Quandaries," *Winterthur Portfolio* 15 (1980): pp. 344–55; Ormond Loomis, "The Folklife Researcher and the Museum" (paper read at the American Folklore Society meeting, Detroit, 1977).

13. Philip Spiess III, "The City as Historical Artifact" (paper read at the Cooperstown Graduate Association meeting, Cooperstown, 1978).

14. The project which took place in the fall of 1975 was funded by a grant from the New York State Council on the Arts. Patricia Laskovski of the Farmers' Museum served as coordinator; I served as special consultant.

15. Roger Showley, "Old Buildings, Bustling Urban Living Must Be Linked, Preservations Told," *San Diego Union* (12 May 1979), p. 1.

16. "Landmark," *The New Yorker* (21 May 1979), p. 29.

17. J. Larry Smith, "The Kitchen Garden: A Case Study of Urban Folk Culture," *Pioneer America Society Proceedings* 2 (1973): pp. 83–92; Robert Thomas Teske, "On the Making of *Bobonieres* and *Marturia* in Greek Philadelphia: Commercialism in Folk Religion," *Journal of the Folklore Institute* 14 (1977): 151–58; Richard March, "The Tamburitza Tradition in the Calumet Region," *Indiana Folklore* 10 (1977): pp. 127–38; Elaine Eff, "The Painted Window Screens of Baltimore, Maryland," *The Clarion* (Spring 1976), pp. 5–12; Marjorie Hunt, "Folklore in Your Community: The Stone Carvers of Washington's National Cathedral," in *1978 Festival of American Folklife*, ed. Jack Santino (Washington, D.C.: Smithsonian Institution, 1978), pp. 36–39.

18. See Fred B. Kniffen, "American Cultural Geography and Folklife," in *American Folklife*, ed. Don Yoder (Austin: University of Texas Press, 1976), pp. 51–70, especially pp. 57–58.

19. Michael Owen Jones, "Ask the Chairmaker" (paper read at the American Studies Association meeting, Boston, 1977).

20. For more on the concept of "organization of diversity," see Anthony F.C. Wallace, *Culture and Personality* (New York: Random House, 1961); Richard Bauman and Joel Sherzer, "The Ethnography of Speaking," *Annual Review of Anthropology* 4 (1975): p. 98.

21. An excellent example of this behavioristic approach (not to be confused with psychologists' use of behaviorism) is Michael Owen Jones, *The Hand Made Object and Its Maker* (Los Angeles and Berkeley: Univeristy of California Press, 1975). See also Robert Georges, "Toward a Resolution of the Text/Context Controversy," *Western Folklore* 39 (1980): pp. 34–40; Simon J. Bronner, "Investigating Identity and Expression in Folk Art," *Winterthur Portfolio* 16 (1981): pp. 65–83; Michael Owen Jones, "L.A. Add-ons and Re-dos: Renovation in Folk Art and Architectural Design," in *Perspectives on American Folk Art*, ed. Ian M.G. Quimby and Scott T. Swank (New York: W.W. Norton, 1980), pp. 325–63; Robert E. Park, "The City: Suggestions for the Investigation of Human Behavior in the Urban Environment," in *The City: American Experience*, ed. Alan Trachtenberg, Peter Neill, and Peter C. Bunnell (New York: Oxford University Press, 1971), pp. 223–36; Stanley Bailis, "The Social Sciences in American Studies: An Integrative Conception," *American Quarterly* 26 (1974): pp. 202–24, especially p, 220; Barbara Kirshenblatt-Gimblett, "The Future of Folklore Studies in America: The Urban Frontier," *Folklore Forum* 16 (1983): pp. 175–234; Simon J. Bronner, *Chain Carvers* (Lexington: University Press of Kentucky, 1984).

22. John M. Vlach, *Charleston Blacksmith* (Athens: University of Georgia Press, 1981); idem, "Philip Simmons: Afro-American Blacksmith," in *Black People and Their Culture*, ed. Linn Shapiro (Washington, D.C.: Smithsonian Institution, 1976), pp. 35–37. See also the approaches to cognitive sense of place found in M.H. Matthews, "The Mental Maps of Children: Images of Coventry's City Centre," *Geography* 65 (1980): pp. 169–79; Yi-Fu Tuan, *Space and Place* (Minneapolis: University of Minnesota, 1977).

23. Examining cans as an urban folk art was suggested by Michael Owen Jones, "Modern Arts and Arcane Concepts: Expanding Folk Art Study" (paper read at the Midwestern Conference on Folk Arts and Museums, Minneapolis, 1980). See also my study of other urban "behavioral" artifacts in "Suburban Houses and Manner Books: The Structure of Tradition and Aesthetics," *Winterthur Portfolio* 18 (1983): pp. 61–68.

24. See John F. Moe, "Folk Festivals and Community Consciousness: Categories of the Festival Genre," *Folklore Forum* 10 (1977): pp. 33–40; Simon J. Bronner, "Festival of American Folklife," *Folkscene* (September 1975), pp. 5–6.

25. For further discussion of this point, see Yoder, "Folklife Studies in American Scholarship," p. 10; Barbara Kirshenblatt-Gimblett, "Culture Shock and Narrative Creativity," in *Folklore in the Modern World*, ed. Dorson, pp. 109–22.

26. See the incisive discussion of this problem in W.F.H. Nicolaisen, "The Folk and the Region," *New York Folklore* 2 (1976): pp. 143–49; Tuan, *Space and Place*, pp. 151–65.

27. See, for example, Timothy Charles Lloyd, "The Cincinnati Chili Culinary Complex," *Western Folklore* 40 (1981): pp. 28–40; Norine Dresser, " 'Is It Fresh?' : An Examination of Jewish-American Shopping Habits," *New York Folklore Quarterly* 27 (1971): pp. 153–60; Janet Theophano, "Food and Its Significance in an Italian-American Setting" (paper read at the American Folklore Society meeting, Pittsburgh, 1980); Ina-Maria Greverus, "Clothing: Necessity, Prinzip Hoffnung, or Trojan Horse?" in *Folklore on Two Continents*, ed. Nikolai Burlakoff and Carl Lindahl (Bloomington, Indiana: Trickster Press, 1980), pp. 250–59; Michael Owen Jones, "A Feeling for Form, as Illustrated by People at Work" in *Folklore on Two Continents*, ed. Burlakoff and Lindahl, pp. 260–69.

28. See the bibliographical and methodological suggestions made in Thomas J. Schlereth, "The City as Artifact," *American Historical Association Newsletter* 15 (February 1977): pp. 6–9; Anthony Filipovitch, *Urban Community: A Guide to Information Sources* (Detroit: Gale Research, 1978); Camilla Collins, "Bibliography of Urban Folklore," *Folklore Forum* 8 (1975): pp. 57–125. See also the bibliographies published by the Council of Planning Libraries (Monticello, Illinois): Susan Feller and Mark Baldassare, *Theory and Methods in Urban Anthropology: Contributions Toward the Study of American Cities* (No. 899, October 1975); James L. Wood, Wing-Cheung Ng, and Patricia A. Wood, *Urban Sociology Bibliography* (No. 1336, August 1977); John A. Jakle, *The Spatial Dimensions of Social Organizations* (No. 118, March 1970); Allen M. Wakstein, *A Bibliography of Urban History* (No. 897, October 1975).

29. For discussion of this bias, see Morton White, *The Intellectual vs. the City* (Cambridge: Harvard University Press, 1962); Leo Marx, *The Machine in the Garden* (New York: Oxford University Press, 1964). Pointing out the heightened sense of behavior in the modern city, and thus underscoring the appropriateness of behavioristic methods there, is Richard Sennett, *The Fall of the Public Man* (New York: Vintage Books/Random House, 1978).

Comments

The Sterile Presentation of Urban Artifacts

Simon J. Bronner touches on several issues which are of immediate concern to the discipline of American folklife research. His most basic contention, that folklorists in the United States have paid relatively little attention to the material aspects of urban culture, can scarcely be contested. In a paper entitled "Ethnic Folklife" which I read at the American Folklore Society meeting in Philadelphia in 1976, I lamented the woeful lack of consideration awarded ethnic material culture in this country, and, as Bronner suggests, that situation has unfortunately changed little over the past few years. Some reasons for this neglect of urban material folk culture, which Bronner insightfully proposes, include the difficulty inherent in defining "urban" and the complexity of conducting adequate fieldwork in an immense and intricate environment. Bronner suggests that these problems can be overcome to a certain extent if American folklorists begin to recognize and cooperate with their allies in the examination of urban material culture—the museums and the historic preservationists. Although the relationship between material folk culture and the museum has been recognized since the resurgence of folklife studies in this country nearly twenty-five years ago, only a few American folklorists have recently awakened to the large number of concerns shared by the students of our discipline and the historic preservationists, and Bronner's attention to these mutual interests is commendable.[1]

Yet despite his recognition of the much-needed expansion of urban field research to include material culture and his awareness of the complementary roles of folklorists, museum professionals, and preservationists, Bronner has understated certain factors which have slowed consideration of urban folklife in general, and he has been somewhat optimistic in looking to alternative formats for exhibiting urban material folk culture. With regard to factors inhibiting examination of urban material folk culture, one of the most serious is the difficulty of differentiating between what is "folk" and what is "pop," especially when the traditional and mass-produced come perilously close to one another in

process, form, or transmission. Should van paintings, garage door decorations, and custom bicycle frames be allocated positions beside ethnic folk art, the Watts Towers, and the stone sculptures of the National Cathedral? Perhaps they should, and perhaps such canonization would advance even further the view of technological change as a positive influence which many of us share with Bronner. Nonetheless, the reasons for regarding certain urban material forms as "folk" or "pop" must first be carefully weighed, the relationships established, and then a broad net cast so that not just "Old World or rural folkloric transplants" come to be regarded as urban material folk culture. In this way, on the basis of a careful examination of the new situations, new stimuli and new techniques available to the contemporary urban folk artist or craftsperson, "the more comprehensive analysis of American folklife" which Bronner favors might finally be achieved without the risk of calling everything folklife or adhering to an antiquarian view of folklore.[2]

With regard to the exhibition of this newly delineated American urban material folk culture, I feel perhaps somewhat more strongly than Bronner that museums suffer under severe limitations. Not only do museum exhibits tend to be "sterile, static, ordered," they also tend to be too heavily artifact-focused. While such an attempt as that of the Farmers' Museum in Cooperstown to establish a mini-museum in an East Utica community center, complete with musical, material, and narrative presentations, is laudable because of its stress on performers and something of the context of the subject, most museums are not in a position to mount such a well-conceived outreach effort. The more common alternatives to such an exhibit format are the "display" of the artist or craftsperson, usually hard at work, alongside of his products, or the demonstration of the individual to the exhibit hall through the magic of slides, films, or videotapes. Although both types of efforts are well intentioned and often do add some aspect of humanity to the objects on display, they seem to be fraught with even greater limitations than festival presentations with regard to accurate re-creation of context function, and even process. As an alternative—or better, as a complement—folklorists and museum professionals might explore more fully the walking tour technique which preservationsists and others have used to considerable advantage. The series of pamphlets by the Michigan Ethnic Heritage Studies Center outlining walking (or driving) tours of Detroit's ethnic communities could serve as a model.[3] By employing such a technique, folklorists and museum professionals can provide closer, more immediate contact with the complex urban background of their exhibit than in any other way, and thereby expand the scope of their efforts beyond sterile presentation of artifacts.

Robert Thomas Teske

Notes

1. See the references in my article, "Folk Studies and Historic Preservation," *Pioneer America Society Transactions* 2 (1979): pp. 71–80.

2. For discussion of the antiquarian "folklore in America" position, see Richard Bauman and Roger D. Abrahams with Susan Kalčik, "American Folklore and American Studies," *American Quarterly* 28 (1976): pp. 360–77; Richard M. Dorson, "Folklore in America vs. American Folklore," *Journal of the Folklore Institute* 15 (1978): pp. 97–112; Simon J. Bronner and Stephen Stern, "American Folklore vs. Folklore in America: A Fixed Fight?" *Journal of the Folklore Institute* 17 (1980): pp. 76–84; Simon J. Bronner, "Malaise or Revelation? Observations on the 'American Folklore' Polemic," *Western Folklore* 41 (1982): 52–61.

3. Paul Travalini, ed., *Field Trip Series* (Detroit: Michigan Ethnic Heritage Studies Center, 1975).

On Finding the Urban in Urban Folklife

The discovery of urban folklife is a problematic venture, and more difficult than "incorporating the material culture of the modern urban field into the folklorist's purview" would imply. Since we rather naturally gravitate toward investigating the impact of urbanism on already familiar traditional patterns of behavior, or on finding the stereotyped "real folk"—"that white-haired old fella with the gleam in his eye whose work-weary hands clapped his knees after a clever maneuver at checkers"[1]—we inevitably find that the old ways continue, though they are reinterpreted to fit the urban circumstance. We do not move directly to searching out intrinsically urban forms.

The complexity and vastness of the city—both internally and with all the networks which lie outside the city—added to most fieldworkers' disposition to work and to cope individually lead quite predictably to a confusion of experience in the urban field. The response, often in self-defense, is to continue to document the known, whether verbal, musical, or material. Such an approach remains at some distance from getting at the essence of the city; it just tells us what happens within it.

I can give an example from my experience with an urban folklife team investigation sponsored by the Folklore Institute of Indiana University during 1975–77 in the Calumet Region of northwestern Indiana. One of the fieldworkers in the project, after several weeks of disquieting and disorienting rummaging for "urban" folklore in the Region, still had little to show for his effort. Then he suddenly "found" a *Märchen* teller. His exuberance at this discovery suggested his feelings of accomplishment, of a goal successfully reached. Never mind that these tales, which she had once told to her children, reflected a memory culture that commented more on an immigrant tradition than on an urban, regional one. In locating her, the fieldworker had not found urban folklife as much as he had demonstrated the variety of folk traditions in an urban area. Ironically, three members of the narrator's family were engrossed in the activities of an urban, social theater group, which improvised a large part of

its material from traditional narratives such as their mothers told. These narratives were often transformed in context and function into contemporary skits that reflected a distinct ethnic group's identity and culture and touched on themes such as Anglo hypocrisy and urban renewal. The theater group, which relied on shared cultural meanings, idioms, current folkloric situations and encounters, seems almost by definition an urban phenomenon; for a large city promotes the theater group's organization and purpose, and provides its audience. It has always seemed to me that when fieldworkers pursue and prefer Old World traditions and familiar genres, they reveal their own uncertainty as to whether or not new urban "stuff" (such as the theater group's material) is "pure" or "traditional" enough; perhaps they even reveal an unwillingness to look for new folkloric markers as they explore the unfamiliar urban setting.

It is all too easy, then, to stick with the imported traditions, but to do so, obviously, is to take but a small, tentative step into the urban landscape, with one's head, moreover still turned backward. Bronner's argument for a fuller, behavioristic treatment of material culture traditions in the city is sound, but the criteria for identifying individuals and artifacts that will help us understand the urban nature of a tradition, remain elusive. Vlach, in his study of Charleston blacksmith Philip Simmons, may in fact offer "a revealing analysis of the complexities of tradition in the modern city from the native perspective," but as Bronner himself states, the next steps—conclusions about the distinctiveness of urban life—must be sought by pursuing certain questions *further.*

And, unfortunately, even as Bronner argues that emphasizing artifactual research will amplify urban folklife documentation and understanding, he must also admit that material culture studies suffer from the same attention to a static, out-of-context, past-oriented, item approach that still exerts such a stranglehold on recorded verbal traditions. It is all too tempting, as anthropologist Richard G. Fox puts it, to concentrate on the familiar exotics, whether they be immigrants, southern mountaineers, or basketmakers.[2] What guidelines or past studies are there for the urban material culture specialist to follow, which sift out the urban artifactual forms and behaviors from the urban and technological adaptations? What are the urban components of blacksmith Simmons's craft? How does a study of his art aid in conceptually understanding the city? To my way of thinking there is a pertinent difference between going into a city and locating believers in the "evil eye" or researching the associated artifacts and documenting an urban category unconceived by us before our discovery of it on city streets (which Bronner has commendably done).[3] Belief in the evil eye is an occurrence that could be predicted as a statistical probability in any city with its variety of peoples. But what are the folklife forms that an urban environment nourishes best?

If, then, we are determined on a course of scholarly investigation we call urban folklife, one which seeks to differentiate between rural and urban folklife, is it not time we turned to figuring out how to tell the difference? Or, first shouldn't we think about whether the difference is an intrinsically important one?

Inta Gale Carpenter

Notes

1. Adrienne Seward, "Some Dilemmas of Fieldwork: A Personal Statement," *Folklore Forum* 11 (1978): p. 245.

2. Richard G. Fox, "Rationale and Romance in Urban Anthropology," *Urban Anthropology* 1 (1971): pp. 205-6.

3. Problems and promises of urban folklore research are further discussed in Barbara Kirshenblatt-Gimblett, "The Future of Folklore Studies in America: The Urban Frontier," *Folklore Forum* 16 (1983): pp. 175-234.

Reply: Meeting the Challenge of Urban Folklife Research

Taken together, the comments of Robert Teske and Inta Carpenter highlight three basic questions which first gave rise to the writing of my essay: (1) how can the study of material aspects of culture in the city help expand the knowledge of American folklife; (2) how can researchers evaluate the concept of tradition in the urban environment; and (3) how can museums and historic preservation agencies, the most prominent keepers of urban material heritages, aid folk researchers to interpret the urban environment and the people living therein? Both commentors have been in the forefront of the movement to arrive at answers to these pressing questions—Teske, for example, with his excellent dissertation of the votive offerings of Greek Philadelphians, and Carpenter with her compilation, *Folklorists in the City*.[1] Thus I am heartened that they agree with my contention that material folk culture research in the city, although neglected by folklorists in the past, is essential, perhaps even central, to the study of the urban environment. This statement is no small concession considering the entrenchment of a rural, pastime bias in material studies, and in addition, the over-reliance on verbal research for evidence in urban folk studies. Still, there are some points of departure presented in Teske and Carpenter's comments, points worthy of discussion.

Teske correctly ties the neglect or urban material folk culture to the general problem of the neglect of the urban environment, a neglect, he suggests, influenced by the problematic task of identifying truly "folk" items. That statement presupposes that the object is necessarily the center of research. On the contrary, as I state in my essay, I view material culture as revealing "insights into the individual lives that artifacts *signify*." The object apart from its situational and behavioral contexts does present serious problems of identification, but I assert that the ethnographic study of *individuals and their behavior*—a study which also includes an assessment of their physical surroundings, technical skills, and cognitive processes—is the center of research.[2] In this view, the researcher should be able to evaluate successfully the meanings of communicative, interactional, and creative *processes* associated with objects in individual lives, to determine the scope of "tradition" and not be

compelled by the academic precedent of surface evaluation to discard data because of a presumed lack of traditionality.[3] Hence while it may be true that previous assumptions about the distinctions between "folk" and "pop" may have hindered broader acceptance of the urban field, behavioristic study in that field is bound to change that orientation, and break down those barriers—a change that has already begun. Indeed, Teske's article, "On the Making of *Bobonieres* and *Marturia* in Greek Philadelphia," and Michael Owen Jones's "L.A. Add-ons and Re-dos" are just two examples of how folklorists are effectively identifying traditional expressive behaviors within the framework of American mass culture.[4]

Teske also appears more pessimistic than I am about the role of museums and historic preservation agencies in achieving the synthesis of urban folklife research that is desirable. To be sure, I share his frustration with the "too heavily artifact-focused" orientation of American musuems. Still another problem is the heavy educational emphasis of American museums at the expense of research. This situation is analogous to putting the cart before the horse, but still, only a few research departments exist in museums, and few museums create adequate links to the academic community.[5] By contrast, European folk museums, in particular, have demonstrated the potential for successful alliances between academe and the museum. In Maria Znamierowska-Prüfferowa's essay, "Ethnomuseology and Its Problems," she lists "museum research work and its documentation" as the first task of museum work and its service to society.[6] Speaking mainly about Europe, she asserts that the present state of affairs "encourages ethnologists in research work."[7] One may justifiably ask, then, whether American history museums *discourage* academic ethnographic researchers. To a large degree they do; but my optimism is based on a belief that through greater awareness of folk studies on the part of museums, and through an urging by critics for a shift in museum purposes, change may take place. Although museums do "suffer under severe limitations," as Teske states, they, after all, also possess useful resources for the folklife researcher who should be made a more integral part of the research and intepretation process. That position is the one I defended in my essay, but I also want to add another here: because of the current problems of museum research perpetuated by museum training programs, academics should think more in the future of controlling museum facilities to effect research goals, rather than merely building alliances. I am thinking, for example, of the establishment of research collections and living history experiments, opportunities not now widely available to the student of material culture.

Inta Carpenter especially addresses the third issue I enumerated at the outset, namely of evaluating "tradition" in the urban environment. She complains that the approach I suggest does not reveal the "essence of the city; it just tells us what happens within it." My reasoning, however, is that to explain

the city, researchers need to know, not presume, what happens within it—and equally significant are individuals' perceptions of those events, objects, and concepts occurring in the city. I admit that my position may sound like an empiricist attitude (actually my perspective has roots in pragmatic and praxiological philosophies), but I hesitate to make pronouncements on the "essence" (a vague abstraction) of "urban" without further specific knowledge of the variety of urban expressive behaviors, the significance of which Carpenter seems to downplay. Consider, for example, Richard M. Dorson's "distinctively" urban characteristics, such as separation of ethnic groups, symbolic value placed on books, richness of personal histories, and plural character of culture, in his classic essay, "Is There a Folk in the City?"[8] Those findings indicated to him the uniqueness of folk culture in the city. But, one can also easily argue that all eight conditions also occur in rural environments. The uniqueness debate by its nature lends itself to ambiguities; one such ambiguity is reflected in the contrapuntal questions of Carpenter's concluding paragraph.[9] That is why I called for a consideration of the continuities, complexities, and disparities of expressive human behavior; her separatist outlook on the urban research perspective myopically denies cultural multivocality. I do not want to dismiss, however, the questions Carpenter raises. They are provocative questions and deserve consideration. But, to arrive at evaluative criteria for urban categories, theoretical formulations based on those designations are goals of research, not means. Before those ends are reached, folklorists need to develop methodological perspectives, a need for which I attempted to lay some groundwork in my essay.[10]

I do not claim that behavioristic approaches are necessarily appropriate to all the problems of urban folklife study. It is important, after all, to match the type of research question to an appropriate conception, of which my behavioristic approach is just one. But a perspective especially worth exploring, I reassert, involves looking for behavioral and cognitive insights, for such a perspective can begin tackling the substantial challenges of urban folklife in modern settings.

Simon J. Bronner

Notes

1. Robert Thomas Teske, "Votive Offerings Among Greek Philadelphians: A Ritual Perspective" (Ph.D. dissertation, University of Pennsylvania, 1974); Inta Gale Carpenter, ed., *Folklorists in the City: The Urban Field Experience* (Bloomington, Indiana: *Folklore Forum* (1978). (See also Carpenter's compilation, *Land of the Millrats: Folklore in the Calumet Region* (Bloomington, Indiana: *Indiana Folklore* (1977).)

2. For elaboration on this point, see S.A. Tokarev's essay in this volume; Simon J. Bronner "'Learning of the People': Folkloristics in the Study of Behavior and Thought," *New York Folklore* 9 (1983): pp 75–88; idem, "Investigating Identity and Expression in Folk Art," *Winterthur Portfolio* 16 (1981): pp. 65–83; idem, *Chain Carvers: Old Men Crafting Meaning* (Lexington: University Press of Kentucky, 1984).

3. See Michael Owen Jones's discussion of this point in *The Hand Made Object and Its Maker* (Los Angeles and Berkeley: University of California Press, 1975), pp. 19–25, 69–73; and one of his more contemporary statements, "Modern Arts and Arcane Concepts: Expanding Folk Art Study" (paper read at the Midwestern Conference on Folk Arts and Museums, Minneapolis, 1980).

4. Robert Thomas Teske, "On the Making of *Bobonieres* and *Marturia* in Greek Philadelphia: Commercialism in Folk Religion," *Journal of the Folklore Institute* 14 (1977): pp. 151–58; Michael Owen Jones, "L.A. Add-ons and Re-dos: Renovation in Folk Art and Architectural Design," in *Perspectives on American Folk Art,* ed. Ian M.G. Quimby and Scott T. Swank (New York: W.W. Norton, 1980), pp. 325–63.

5. See Ormond Loomis, "The Folklife Researcher and the Museum" (paper read at the American Folklore Society meeting, Detroit, 1977); Thomas J. Schlereth, "It Wasn't That Simple," *Museum News* 56 (Jan./Feb. 1978), pp. 36–44.

6. *Ethnologia Europaea* 4 (1970): pp. 203–6. The quote is on p. 206.

7. Ibid., p. 206.

8. In Américo Paredes and Ellen J. Stekert, eds., *The Urban Experience and Folk Tradition* (Austin: University of Texas Press, 1971), pp. 21–52. His conclusions appear on pp. 43–49.

9. See, for example, the time-worn debate on the uniqueness of America discussed in Richard Bauman and Roger D. Abrahams with Susan Kalčik, "American Folklore and American Studies," *American Quarterly* 28 (1976): pp. 360–77; Simon J. Bronner and Stephen Stern, "American Folklore vs. Folklore in America: A Fixed Fight?" *Journal of the Folklore Institute* 17 (1980): pp. 76–84. The uniqueness debate is symptomatic of an academic fixation on "essence," which Carpenter shares, but I concur with Conrad Arensberg's complaint that "Despite such obvious everyday experiences of directional lineup in activities as simple as bucket lines and traffic queues and pecking orders or dinner-party precedence, or routing office memoranda, social science still seeks to derive its constructs from purposes and essences rather than from behaviors." The quote (p. 11) is from his "Culture as Behavior: Structure and Emergence," *Annual Review of Anthropology* 1 (1972): pp. 1–26.

10. I pursue this point further in my "Concepts in the Study of Material Aspects of American Folk Culture," *Folklore Forum* 12 (1979): pp. 133–72; idem, "Historical Methodology in Folkloristics: Introduction," *Western Folklore* 41 (1982): pp. 28–29; "'Visible Proofs': Material Culture Study in American Folkloristics," *American Quarterly* 35 (1983): pp. 316–38.

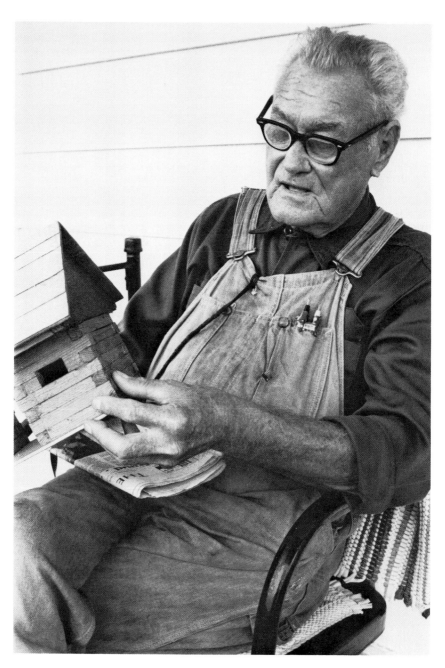

(Simon Bronner)

Part V: Epilogue

In southern Indiana several summers ago, I watched Leonard Langebrake carve wooden canes many times. After finishing one, he liked to sit on his porch, cane in hand, and look out on the setting he called his homeplace. On one such occasion, he turned to me and put his walking stick firmly in my hand. He read my questioning countenance, for then he explained his action by drawling, "Grasp it. Go ahead. I'll be dead soon, and you'll know what the cane means and where it's from." He thus drew attention to a crucial issue in my thinking: the human meaning of objects in behavior. Meaning became clearer when Leonard held that cane, and when I recalled how he carved one, how he felt about it, how he used it, how he leaned on it and looked out on his community—and hence how he viewed his world.

That incident came to my mind recently when I sat through a slide lecture on architecture. Building after building flashed on the screen—sights often relished by the student of material culture—yet I felt unsettled. Where were the people? I saw facades, but life was absent on the screen and in the explanations I heard. The buildings meant something profound only in relation to the people who lived with, and in, them, and who reacted to them and met with one another. People give material culture its depth and detail. I thought of Leonard's cane. It bore meaning because of his personal imprint, and the life and lineage of his experience. We who study objects and the people they belong to realize that we are often faced with things of uncertain provenance and history, but in seeking explanations for the questions and quandaries of humanity, our task most often, in my view, is to search empirically and theoretically for how these results of human conduct signify continuities and consistencies, and sometimes even disparities, in human thought and behavior, and the conditions under which people operate.

These afterthoughts help explain why the volume's subtitle joins "material culture" and "folklife," for the contributors tend to view and grasp objects relative to life, indeed the human behaviors, thoughts, and conditions that surround the material world. As interpreters of artifacts we are also naturally concerned with the presentation of our objects and findings—in the museum, historical society, festival, or book. Our discussions move between theory and practice, between interpretive and presentational philosophies.

At the same time that most contributors often invoke one or all these labels, a basic discord sounds between those who use folklife to represent an orientation stressing holistic studies of so-called folk communities or regions, and those who want to base folklife (or folkloristics) on an individual-centered, modern behavioral research foundation. Although vigorous argument continues over what constitutes "folk" life, or material "culture," or for that matter "American," we share a sense that making significant revelations about humanity can come from apprehending the traditional things, the pursuits, and the events—the physical, social, spiritual, and psychological modes of life—in human experience and expression.

Much more can be done in the realm of experience and expression; I feel confident much more will be done. If the contributions to this volume suggest a diversity of ways to approach and interpret this realm, then they also point to a certain unity of spirit—a spirit of inquiry for comprehending meaning in people's object and event-filled lives.

Simon J. Bronner

Contributors

Elizabeth Mosby Adler is program consultant for the Kentucky Humanities Council. She received her Ph.D. in folklore and American Studies from Indiana University. She is a contributor to *Afro-American Folk Art and Crafts* (1983), *Foodways and Eating Habits* (1983), and *American Folk Art: A Guide to Sources* (1984).

Thomas A. Adler is assistant professor of folklore at the University of Kentucky. He received his Ph.D. in folklore from Indiana University. He is the author of a monograph *"Sunday Breakfast Was Always Special With Us": A Report on Foodways in South Central Georgia* (1979) and contributor to *Approaches to the Study of Material Aspects of American Folk Culture* (1979).

John H. Braunlein is director of the Rockwood Museum in Wilmington, Delaware. He received his M.A. in philosophy from the University of Delaware and another M.A. in American folk culture from the Cooperstown Graduate Programs of the State University of New York. He is the author of *Colonial Long Island Folklife* (1976) and was editor of *Studies in Traditional American Crafts*.

Simon J. Bronner is assistant professor of folklore and American Studies at the Pennsylvania State University—Capitol Campus. He received his Ph.D. in folklore and American Studies from Indiana University. He is the author of *Chain Carvers: Old Men Crafting Meaning* (1984), editor of *American Folk Art: A Guide to Sources* (1984); and coeditor of *Approaches to the Study of Material Aspects of American Folk Culture* (1979). He is president of the Pennsylvania Folklore Society and editor of *Material Culture* and *The Folklore Historian*.

Inta Gale Carpenter is associate director of the Folklore Institute at Indiana University, where she completed her doctoral studies in folklore. She is the author of *A Latvian Storyteller* (1980), editor of *Folklorists in the City: The Urban Field Experience* (1978), and associate editor of *Handbook of American Folklore* (1983).

Tom Carter is an architectural historian in the Utah Division of State History. He received his Ph.D. in folklore from Indiana University. He is a contributor to *Material Culture in the South* (1975).

C. Kurt Dewhurst is director of The Museum, Michigan State University. He received his Ph.D. in American Studies from Michigan State University. He is coauthor of *Artists in Aprons: Folk Art by American Women* (1979), *Rainbows in the Sky: The Folk Art of Michigan in the Twentieth Century* (1978), and *Religious Folk Art in America* (1984).

Elaine Eff is a museum consultant in Baltimore. She received her Ph.D. in folklore and folklife from the University of Pennsylvania. She is a contributor to *American Folk Art: A Guide to Sources* (1984).

Henry Glassie is professor of folklore and folklife at the University of Pennsylvania, from which he received his Ph.D. He is the author of *Pattern in the Material Folk Culture of the United States* (1968), *All Silver and No Brass* (1975), *Folk Housing in Middle Virginia* (1975), and *Passing the Time in Ballymenone* (1982). He is president of the Vernacular Architecture Forum and is on the editorial board of *Material Culture*.

Patricia A. Hall is director of the Education Division, American Association for State and Local History. She received her M.A. in folklore from the University of California at Los Angeles. She is the author of the booklet *So You've Chosen to be a History Professional* (1977).

Alice Hemenway is director of Pennsbury Manor in Morrisville, Pennsylvania. She received her M.A. in history museum studies from the Cooperstown Graduate Programs of the State University of New York. She is the coauthor of five community architectural histories for the Cornell University Preservation Planning Workshop, 1978–79.

Bernard L. Herman is assistant director of the Middle Atlantic Center for Historic Architecture and Engineering at the University of Delaware, where he is on the faculty of the history department. He received his Ph.D. in folklore and folklife from the University of Pennsylvania. He is a contributor to *The Scope of Historical Archaeology* (1984) and is on the board of directors of the Vernacular Architecture Forum.

Michael Owen Jones is professor of folkloristics and history at the University of California at Los Angeles. He received his Ph.D. in folklore and American Studies from Indiana University. He is the author of *The Hand Made Object and Its Maker* (1975), coauthor of *People Studying People: The Human Element in Fieldwork* (1980), and coeditor of *Foodways and Eating Habits* (1981). He is on the executive board of the American Folklore Society and the editorial boards of *Material Culture* and *Western Folklore*.

Darwin P. Kelsey is director of the National Museum of the Boy Scouts of America in Murray, Kentucky. He received his M.A. in American folk culture from the Cooperstown Graduate Programs of the State University of New York and completed his doctoral studies in geography at Clark University. He is the editor of *Farming in the New Nation: Interpreting American Agriculture, 1790-1840* (1972).

Ormond H. Loomis is director of Florida Folklife Programs, a bureau of the Florida Department of State. He received his Ph.D. in folklore from Indiana University. He is the author of *Cultural Conservation: The Protection of Cultural Heritage in the United States* (1983) and *Sources on Folk Museums and Living Historical Farms* (1977).

Marsha MacDowell is curator of folk arts at The Museum, Michigan State University. She received her Ph.D. in education from Michigan State University. She is the coauthor of *Artists in Aprons: Folk Art by American Women* (1979), *Rainbows in the Sky: The Folk Art of Michigan in the Twentieth Century* (1978), and *Religious Folk Art in America* (1984).

William K. McNeil is folklorist at the Ozark Folk Center in Mountain View, Arkansas. He received his Ph.D. in folklore and American Studies from Indiana University. He is the editor of *The Charm is Broken: Readings in Arkansas and Missouri Folklore* (1984) and *On a Slow Train Through Arkansaw* (1985). He is review editor for *MidAmerica Folklore* and associate editor of *The Folklore Historian*.

Gerald Parsons is reference librarian in the Archive of Folk Culture at the Library of Congress. He completed his doctoral studies in folklore and folklife at the University of Pennsylvania. He is secretary-treasurer of the National Council for Traditional Arts.

Roderick Roberts is associate professor of folklife and English at the State University of New York at Oneonta. He received his Ph.D. in folklore from Indiana University. He is the author of *The Powers Boys: The Uses of an Historical Legend* (1980).

Warren E. Roberts is professor of folklore at Indiana University, from which he received his Ph.D. He is the author of *The Tale of The Kind and Unkind Girls* (1958), *Norwegian Folktale Studies* (1965), and *Log Buildings of Southern Indiana* (1984). He is on the editorial board of *Material Culture.*

Robert Thomas Teske is senior arts specialist in the Folk Arts Program of the National Endowment for the Arts, a federal agency. He received his Ph.D. in folklore and folklife from the University of Pennsylvania. He is the author of *Votive Offerings among Greek Philadelphians* (1980) and a contributor to *American Folk Art: A Guide to Sources* (1984).

Sergeij Tokarev is head of the department on Western Europe in the Institute of Ethnography, USSR Academy of Sciences. He has written over twenty books, including *Narody Ameriki* (1959) on America, *Narody Zarubezhnof: Europy* (1964) on Europe, *Die Religion in der Geschichte der Volker* (1976) on folk religion, and *Istorikila Zarubezhnofi getnofrafii* (1978) on the history of international ethnography. He is on the editorial boards of *Ethnologia Europaea* and *Sovietska Ethnografia.*

Dell Upton is assistant professor of architecture at the University of California, Berkeley. He received his Ph.D. in American Civilization from Brown University. He is the author of *Holy Things and Profane: Anglican Parish Churches in Colonial Virginia* (1985) and coeditor (with John Vlach) of *Common Places: Readings in American Vernacular Achitecture* (1985). He is on the editorial boards of *American Quarterly, Material Culture,* and *Winterthur Portfolio.*

John Michael Vlach is director of the folklife program at the George Washington University, Washington, D.C. He received his Ph.D. in folklore from Indiana University. He is the author of *The Afro-American Tradition in the Decorative Arts* (1978) and *Charleston Blacksmith: The Work of Philip Simmons* (1981), and is coeditor (with Dell Upton) of *Common Places: Readings in American Vernacular Architecture* (1975). He is on the editorial boards of *Material Culture* and *Western Folklore.*

Peter Voorheis is a free-lance translator and writer in New York. He received his Ph.D. in folklore from Indiana University. He is coeditor of *Folklorica: Festschrift for Felix J. Oinas* (1982).

Roger Welsch is professor of English and Anthropology at the University of Nebraska. He is the author of *Treasury of Nebraska Pioneer Folklore* (1966), *Sod Walls: The Story of the Nebraska Sodhouse* (1968), *Shingling the Fog* (1972), *Mister, You Got Yourself a Horse* (1981), *Omaha Tribal Myths and Trickster Tales* (1981), and *Catfish at the Pump* (1982).

Index